THE Sopranos®

THE COMPLETE VISUAL HISTORY

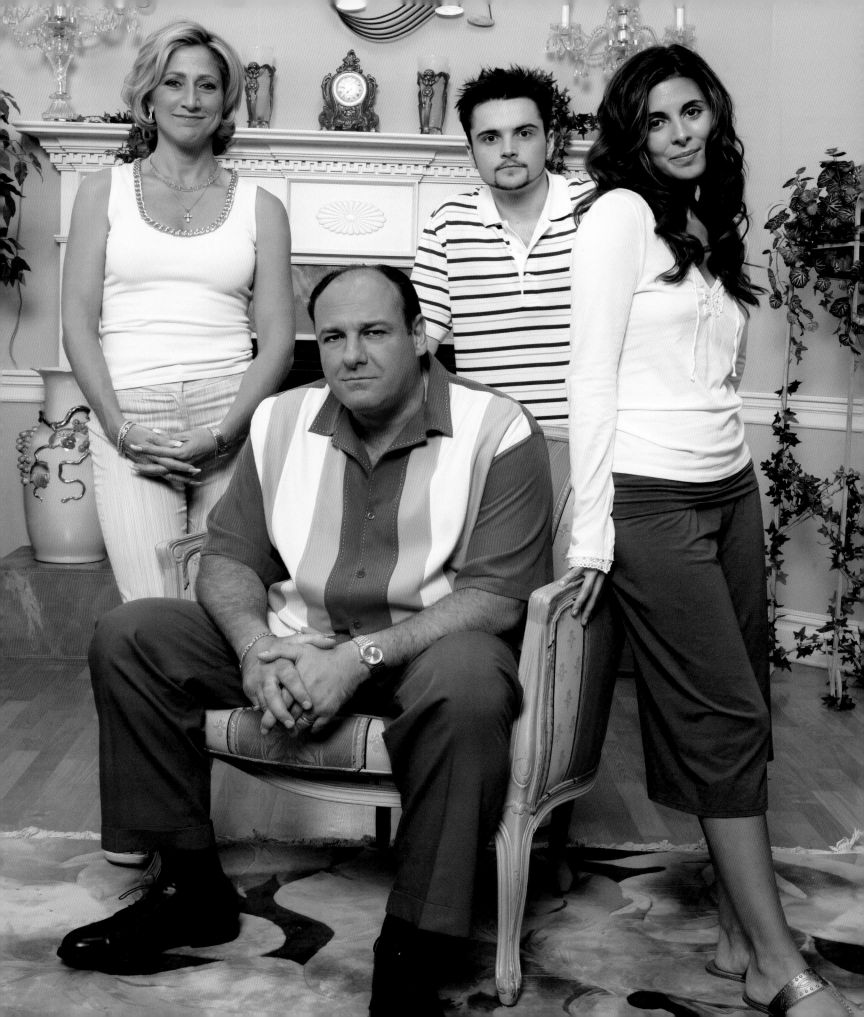

THE Sopranos

THE COMPLETE VISUAL HISTORY

RAY RICHMOND
WITH A FOREWORD BY ALAN SEPINWALL

INSIGHT
EDITIONS

SAN RAFAEL • LOS ANGELES • LONDON

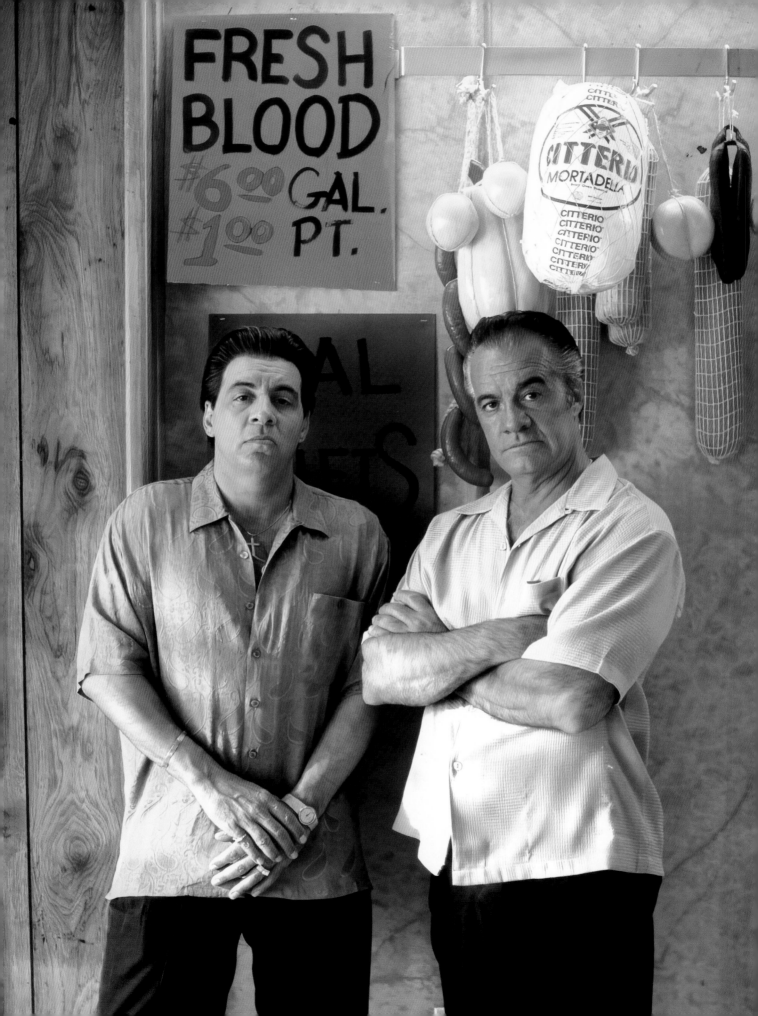

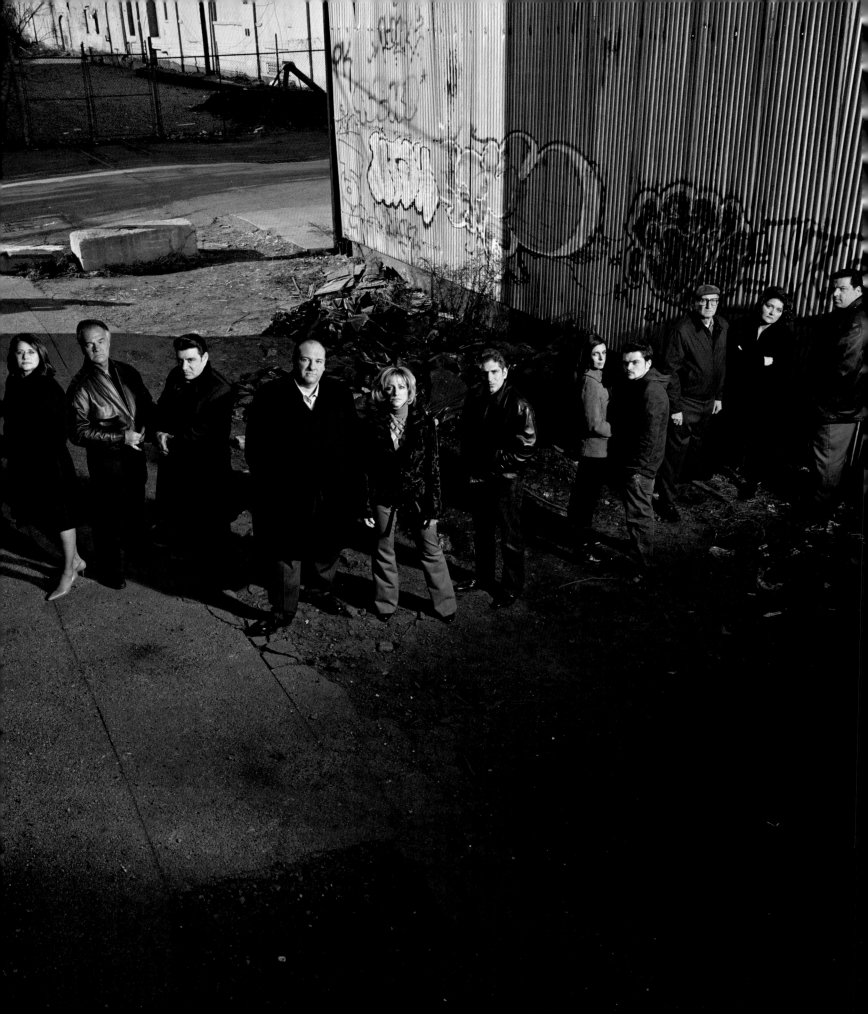

Groundbreaking Television

"It's good to be in something from the ground floor. And I came too late for that, I know. But lately, I'm getting the feeling that I came in at the end. The best is over."

This is Tony Soprano, early in his first therapy session with Dr. Jennifer Melfi. He is talking about life in the Mafia in 1999 while she suggests the sentiment applies to how people are feeling about the state of America as a whole, if not the world. Viewed through that lens from a quarter-century later, both appear to have been right in many ways.

But Tony and the good doctor are also fictional characters on a TV show. And from that perspective, *The Sopranos* represents not the end of something but that ground floor Tony so desperately wishes he could have entered on.

It is not an overstatement to say that *The Sopranos* is the single most important scripted TV show of the twenty-first century and the most influential scripted show of any kind since *I Love Lucy*. Nearly every drama or comedy you watch today has some trace of Tony's DNA in it. Sometimes, it's in a willingness to tell stories in a more serialized, ongoing fashion. Sometimes, it's a lack of fear of building shows around characters the audience is not conditioned to empathize with—from Don Draper (*Mad Men*) and Walter White (*Breaking Bad*) to the children of Tywin Lannister (*Game of Thrones*) and Logan Roy (*Succession*). And sometimes, it's as simple as a show where a creator has been trusted to follow their passions, rather than leaning on a tried-and-true formula, in the same way that HBO gave David Chase a chance to do whatever he wanted with this tale of a complicated guy from New Jersey, caught between the demands of his family and his Family.

Even if you set aside the boundless shadow *The Sopranos* has cast over the TV world that followed it, it's impossible to ignore what a spectacular achievement the show itself is, as both a complex

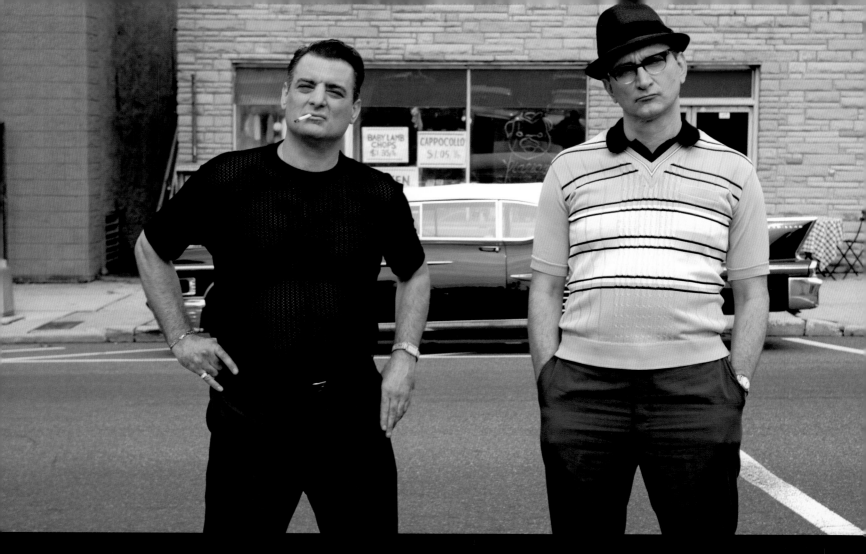

exploration of psychology and the darkness at the heart of the American dream, and as a wildly entertaining story packed with unforgettable characters and performances.

I grew up two towns over from Tony and Carmela's McMansion in North Caldwell. I had a summer job at a bank branch a few doors down from the spot where Artie Bucco opened Nuovo Vesuvio after Silvio Dante burned down his original location (to stop Uncle Junior from having Little Pussy Malanga killed there, of course). The storefront where Tony Blundetto tried to set up a massage parlor in Season Five was once the home of my favorite childhood bookstore. I patronized the same Sports Authority where Carmela went to buy A.J. sweat socks in the middle of one of Tony's more crippling depressive episodes. I knew the geography of *The Sopranos* intimately. When the show debuted, I was working as a TV critic for *The Star-Ledger*, the same suburban newspaper that Tony waddled out to the end of his driveway to pick up each morning. And I had spent much of my life watching shows like *St. Elsewhere* and *NYPD Blue* that were, to that point, considered to be the pinnacle of what TV could

achieve. In January 1999, I thought I was prepared for what Chase, James Gandolfini, Edie Falco, and company had in store for me.

I was not prepared at all for what I saw.

Here was a show that broke every unwritten rule TV had ever operated on, particularly the fear of challenging the audience in terms of plot, theme, or even whether they had to like the characters they were watching. Here was a show built around a largely unknown actor, who in no way looked like a traditional leading man, but whose charisma, versatility, and depth of feeling were so palpable that it was impossible to imagine anyone else in the role. Here was a show with grisly violence but also artful dream sequences, thorough explorations of toxic masculinity and mental illness but also fart jokes, and malapropisms, with one idea or contrast after another that no one had ever thought to attempt before on the small screen, never mind pull off well. Here was a masterpiece from minute one.

It was also a sensation in the home state that Tony and I shared. Whether Jerseyans were thrilled to see the attention

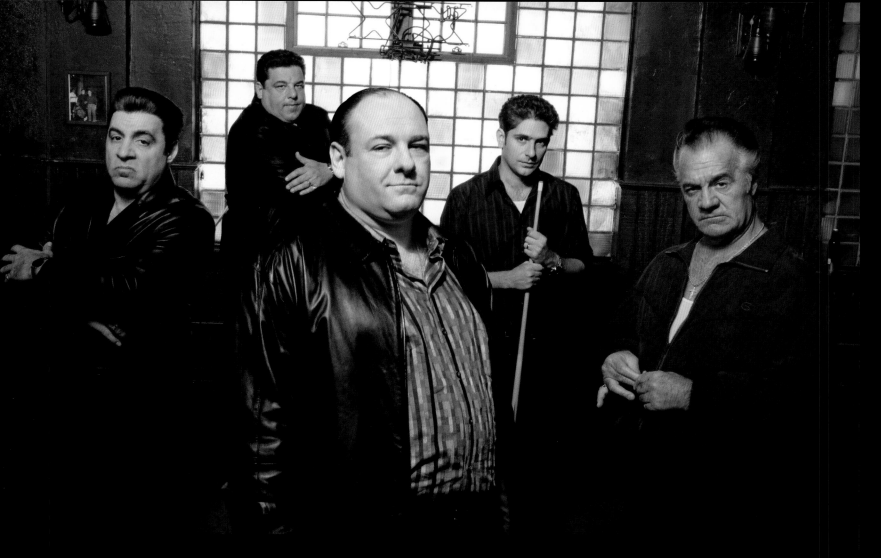

moving to our side of the Hudson River (for once) or were dismayed that the world's tour guides to the Garden State were so disreputable, it was all anyone could talk about for close to a decade. But *The Sopranos* obsession was never limited to Essex County and its immediate surroundings. Everywhere I traveled from 1999 to 2007—and even for long after—people had passionate, varied takes on the show. Some were both fascinated and repulsed by Tony's inability to stop harming himself and the people around him. Others went completely native. In the Season Five premiere, Paulie Walnuts and Christopher Moltisanti murder a waiter who had the audacity to complain about the minuscule tip Christopher left on a $1,200 dinner tab. At a bar a few hours after the episode first aired, I ran into a woman who told me, without irony, that the waiter had it coming because he was talking back to those guys.

In the middle of this phenomenon was a man who was never remotely comfortable with the attention his mammoth talent had earned him. James Gandolfini—Jim and Jimmy to his friends—was a Jersey guy himself who had his own

demons and anxieties, particularly when it came to playing such a dark and complicated role. Chase once told me that Gandolfini walked out midway through what, to that point, had been a very impressive first audition, insisting that he couldn't focus and would return that Friday to try again. When Friday rolled around, he gave a flimsy excuse for not coming in and had to be all but dragged kicking and screaming to a complete and successful audition. Something about playing this terrible man scared him, and he would wrestle with that darkness for nearly all of the show's run.

But that internal struggle in no way diminished the work that audiences could see. It is as stunning a performance today as it was in the late nineties and early aughts: layered, magnetic, vulnerable, terrifying, and even oddly lovable. You could not take your eyes off him, even when he was working alongside some incredible actors in their own right, such as Edie Falco, Michael Imperioli, Lorraine Bracco, and Joe Pantoliano. But where Tony reveled in the attention and respect he commanded as he rose to become the boss of North Jersey, Gandolfini shrank from the fame he had earned,

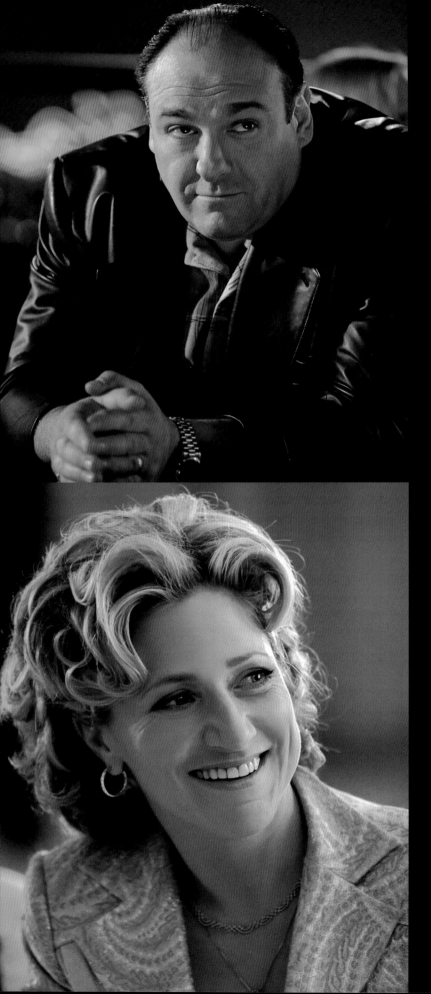

rarely doing interviews because, he claimed, he didn't understand why anyone would care about what he had to say as himself rather than as the iconic character he played.

Well beyond Gandolfini's unmistakable face and silhouette, *The Sopranos* offered indelible pictures week after week, year after year. With rare exceptions such as *Miami Vice*, TV had a long history of going for the most efficient low-frills visual style possible because there simply wasn't time to shoot anything more distinctive. But HBO gave *The Sopranos* a more relaxed schedule, and longtime film fan Chase made sure that he and his other directors took as much advantage of that freedom as they could. The locations always looked completely authentic, even when parts of Jersey had to stand in for other places, such as Vito's idyllic New Hampshire getaway. (That's Main Street in Boonton.) The dream sequences were loaded with abstract images that seemed like they could only have been conjured by the unconscious mind. And the sense of nature, in a locale with four distinct seasons, was so vividly captured that viewers couldn't be blamed for shivering when Paulie and Christopher were lost in the snowy Pine Barrens or feeling a welcome breeze against their skin while Tony and Bobby Bacala were lounging on a boat near Bobby's lake house. Patsy Parisi once warned Gloria Trillo that if Gloria kept bothering Tony, her death wouldn't be cinematic. But *The Sopranos* itself looked as gorgeous and detailed as the best the cinema had to offer over the same period.

The book you're reading is called *The Sopranos: The Complete Visual History* because it digs deep into how and why the series looked as great as it did. But it also offers rich portraits of the characters we all fell in love with, often against our better judgment, and a lot of discussion of how *The Sopranos* grew and changed, even as Tony and friends so often struggled to do the same.

So sit back, pour a glass of orange juice with *some* pulp (not *no* pulp), and enjoy this look back at the world David Chase and Tony Soprano made.

Alan Sepinwall
Chief TV critic of *Rolling Stone*
New Jersey

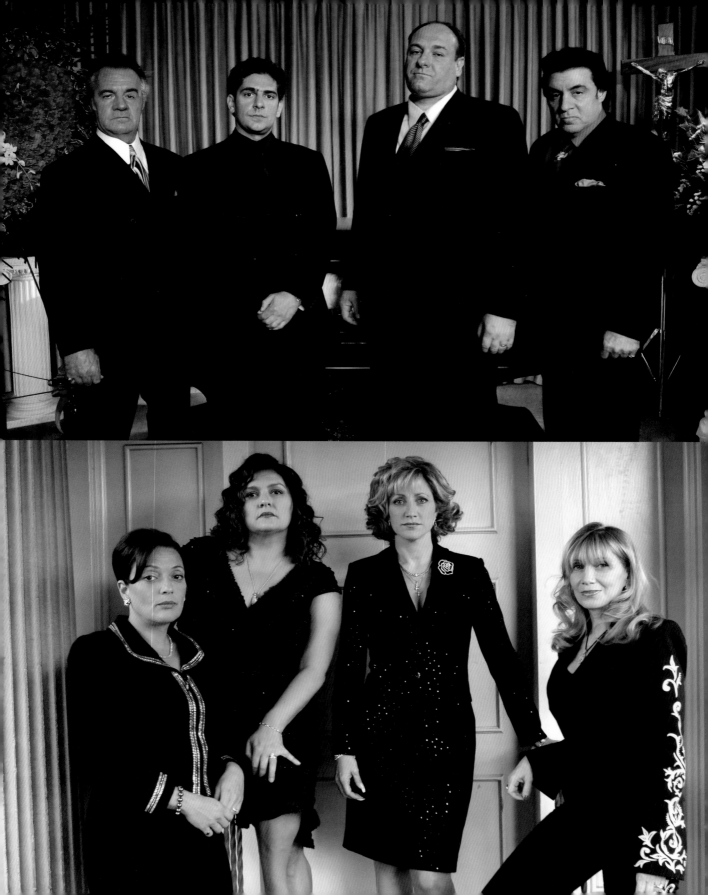

PREFACE

An Interview with David Chase

It isn't fair to say that David Chase was an overnight sensation. He had, in fact, been working in TV as a writer and writer-producer starting in the early 1970s on shows such as *Kolchak: The Night Stalker, The Rockford Files, Almost Grown, Northern Exposure,* and *I'll Fly Away*—well before *The Sopranos* came to define his legacy in the late 1990s. In this interview, seven-time Emmy Award winner Chase talks about his years as the creator, executive producer, and head writer of the groundbreaking series that spanned six seasons between 1999 and 2007. He reveals how *The Sopranos* grew to become a phenomenon whose impact continues to reverberate twenty-five years later.

When you created *The Sopranos,* did you have any clue you were producing something historic in terms of its impact on TV drama and American popular culture?
David Chase (DC): What I thought back then at the beginning was, "God, we put everything in here but the kitchen sink, and I think a lot of this is falling flat." Well, I don't feel that anymore.

You thought a lot of it was falling flat with the audience or with critics?
DC: Both. I mean, I knew the show was very much appreciated during its time on the air. But I still felt like I wasn't sure it was all going over well. But that may very well just be my insecurity.

The Sopranos was hailed as something of a masterpiece from day one, and that sentiment only grew as the years passed. Would this show be greenlit today?
DC: No. I think too much of the content would make various people uncomfortable. And the aim of the show—well, for me, *any* show—was never to make people comfortable.

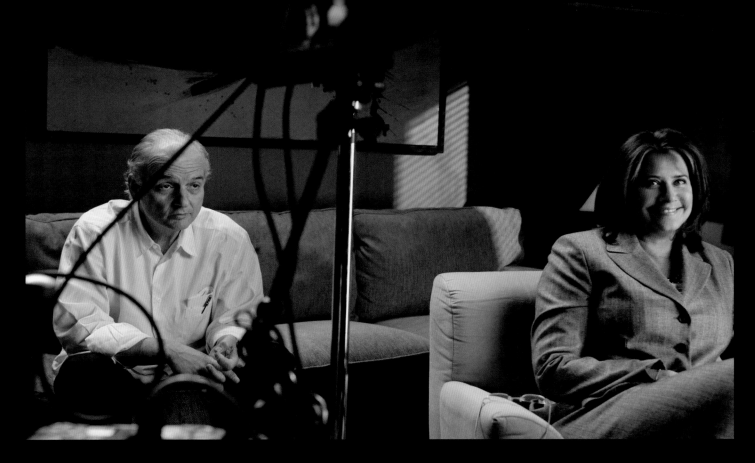

What do you think made people uncomfortable back then? The show's depiction of Italian Americans?

DC: That was a problem then, for sure. But no, I'm talking about our depiction of African Americans, women, gay people, people from the Indian subcontinent, you name it. I see all the things that offend people now and I think, "Oh my God, our timing was blessed."

What was *your* aim then, besides creating discomfort?

DC: It was to excite people.

You made a show about a mobster in therapy. You had your own therapy experience too, correct?

DC: Yes, I did. I had my own Livia.

And you thought you could build a series around her?

DC: Actually, my wife was the first one who got the joke, such as it was, and used to tell me I should make a show about her. And it was originally going to be a feature. That's what my hope was. I'd just signed with a new agency, and they said, "Mob comedies? Forget it." So, I never submitted it as a feature. And then when I signed a deal with [producer] Brad Grey, his team said to me, "We believe you have a great series in you." And I was like, "What?" No one had ever talked to me that way.

Well, it wasn't like you were a rookie working on your first spec script.

DC: No. I had two Emmys by that time and a Writers Guild Award, so I thought, "A great series in me? That's not on my agenda."

You thought you had a great film in you.

DC: Yes, that's what I wanted. And Brad said something about *The Godfather* for TV, and I thought, "I don't want to do that. It's been done." Then on the way home, it all fell together: a mobster in therapy.

What did you do at the beginning to make *The Sopranos* stand out from the stuff on the networks?

DC: The two main things I focused on at that time were pace and language. Slowing it down. And having no commercials was a real boon for storytelling. All those false climaxes in the middle, the sting moments—we didn't have to worry about any of that.

Did you spend much time worrying about what actual mobsters would think of the show?

DC: Not really, but we got feedback that told us we were getting it right. Through their listening devices, the actual FBI heard [real-life mobsters] talking on Monday mornings about *The Sopranos*. The mob guys would say, "That's us.

Last night they were talking about Ralph? You know him, he's your cousin." And, of course, it wasn't based on them at all.

Was it based on any real-life people?
DC: There were two groups from two well-known crime families [that inspired the stories].

Did what the FBI record sound like the real-life mobsters were wondering how you guys were able to duplicate what they were actually up to?
DC: No, I never got that impression. I think they were amazed, and I think they were entertained, maybe even amused by what we came up with. Now, I'll just say someone who worked on the show was [allegedly] married to someone who was connected. And this individual asked the cousin-in-law or whatever you want to call it, "Are we all right?" And this person was at Christmas dinner or something at the time. They said, "Yeah, I think so." Then a couple of years later, I finally got together with a cousin of mine by marriage who was connected—something I had always resisted. And my wife and I had dinner with this cousin and her husband, who was the connected guy. And I asked, "Are we okay?" And he answered, "Let me find out." And then he called me a couple of days later and said, "Yeah, you're all right."

What was behind that "Are we all right" question? Was it meant as, "Are we accurate" or "Are we being respectful enough to you guys?"
DC: It was more, "Are we in danger? Have we pissed anybody off?"

And if you had pissed someone off, what then? Was the concern that someone might take some kind of hostile action against you or the production?
DC: In a word, yes. If we'd unwittingly insulted somebody, we wanted to know. Maybe we'd given away secrets. Who

knows? We portrayed them as puppets of the FBI. You never know when you might've rubbed somebody the wrong way.

Did you wind up dramatizing any actual stories that you heard from your cousin in the show?
DC: Janice [Aida Turturro] told the story in Season Six [Episode Thirteen, "Soprano Home Movies"] about Johnny and Livia, about her father shooting her mother's beehive. That came from my cousin.

I imagine you had a very active hand in casting.
DC: Absolutely. Who we had on *The Sopranos* were nonpareil. I'd hired our casting directors Georgianne Walken and Sheila Jaffe because they'd handled Steve Buscemi's movie *Trees Lounge,* which I thought was great. It was so East Coast and terrific.

Were there a lot of challenges in creating the necessary chemistry with the cast, or did it all come together naturally?
DC: It came together naturally, and I think a lot of that had to do with our trying to get as many tristate Italian Americans on the show as I could. I wanted the sense when you watched the show that you were in the neighborhood.

They were so good I imagined that some of them had to have actual mob connections.
DC: Well, that was true only of Tony Sirico [Paulie Gualtieri]. A lot of the other actors might have known people or rubbed shoulders. But Tony had done jail time and was being groomed to be a made guy. But it was, you know, six degrees of separation. Everyone had a distant cousin or the friend of a friend with a connection. It was just part of the culture.

How did you come to cast James Gandolfini for your lead? He'd been a successful character actor up to that point but never the lead.

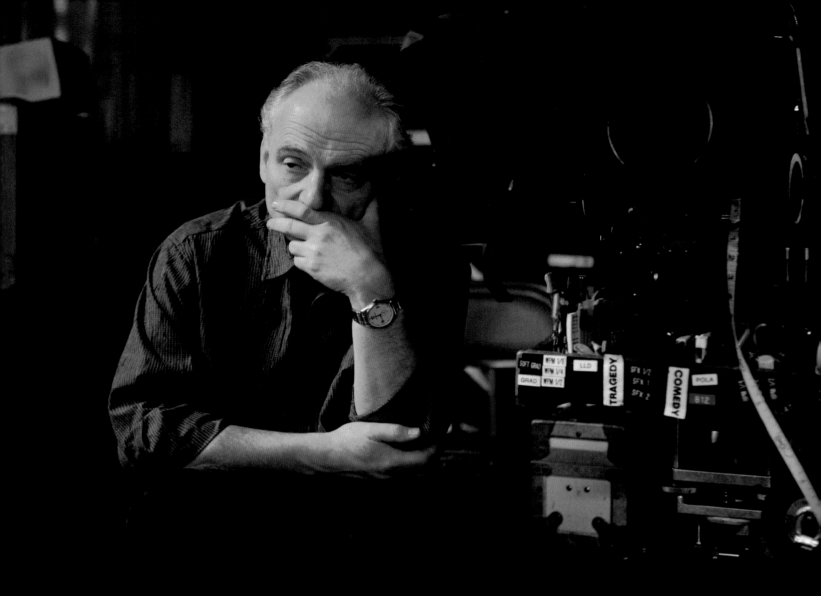

DC: It was Georgianne and Sheila. They said when we were starting our search, "Do you know Jim Gandolfini?" I admitted I didn't. They showed me some of his stuff. We'd had a lot of people in to read for it. Audition after audition. We finally brought three people to HBO who we were considering, and Jim was one. When he walked in, that pretty much sealed it.

I've heard stories about how things didn't go so well at his first audition.

DC: That's correct. He came in to read, and in the middle of the audition, he stopped and said, "I've got to go. I'm not doing this right." And he left the room. And then he was going to come the following Friday, and he didn't show up. It ultimately took a while to corral him. We finally got him to LA and brought him to my house, and we taped his audition in my garage. And it was great.

Is it true that Steven Van Zandt was originally trying out to play Tony?

DC: Yes, he was. And he was a believable gangster. Steven had never acted before that, but he ultimately felt he shouldn't take the lead role from a real actor. So he withdrew from the process, and we found another role for him that turned out to be perfect.

How would you describe your working relationship with James Gandolfini?

DC: We started out with a great deal of affection. We were two Italian kids from New Jersey. He was younger than me. He was from a different generation, and he probably had different tastes than I did. Jim was actually a hippie in his private way. And I was not a hippie, but over time, we got along really well. I remember the first time we went out to dinner together. We had a great time, and I remember him

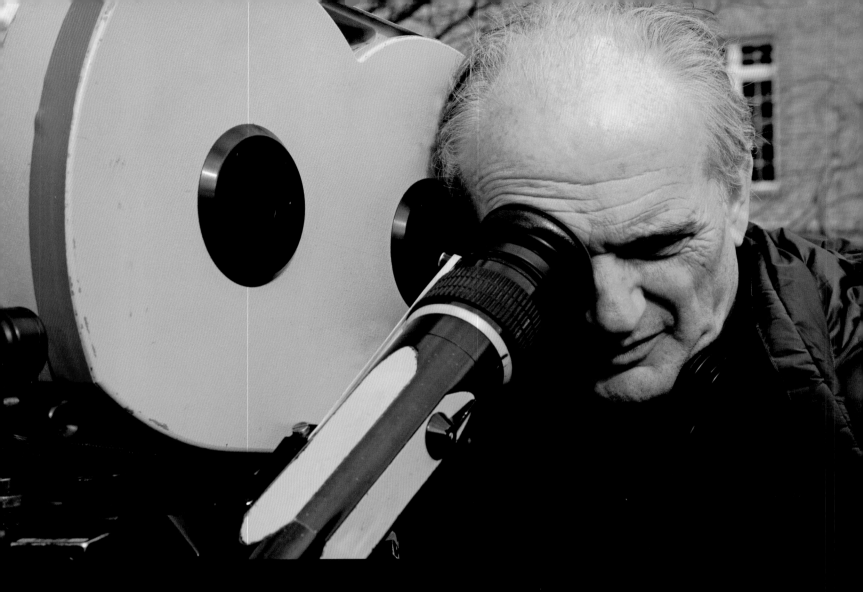

picking me up off the sidewalk and spinning me around. But over time, some of the closeness faded.

How about working with Edie Falco?
DC: Never blew a line in six seasons. Not once did she make a misstep. She was amazing. I don't think she ever read the whole script. She read her part. She came to work, and what she turned in was beyond perfection.

I've always wondered what the psychiatric and therapeutic community thought of the show.
DC: Actually, the American Psychoanalytic Association gave the show and Lorraine [Dr. Jennifer Melfi] awards, if that tells you anything. They didn't say it as grossly as this, but they noted that since our show went on the air, it had helped pick

Was that a surprise to you?
DC: Totally. I'd thought by that time in American culture, psychotherapy was already accepted. I was surprised to hear there was still a taboo surrounding it. But I had already been in therapy for twenty years. And also, I lived in Los Angeles. I guess the message was that if this guy can get help, so can I.

A lot of the credit for that would seem to be how convincingly James Gandolfini sold it.
DC: That's exactly right. It was all Jim. It was part of the magic that he worked, with his expressive eyes and a thing about him that feels very carrying. No matter how he behaved, you still saw the little boy.

Here's where I ask about the way you ended the series with the sudden cut to black. Do you still get crap from people over it, or has the world finally moved on?

DC: Nobody talks to me about it anymore. But at the time, ambiguity was very important to me. It was the opposite of network TV, which was nothing but easy answers and certainties.

What did they want you to do? Were they counting on Tony getting gunned down in the diner with blood splattering all over his family?

DC: Stevie Van Zandt went on some talk show—I think it was with Howard Stern. All morning long he was getting grilled about it. Finally, he said, "Okay look, tell me what you would've done. What did you want? You want Tony killed? The kids? Does the whole family get wiped out?" Nobody could or would answer. I guess they would say, "That's your job, not mine."

Were you surprised that the ending sparked this hysteria?

DC: That's a tough one because on the one hand, being a human being with an unhealthy streak of narcissism, you're going, "Great! We're being talked about." On the other hand, the hysteria sparks—especially online—all of this anger and these nasty comments. It used to upset me in a way because I thought, "God, they've watched this guy and loved this guy for years, and now they want to see him killed?" I found it disappointing. Except he's not a real person—he's a character. So I didn't need to get that emotionally invested in it.

When you hear people talking about The Sopranos being maybe the greatest TV drama of all time, how do you respond?

DC: I try not to focus on it or think about it too much. I think I must've told this story a hundred times. Before I started writing the show, or maybe while I was writing the pilot, I listened to this Elvis Costello song called "Radio, Radio." It's got this lyric, "I wanna bite the hand that feeds me. I wanna bite that hand so badly. I wanna make them wish they'd never seen me." I think I succeeded at that.

All things considered, to have this show be in the first line of your obituary—you could do a whole lot worse than that.

DC: I just hope the obituary happens for the right reason.

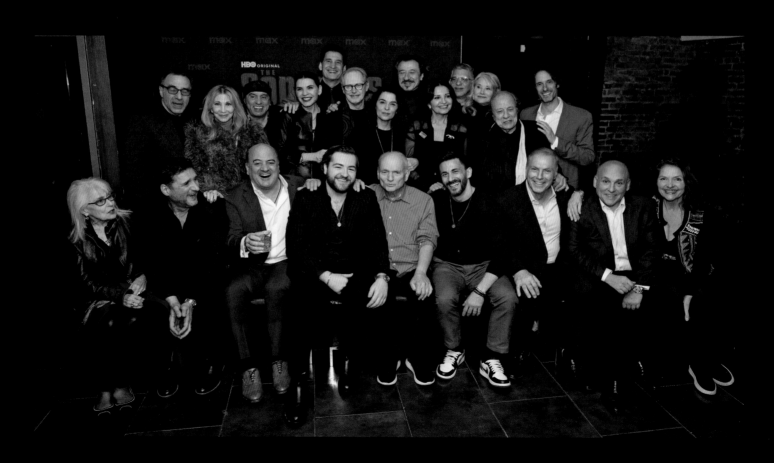

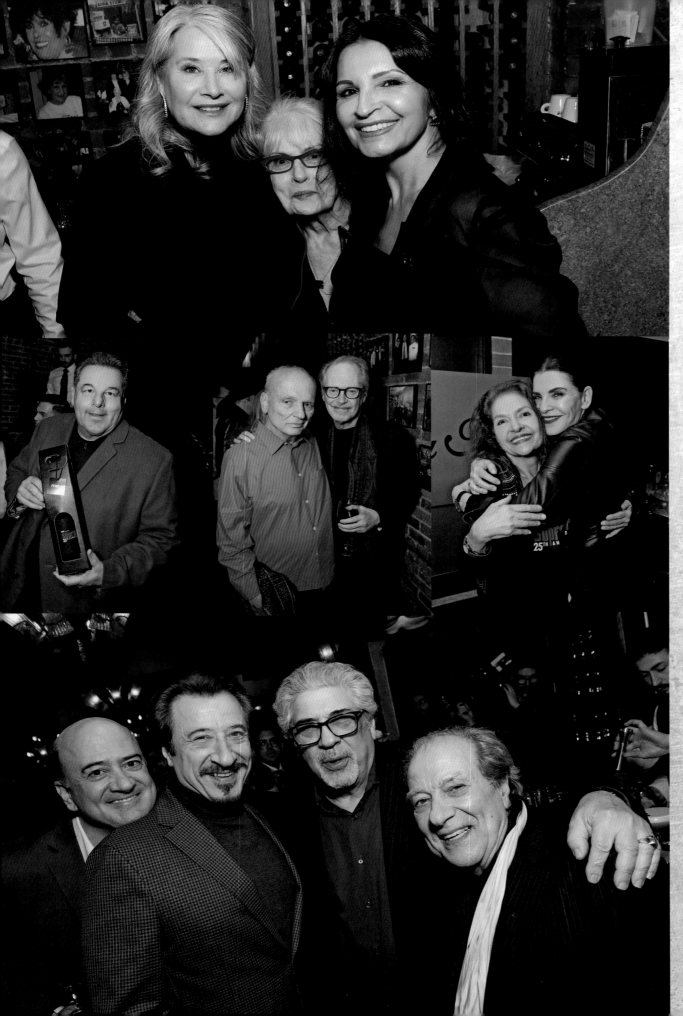

Opposite: *The Sopranos* aired January 10, 1999, on HBO. Twenty-five years to the day after its premiere, a gathering of cast and crew met at New York City's Da Nico Ristorante for an anniversary bash headed by Chase himself.

Top: Lorraine Bracco (Dr. Jennifer Melfi), Georgianne Walken (casting director), and Kathrine Narducci (Charmaine Bucco).

Middle: Steve Schirripa (Bobby Baccalieri), David Chase (series creator) and Steve Buscemi (Tony Blundetto), Aida Turturro (Janice Soprano) and Julianna Margulies (Julianna Skiff).

Bottom: Matt Servitto (Agent Dwight Harris), Federico Castelluccio (Furio Giunta), Vincent Pastore (Big Pussy Bonpensiero), and Dan Grimaldi (Patsy Parisi).

19

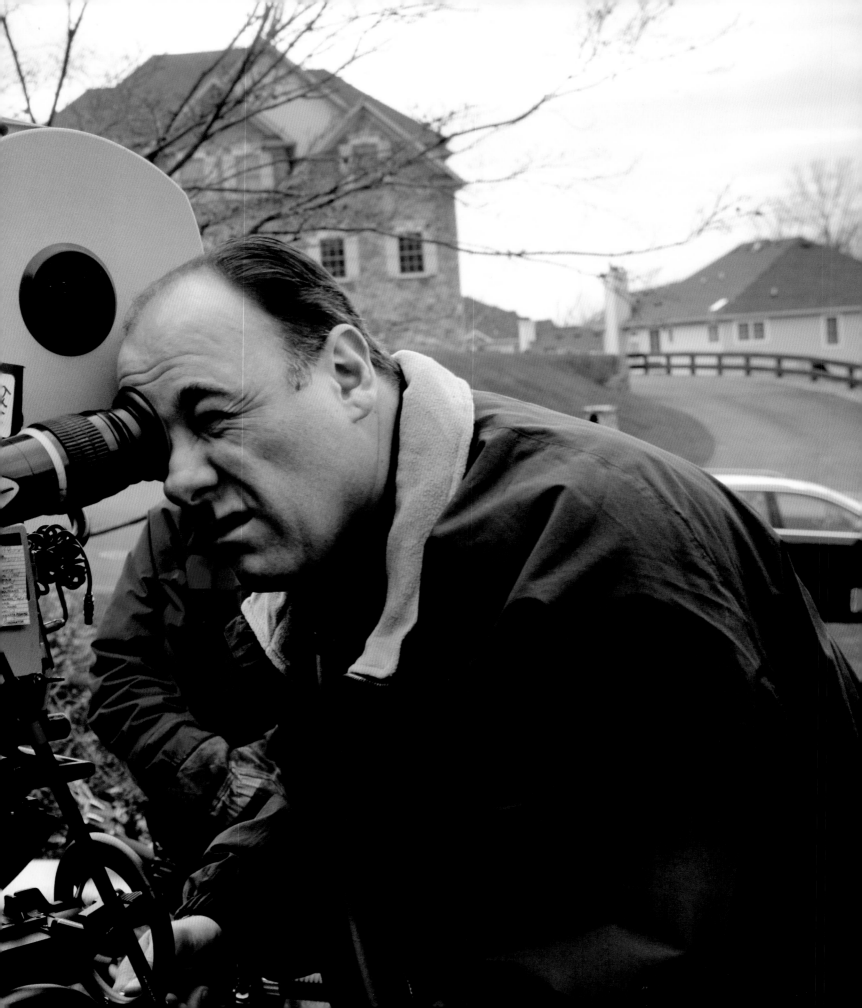

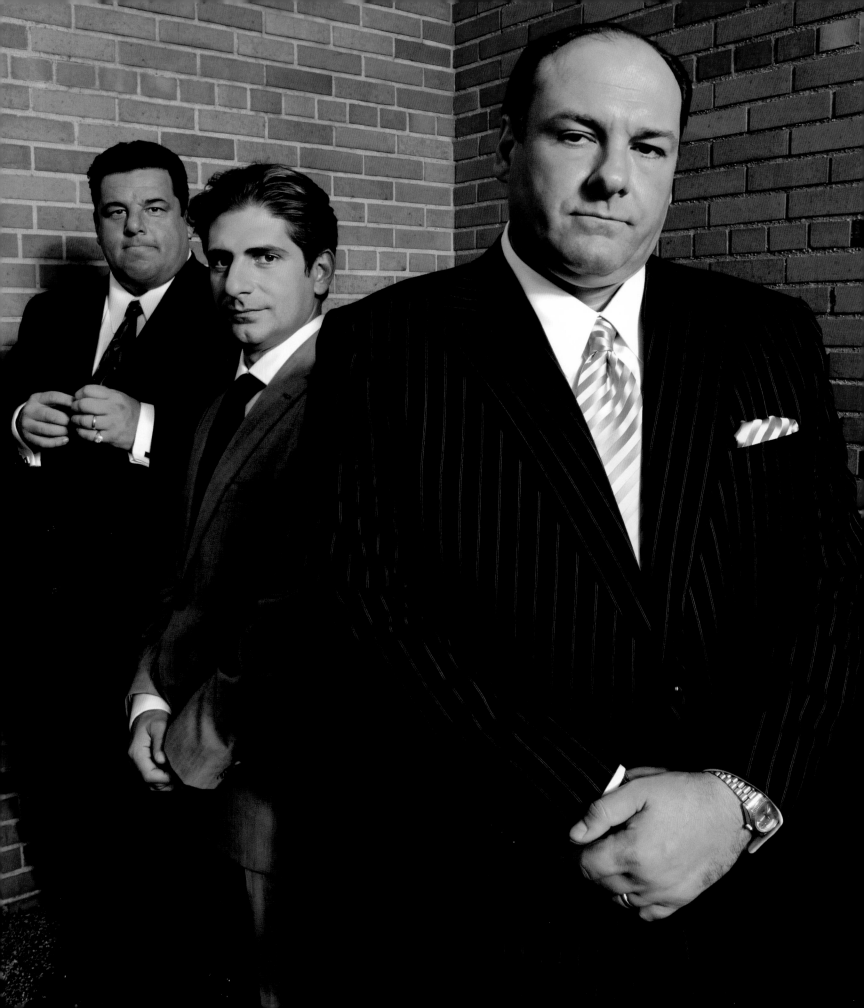

INTRODUCTION

From the start, *The Sopranos* broke new ground in TV, launching the golden age of cable drama and setting a benchmark for the ongoing evolution of the medium with its innovative storytelling techniques and nonlinear narratives. What made it unique even in the world of mob-themed projects was the idea of a gangster being anxious and depressed and requiring therapy. On its face, it's an uproarious conceit. In practice, it's alternately revealing, stressful, and comical.

The entertainment world that *The Sopranos* entered twenty-five years ago was radically different from the one it departed some eight-and-a-half years later. The idea that the medium might embody something "cinematic" or "prestige"-based was pretty much unthinkable. The chasm that existed between projects on the big screen and the small one was vast. Movie stars stayed in the movies. Film directors would never consider crossing over to lend their talents to the purportedly inferior art form of TV.

But that all changed when creator David Chase injected *The Sopranos* into the nation's cultural bloodstream. Suddenly, film professionals were lining up to dive into TV production—and it was all Tony Soprano's fault.

The series was transformational in ways that bridged the divide separating film and TV. Thanks to *The Sopranos*, TV suddenly emerged as the bolder, more innovative place to gather. The introduction of Tony proved a seminal event in the evolution of the medium. Indeed, the series invited viewers to accept—even embrace—an antihero who, sure, sometimes killed people but was also just another suburban shmoe struggling to stay sane while navigating traditional husband and father turf.

Since autumn 1996, HBO had daringly proclaimed in its marketing that it was "Not TV," and now the network was proving it. *The Sopranos* premiere marked the watershed moment that changed the way stories were told on what was once euphemistically called the "tube." From its writing to its production design to its fashion choices to its music to its cinematography to its acting performances, the series played like TV's first thirteen-hour movie, one glorious hour at a time.

The Sopranos jolted America out of its collective comfort zone and demonstrated that none of the previous rules applied any longer. All the network standards regarding language, nudity, sex, violence, and subject matter suddenly evaporated. This is made clear in "College" (Season One, Episode Five) when Tony kills a onetime mob rat now living in hiding—Tony garrotes him with a piece of wire. I don't think we're in Kansas anymore, Toto. As the season continues, Tony's uncle and mother conspires to have Tony killed.

Here is a vile lead character with a vile mother; he kills his friends, roughs up his family members, and sleeps with mistresses and hookers. And yet he regularly, sometimes tenderly, takes the feelings

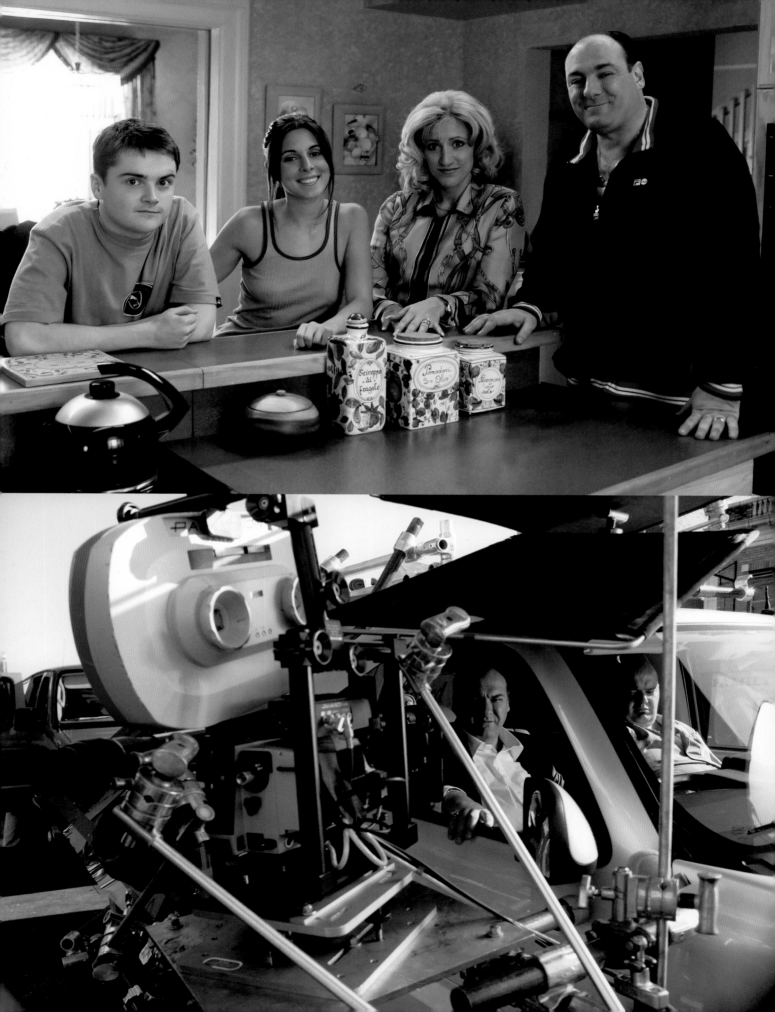

of his wife and kids into consideration as he works to better himself in therapy (though he notably also hits on his therapist). He's hero and villain all at once. And we couldn't take our eyes off him.

Every character is flawed in the show in some way. Consistently presented to be either damaged, entirely out for themselves, or both, these characters don't merely cross ethical lines—they pulverize them. They are difficult to love, but we love them anyway. Tony, Carmela, Livia, Paulie, Christopher, Big Pussy, Silvio, and the rest operate inside a cinematic story that plays out in an intricately layered manner week after week for six seasons (seven if you count the final double season as two).

The show is by turns harrowing and graphic, ridiculous and broadly comedic. But it is never less than compelling. There's bickering, there's bantering, there's fighting, there's making up. The Sopranos is, in other words, a lot like our own lives—if we also happen to be mobsters and kill people when it suits our needs.

So many of the routine conventions of TV disappear inside the presentation of this series, with serialized narrative arcs rather than self-contained episodes) becoming routine. Too, The Sopranos pioneered the practice of showcasing life in all its morally ambiguous splendor, seeing no need to wrap up storylines in a tight little bow and leaving many completely unresolved—none more so than the cut-to-black that marks the end of the series itself.

And even in the context of a mob drama leavened with a generous helping of black comedy, the show takes mental illness seriously. When The Sopranos premiered, there was still a significant stigma surrounding it in the US. But the series helped push the conversation forward in a major way, giving us at its core the story of a very conflicted man struggling to retain his personal and professional relevancy in a world he often has trouble navigating.

The series would give rise to a whole new brand of quality dramas that followed in its wake, including The Wire, Deadwood, Mad Men, Breaking Bad, and Game of Thrones. Would they have ever existed had The Sopranos not first paved the road they ultimately traveled? There is more than a small measure of doubt.

The book you're holding in your hands—The Sopranos: The Complete Visual History—was made necessary by all the above. It offers an intimate portrait of the show—revolutionary for its time and still one of the greatest in the annals of American TV. The book features the stories behind the stories as told through exclusive one-on-one interviews with producers, crew members, and members of the cast including Edie Falco, Lorraine Bracco, Steven Van Zandt, Dominic Chianese, Steve Schirripa, Aida Turturro, and more. Also included are a plethora of photographs, unique archival materials, and collectible ephemera from the series.

Designed to sate the appetite of serious fans of the show while drawing in new enthusiasts, this visual journey takes readers through the twists and turns of New Jersey's DiMeo crime family and its leader, Tony Soprano, where every permutation of his life as son, boss, father, husband, and philanderer is covered. Chapters One through Six coincide with each of the show's six seasons, and each chapter-by-season highlights an overarching theme that weaves itself through those episodes, tying into the various plotlines.

Chapters begin with an opening quote or phrase that situates the reader and attaches fresh perspective to the storyline. The next spread features a collection of favorite quotes from the featured season, followed by a quick introduction to the season highlighting some key plot points. From there, rich, animated storytelling unpacks key events of the season while examining how the various puzzle pieces fit into the wider perspective of the series. As such, the commentary is not strictly chronological and linear. Instead, it jumps around between episodes across the series, drawing connections that provide a more holistic view of the show. You got a problem with that?

In Chapter One (Season One), for instance, the theme of "Mother" supports the main narrative. And by mother, of course, we're mostly talking about the mother of all mothers: Livia Soprano (portrayed so memorably by the great Nancy Marchand). The chapter's theme delves into Livia's toxicity that manifested in her son Tony as panic attacks and depression, driving him into therapy with psychiatrist Dr. Jennifer Melfi. In this chapter, we discover how much Tony's relationship with his mother impacts every other relationship in his life, including those with his wife, his kids, his Uncle Junior, and even his therapist.

Chapter Two (Season Two) focuses on the theme of "Siblings," which is dominated by the arrival of Tony's older sister Janice and the trouble she stirs up inside all three of Tony's families: his mob family, his nuclear family, and his family of origin. In this context, we also examine the brotherhood of the crime family and the toll of unexpected betrayals.

Chapter Three (Season Three) looks at the theme of "Father," examining Tony's role as patriarch and father not

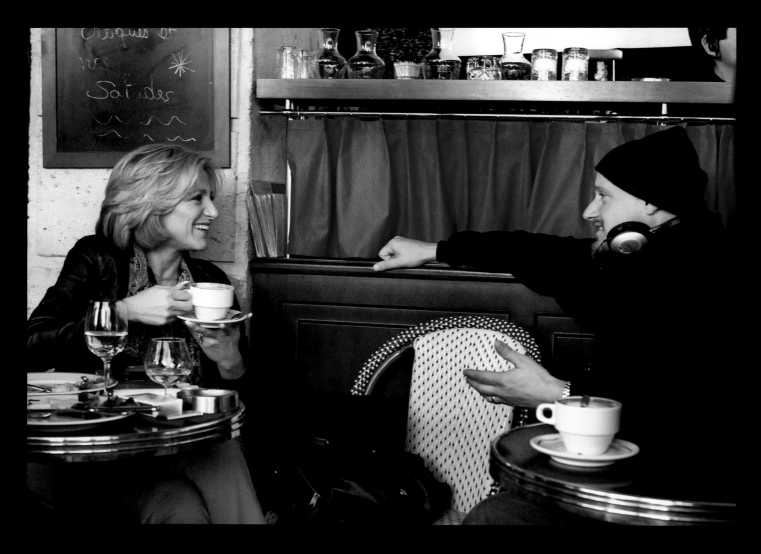

only to his actual children Meadow and A.J. but also to his nephew Christopher, Tony's best friend's son Jackie Jr., and various other members of his crew who turn to him for advice and approval.

Chapter Four (Season Four) examines "Marriage," including the collapse of Tony and Carmela's union as well as loyalty in relationships in general, such as the secrets brewing in the shadows of Christopher and Adriana's relationship. It also explores the question of what being married even means in the context of mob life, when casual liaisons are baked into the culture of organized crime.

Chapter Five (Season Five) surveys the theme of "Family," specifically surrounding the release of Tony's cousin, Tony Blundetto, from prison. This chapter also reflects on how far one family member will go to protect another and questions how guilt plays a part in the redemption of another. The moral: never believe any career mobster who says he's been rehabbed and wants to go straight. Loyalty

takes center stage this season, and we watch as relationships crumble under the pressures of life in the Mafia.

Finally, Chapter Six (Season Six)—the supersized two-part final season—centers on Tony as he suffers a series of existential crises that make him question what it means to be Tony Soprano. It starts with being shot and nearly killed by his dementia-addled uncle. While in an induced coma, Tony's vivid dream finds him in another identity on a neighboring plane of existence. The season also finds Tony reconciling what it means to be a devoted husband and coming to grips with the Soprano depression gene. And with the continued unraveling of both the New York and DiMeo criminal enterprises, we see the walls close in on Tony as he meets his wife and children for what might be a last meal at their favorite New Jersey diner. Here Tony's fate comes to a head, but it is only for him and his families in the fictious world of *The Sopranos* to know what that fate is.

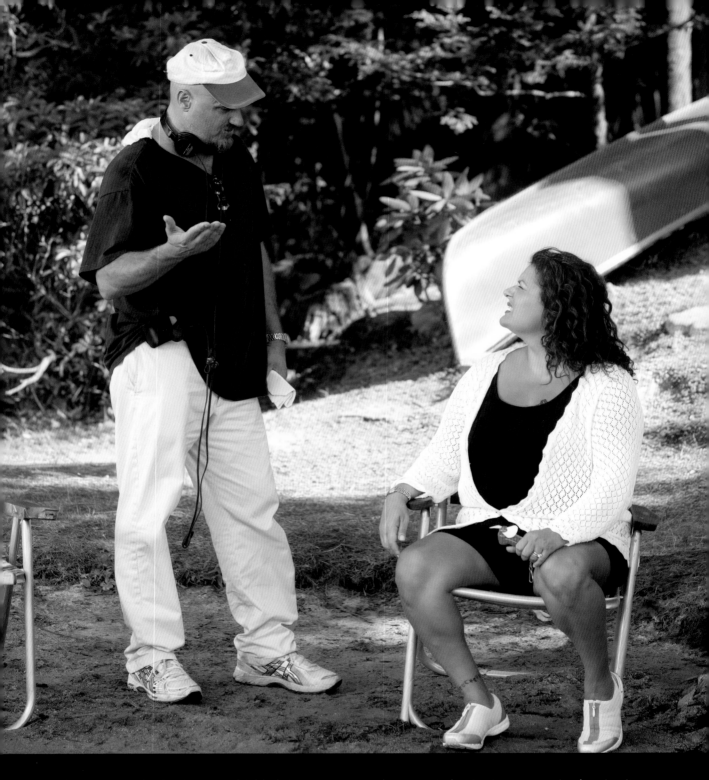

Chapter Seven covers The Garden State, highlighting locations, both real and fictitious, where the action in *The Sopranos* takes place.

And last, but certainly not least, Chapter Eight features a heartfelt tribute to the late James Gandolfini, with memories from cast and crew.

This book has been a labor of love, put together by people

to have created a viewing companion bearing its name.

Prepare to relive every moment of a show that is twenty-five years old but still looks as fresh and contemporary as the day it premiered—flip phones notwithstanding. As timeless as it is historic, the show changed the way TV approached dramatic entertainment. It's our hope that the book serves to pay homage to this thing of theirs.

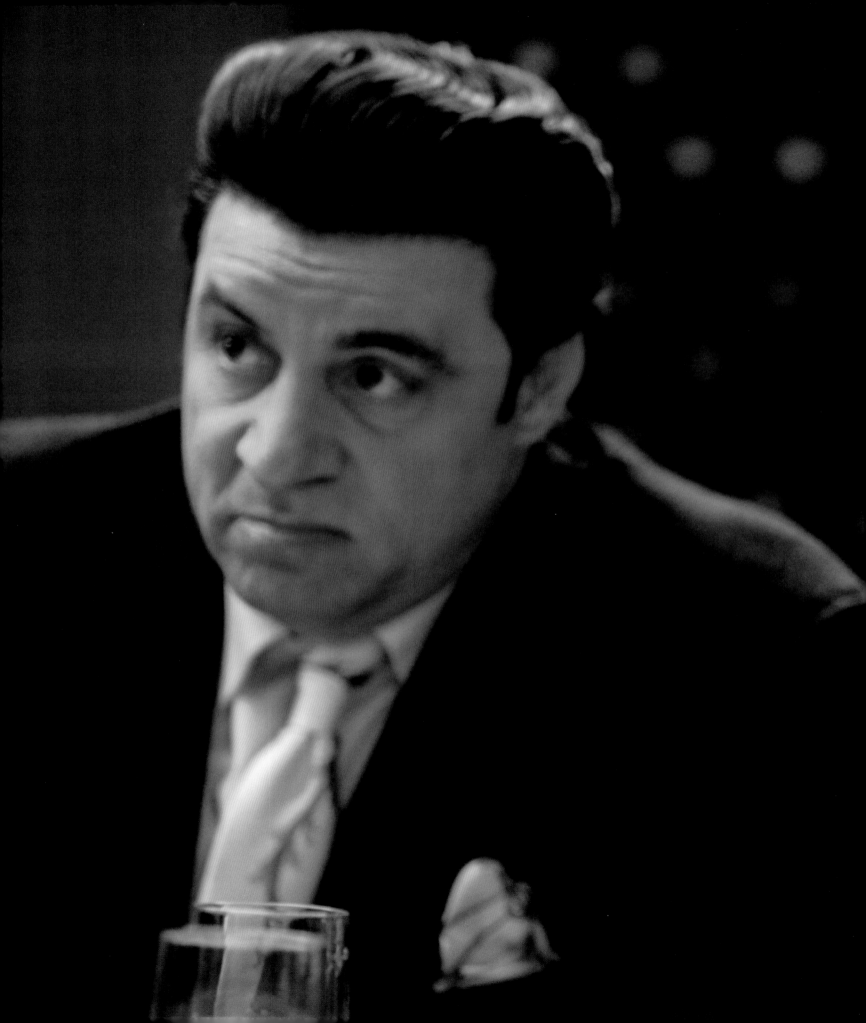

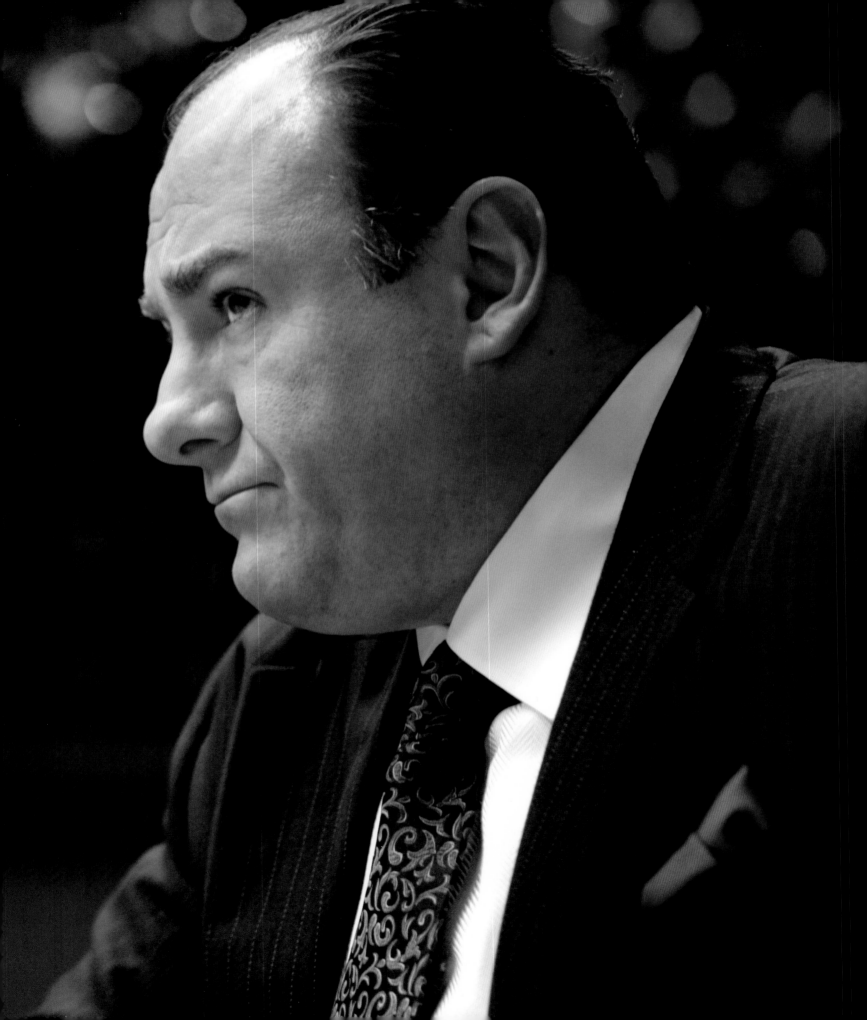

IT'S AMAZING
HOW MUCH
DESTRUCTION
ONE PERSON
CAN CAUSE

"So what?
No fuckin' ziti now?"
A.J. SOPRANO

"I gave my life
to my children on
a silver platter."
LIVIA SOPRANO

"This ain't negotiation time.
This is Scarface, final scene,
fuckin' bazookas under
each arm, 'Say hello to
my little friend!'"
CHRISTOPHER MOLTISANTI

"You may run North Jersey,
but you don't run your Uncle
Junior! How many fucking
hours did I spend playing
catch with you?"
JUNIOR SOPRANO

"A lot of top guys have dark moods.
That Winston Churchill drank a quart
of brandy before breakfast. Napoleon,
he was a moody fuck, too."
SILVIO DANTE

THEY SAID IT IN SEASON ONE . . .

"All our food. Pizza. Calzone. Buffalo mozzarella. Olive oil. These fucks had nothin'. They ate puzzi before we gave 'em the gift of our cuisine."

PAULIE WALNUTS

"Wasn't it Salvatore Lucania, better known as Charlie "Lucky" Luciano, who organized the five families? Lucchese, Gambino, Bonanno, Profaci . . . "

MEADOW SOPRANO

"That's a shame. A medication comes along after your gambling gets your fucking hip busted to shit."

BIG PUSSY

"Let me tell you something. I had a semester-and-a-half of college, so I understand Freud. I understand therapy as a concept."

TONY SOPRANO

"Is that why they tried to kill you? Because you're seeing a psychiatrist?"

CARMELA SOPRANO

"Oh, poor you."

LIVIA SOPRANO

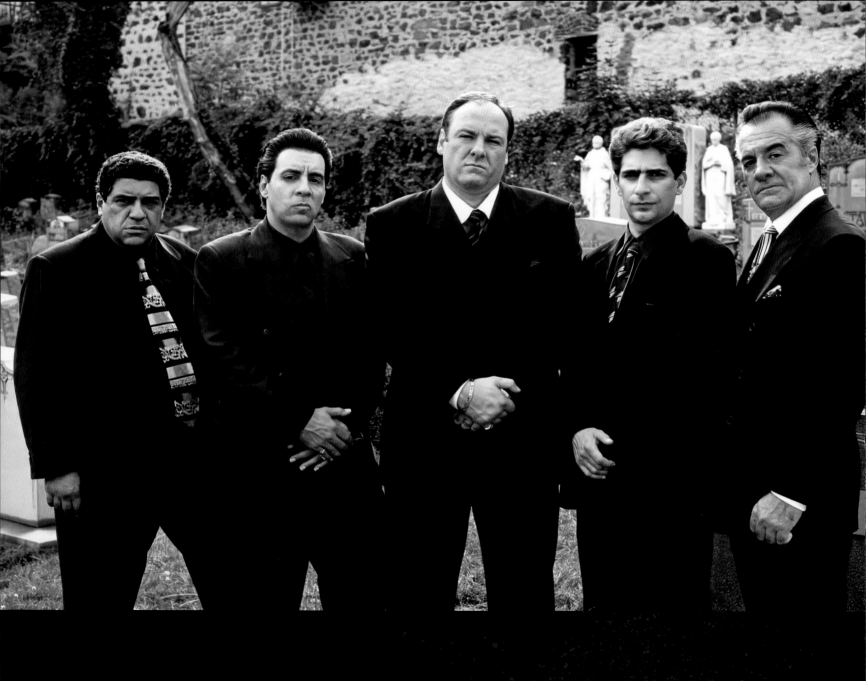

"Lately, I'm gettin' the feeling that I came in at the end—the best is over."

TONY SOPRANO

INTRODUCTION TO SEASON ONE

There was never going to be anything sweet about *The Sopranos*, at least not with the relationship between its main protagonist and his mother. Early in the pilot, our antihero Tony Soprano (James Gandolfini) has a panic attack triggered by a family of ducks that flies away after taking up temporary residence in the Sopranos' backyard swimming pool. This lands Tony in the office of psychiatrist Dr. Jennifer Melfi (Lorraine Bracco). But why would a tough guy melt down over a couple of birds? Well, that's just it. It ain't *really* the fowl but the fouls perpetrated by his contemptible mother Livia (Nancy Marchand). It's the buildup of years of emotional abuse heaped upon her only son—the spiritual wounds and unresolved issues wrought by a woman who possesses neither shame nor boundaries.

Tony has always tried to do right by Livia, but she's impossible to please. When she's no longer able to care for herself, Tony tries to convince her to move to Green Grove, a luxurious retirement community, but the petulant Livia refuses—she's convinced Tony's intention is to abandon her in "that nursing home." This is what triggers Tony's second panic attack. Now we're off to the races.

The first season also introduces us to Tony's duplicitous lifestyle as underboss to Jackie Aprile Sr. (Michael Rispoli) of New Jersey's DiMeo crime family. And there is much for Tony to manage. Between navigating the changing landscape of organized crime, spilling the details of his life to a female psychiatrist, adjusting to antidepressants, and struggling to maintain a "normal" family life with wife Carmela (Edie Falco), sixteen-year-old daughter Meadow (Jamie-Lynn Sigler), and thirteen-year-old son Anthony Jr. "A.J." (Robert Iler), it's a lot for a mobster to have on his plate.

Then there's Corrado "Uncle Junior" Soprano (Dominic Chianese), brother to Tony's father Johnny, who is cantankerous, conniving, and dying—or, shall we say, willing to kill—for the opportunity to take the reins as boss.

It's these and other hassles that complicate Tony's life. And, as he's quick to learn in therapy, it all originates with his mother, a woman more concerned with protecting her sense of security than her own flesh and blood.

Key Plot Points

- **Tony struggles to balance responsibilities in both families that include a critical wife, ungrateful children, an impatient crew, a toxic mother, and a backstabbing uncle.**
- **Tony works to understand why he has panic attacks and depression while trying to keep his therapy sessions on the down-low.**
- **The Feds are closing in and Tony must weed out the rat who threatens to upend it all.**

ALL ROADS LEAD TO MOTHER

"It was my wife who used to say, 'God, you've got to make a show about your mother.' Because she saw how often—what's the expression?—that we dined out on stories about her. And then someone else said, 'You've got to make a show about your mother and you.' And then I thought, 'Really? Who wants to see a show about a TV producer and his mother?' And I thought, 'Well, maybe if he's a badass guy and his mother makes his life miserable, maybe there's more room to go there.'"

—David Chase, creator

It's ultimately a show about a man's relationship with his mother. From the point of view of creator David Chase, there was no more important character on the show than Livia Soprano—arguably even more important than Tony. Chase made it clear from the start that Livia is based, in large part, on his own mother Norma Chase, who has been variously described as tyrannical, thin-skinned, and paranoid. The question from day one, however, was who Chase was going to get for his new mob-themed seriocomic series—particularly when it came to casting the matriarch. It was a question that consumed the show's casting directors Sheila Jaffe and Georgianne Walken, too.

"Everybody we hired for the show was actually Italian, at David's insistence," Walken recalls. "Nancy Marchand, who we all knew—and was not Italian—came in to read. She always played these incredibly elegant women. Everything she did, she was a high-society broad. So she shows up and had to climb a flight of stairs. I came into the hallway and she was so out of breath, I got scared. I didn't know Nancy had emphysema. Nobody knew it because she didn't broadcast it."

In fact, Walken had been told by Marchand's agent that she wouldn't audition. But there she was, ready to read. Remembers Walken: "I sat her down and got her a bottle of water. And she's sitting in this tiny hallway, gasping for air. Her hair is all askew and straggly. She has no makeup on. I take one look at her, and I go, 'Holy cow. That's her. This is Livia.' Anyway, she finally comes into the room, and after having that big announcement from her agent that she wouldn't read, I didn't even ask her. She sat down and asked, 'What do you want me to read?'

"So David looks at me, and I look at David, and I go, 'Nancy, read anything you want. Read the phone book.' So she read a scene, and it was brief. She didn't stay very long. David looked at me and said, 'Okay.'"

The presumption was the supremely important role of Tony's mother was now cast, though that wasn't entirely true. As Walken emphasizes, "I won't lie. We did keep looking. But during the couple of seasons Nancy was with us, David admitted, 'Nancy has become my mother.' And that was pretty extraordinary. I get the chills when I think about it. Because that woman was Livia to the bone. [Casting her was] my proudest hour on the show." So good was Marchand in the role, brief as it was (the actress died of lung cancer between Seasons Two and Three), that it's impossible to imagine another actress as Livia Soprano.

Livia sparks greater anxiety in Tony than any fight with his wife, children, or crew ever could. She is impudent, bitter, conniving, spiteful, and malicious—and that's on a good day. She's such an ungrateful old hag that it can be baffling that Tony doesn't cut her out of his life completely. But there was something decidedly Oedipal in the relationship, and the masterful way that Livia serves to ensnare her son in her psychological web of manipulation helps explain Tony's inability to form healthy relationships with women.

Born Olivia "Livia" Pollio in Providence, Rhode Island, in 1929, daughter of Theresa and Faustino "Augie" Pollio, Livia grew up in poverty and misery. She married Giovanni "Johnny Boy" Soprano (Joseph Siravo) as a way out of pennilessness, though it came at a significant cost—having

to share life and parenting duties with a tough, working-class mobster who was as unfaithful as his son would later be. Suffice to say, the relationship between Livia and her equally sociopathic gangster husband left much to be desired.

To say that Livia Soprano has a negative streak is like saying JFK suffered some health issues while visiting Dallas. Scheming, controlling, and emotionally abusive, Livia has left a long-lasting, deep-seated negative impact on the lives of her middle child Tony, eldest child Janice (Aida Turturro), and youngest child Barbara (Nicole Burdette). She has never had the best interests of her children at heart. Instead, as a matriarch whose self-aggrandizement knows few bounds, she is very much in the Livia Soprano business.

Tony, as we know, dutifully follows in his father's footsteps. Janice moves to Los Angeles after graduating high school, joins an ashram, and changes her name to Parvati Wasatch. After languishing for a time as a hippie on the West Coast, she eventually returns home to follow in her mother's footsteps. Barbara marries into what we presume is a "normal" family, eschewing the path of her family of origin. This leaves Tony alone to care for Livia as her health and mental acuity declines in the years following his father's death.

Livia derives pleasure from filling those around her with anxiety, particularly Tony. Yet she hardly restricted her venom to her son. On Tony and Carmela's wedding day, Livia tells her new daughter-in-law that marrying Tony is a mistake and that he'd get bored with her. You'd think that becoming a grandmother might soften her heart, but she never does fill out those "Granny Remembers" books that Carmela gives her when the kids were born. And why would she? It's not like Livia has any happy memories to choose from. And when she does dispense advice to her grandchildren, it is generally of the bitter variety, like this heartwarming gem she shared with A.J. in "D-Girl" (Season Two, Episode Seven):

"The world is a jungle. And if you want my advice, Anthony, don't expect happiness. You won't get it. People let you down. And I'm not naming any names, but in the end, you die in your own

Livia Soprano has made a career of martyrdom and manipulation and is practiced in making her son Tony feel guilty at every turn no matter what he does. One of Livia's frequent refrains is, "I wish the Lord would take me now." She eschews going to an upscale retirement community, but when she nearly sets her kitchen on fire, Tony has no choice but to force the issue.

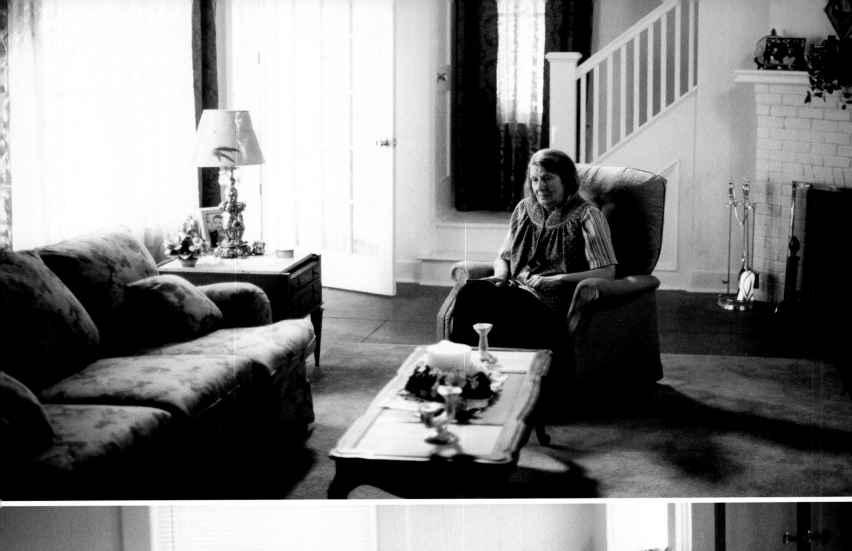
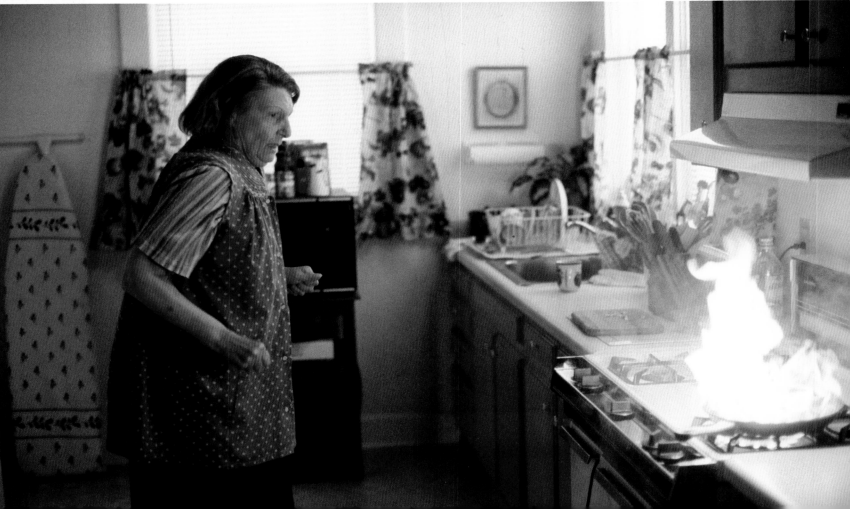

arms . . . It's all a big nothing. What makes you think you're so special?"

Based on Tony's descriptions of his mother and referencing the Diagnostic and Statistical Manual of Mental Disorders (DSM), Dr. Melfi believes Livia has borderline personality disorder, citing the woman's "inability to experience joy." Tony's initial reaction to this news sends him into a rage that scares Dr. Melfi to the point of locking her office door after Tony storms out. ("I Dream of Jeannie Cusamano," Season One, Episode Thirteen). But the reality of who his mother truly is—and what she is capable of—becomes all too real, all too soon. While she is critical and emotionally inept, she also lacks empathy and love. When these attributes combine with hate, they become a deadly combination.

Livia drives tension, conflict, and dysfunction within her family, but more specifically, she uses her victimhood as a weapon to control her son, always playing on his sense of loyalty, duty, and obligation. All of this eventually culminates in her revenge plot against Tony for "dumping" her in a "nursing home" and putting her own house up for sale. Using her well-honed special brand of manipulation, Livia plays to Junior's paranoia and plants the seed that maybe Tony needs to go.

Tony survives an attempted assassination. When he learns that Livia and Junior are in cahoots to have him clipped, he races over to Green Grove to smother dear old mom with a pillow. Alas, his plan is foiled when she conveniently suffers a stroke and is moved to the dreaded nursing ward at Green Grove—her worst fear realized.

Tony and Carmela cut off all contact with Livia, though Meadow and A.J. continue to visit her. And Tony returns to Dr. Melfi, hat in hand. As the series moves forward, Livia remains as insufferable as ever, and her eventual death in Season Three comes as a relief for Tony. However, the impact of a Machiavellian woman like Livia Soprano doesn't simply evaporate upon her passing. Tony, whose unresolved issues and emotional scars will continue to impact his choices, conflicts, and dilemmas, will feel the reverberations of Livia's toxic mendacity and treachery for years to come. Thanks, Mom.

Right: Livia never smiles, so we know this is Nancy Marchand (Livia Soprano) and Dominic Chianese (Junior Soprano) between takes on location during a Season One shoot.

Opposite top: As much as Tony tries to please his mother, Livia bears a toxicity that makes her dark to her core, and nothing he says or does will ever change how she sees him: as the perpetrator of her unhappiness.

Opposite bottom: Greenhill Senior Living and Rehabilitation in West Orange, New Jersey, served as Green Grove Retirement Community where Livia lived in Seasons One and Two. Later in the series, Paulie places his mother at Green Grove.

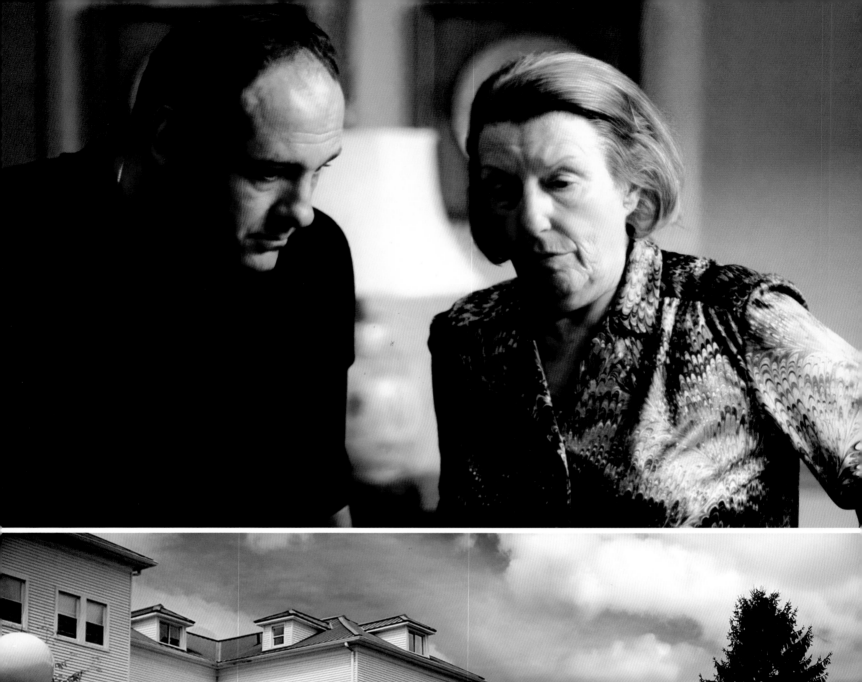

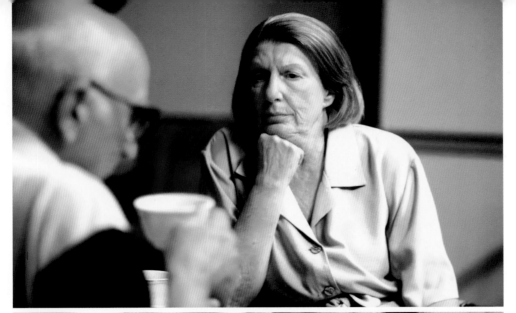

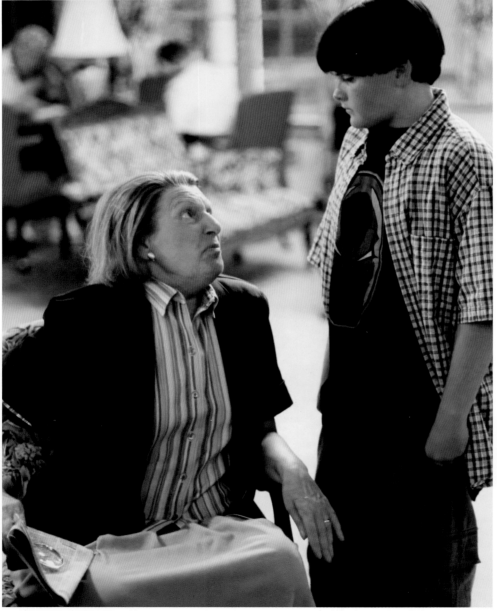

"What kind of person can I be where his own mother wants him dead?"

TONY SOPRANO

Tony doesn't always take his medication as prescribed. As we see in "Isabella" (Season One, Episode Twelve), he overmedicates himself on lithium to the point of delusion.

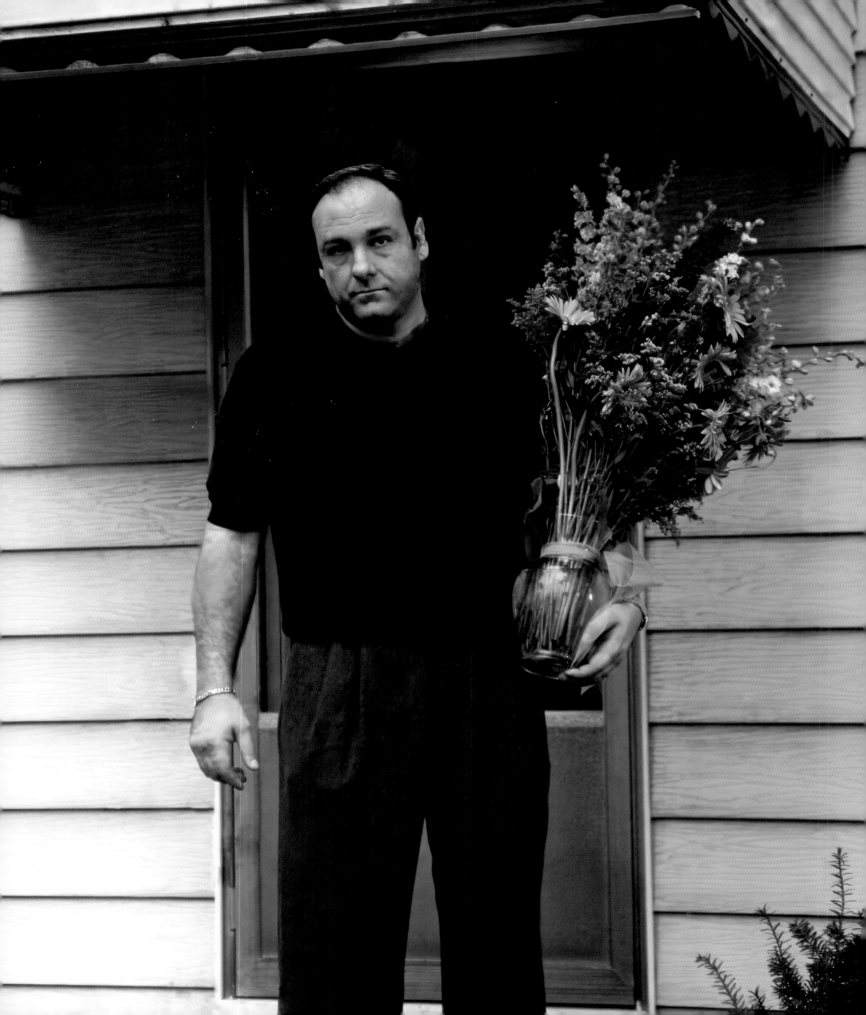

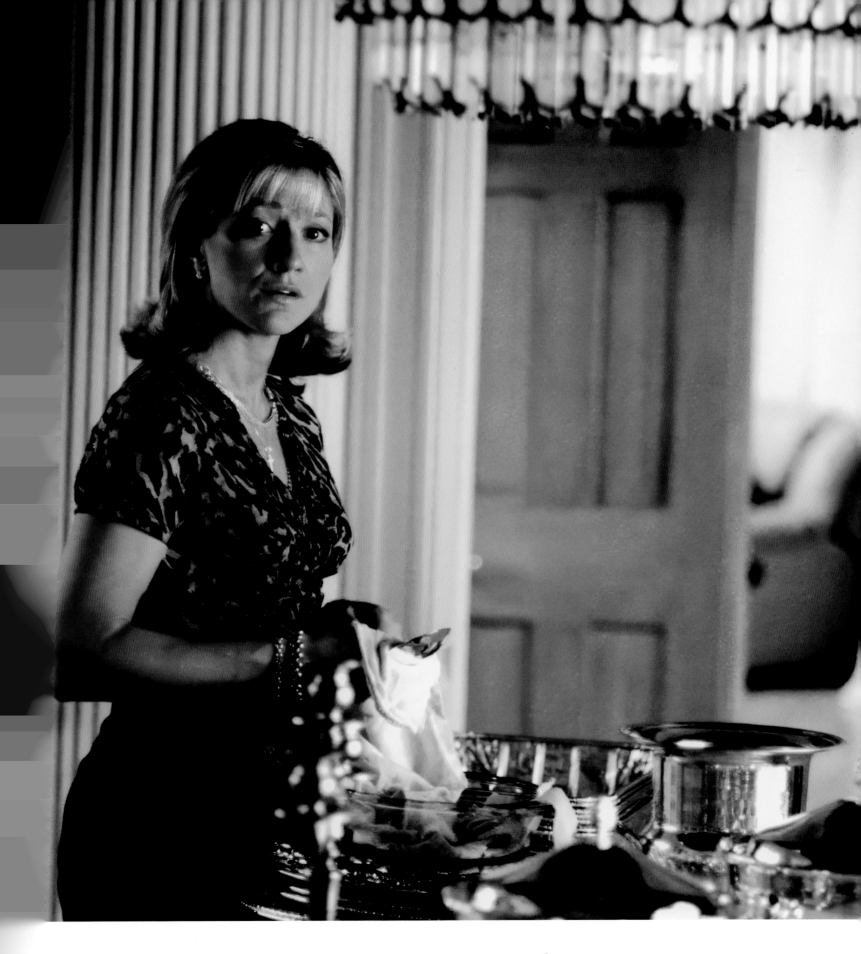

The Other Matriarch

Carmela Soprano is undeniably one of the most complex characters on the show, possibly *the* most complex. Her life is an ongoing act of extreme balancing as she is challenged to maintain loyalty to her husband while struggling to create a stable and nurturing environment for her children, Meadow and A.J.

It isn't that Carmela is at all blind to what her husband does for a living or how he spends his days (and sometimes nights). She understands his position in an organized crime family consists of engaging in illegal activities and sometimes having to commit brutal murder. It's the trade-off she's accepted to maintain her opulent, New Jersey society lifestyle based on what she knows to be blood money. But she can't spend a lot of time dwelling on it or how it so radically conflicts with her morals and deeply religious beliefs. It's the great central dilemma of her life.

Sensitive, straightforward, and forever intellectually curious, Carmela appreciates art, culture, and the good life. Indeed, she can't help herself. She deeply values the materialistic perks: the mansion she lives in, the expensive gifts,

cars, and jewelry from her husband, and the financial security that being a mob wife affords her. Yet Carmela grapples with the moral implications of her lifestyle, which is why she takes great pains not to think about her dilemma too much.

Marrying Tony was never going to be a talk-about-your-day-around-the-dinner-table, tuck-the-kids-in-and-read-them-a-bedtime-story kind of life for Carmela. On the surface, the Sopranos live a typical suburban family life, but on some level, she knows it's a big lie. She has her charities and book clubs, and she loves being part of the moneyed class. She struggles to remain ambivalent to what she knows are her husband's one-night stands and casual affairs, but the line she draws is in refusing to be played for the fool.

Carmela is open in her questioning of God and does so regularly with Father Phil Intintola (Paul Schulze), the handsome Catholic priest to whom she has grown close. An observant Roman Catholic, she strives, sometimes unsuccessfully, to rationalize her husband's profession and the gaping holes in their marriage. She prefers to bury Tony's serial infidelity deep in her consciousness, but the knowledge of it nearly justifies in Carmela's mind the idea that she could break her marriage vows with Father Phil, who, at least under the influence of ample glasses of red wine, seems open to the idea himself.

The contradictions in Carmela sometimes manifest in her fashion choices. She's comfortable flaunting her slender figure with low-cut tops and plenty of jewelry, but as a middle-class gal who suddenly came into money via her marriage, her style has a certain "keeping up with the Joneses" quality to it, which sometimes reads as over the top. This was all very much set in motion at the beginning of the show, assures costume designer Juliet Polcsa.

"Carmela was a tough nut to crack in the beginning," Polcsa says. "There was a certain kind

In this scene from "Denial, Anger, Acceptance" (Season One, Episode Three), we see a look of shock on Carmela's face. She has just learned from Charmaine Bucco (Kathrine Narducci) that Charmaine slept with Tony in high school during a summer when Tony and Carmela were broken up. Charmaine intimates to Carmela that she could have married Tony and had Carmela's lifestyle if she'd wanted it, but ultimately it wasn't for her.

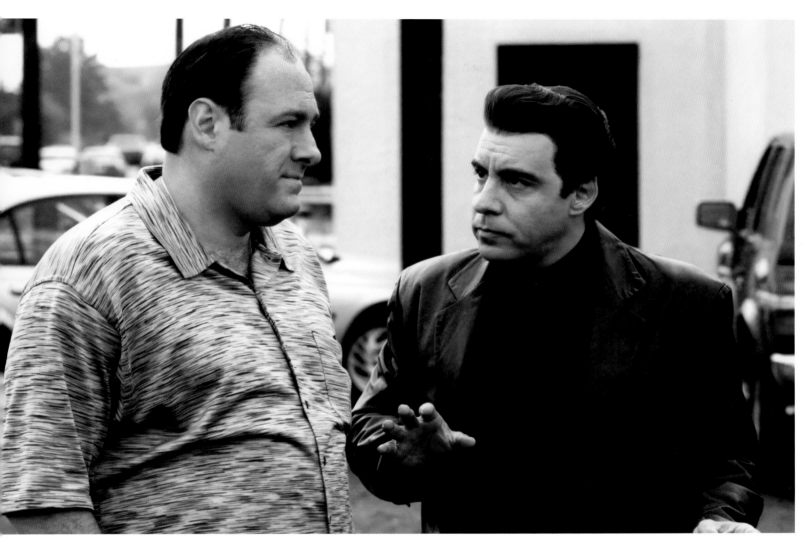

other. I'm like, 'Where am I? Is this heaven? How did I get here?' Every day created memories like that. And I mean, we all got to work with Jim Gandolfini. It will never get better than that. I've never seen anyone work harder or with greater intensity than that guy."

Director Tim Van Patten agrees. "Jimmy never showed up unprepared," he emphasizes. "I think his process was that he was very serious about the work. I feel like Jim was connected to that character in such a powerful way, though I don't know that he liked Tony very much. He owned it, and I can't imagine that was easy."

Both Coulter and Van Patten agree that Edie Falco, as Carmela, was a dream to work with as well. Says Van Patten: "Edie put on the wig and the nails and threw on the accent, and she was good to go. Very easy. I learned more about acting from watching those two actors."

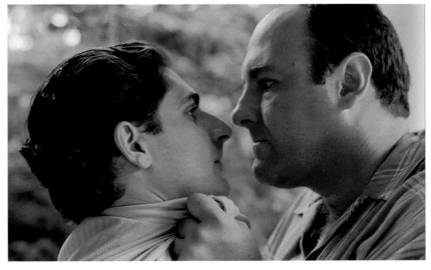

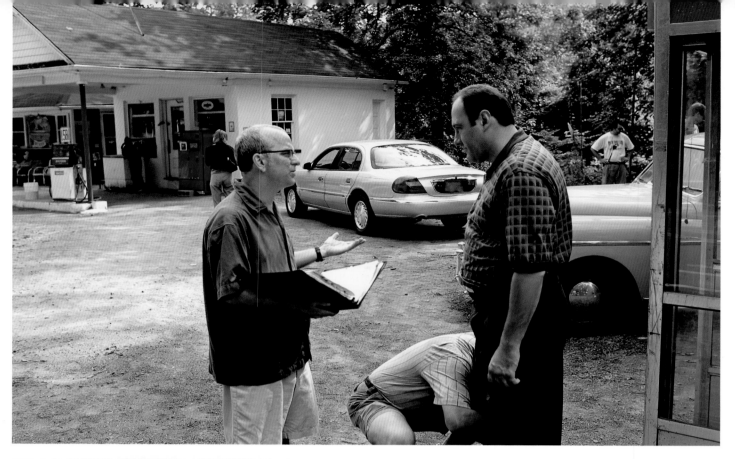

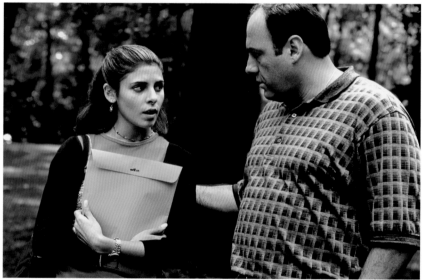

reacting to a tender exchange between Richie Aprile (David Proval) and Janice at the couple's engagement party. "She's about to cry and she escapes into the kitchen," says Coulter. "We did that shot. It was a single take on a Steadicam, and we pulled her back into the kitchen, and she ducks behind a little wall—and then she breaks down. I had her do that seven times, and every time she was able to break down. On cue. Seven times."

What happened when they tried it the eighth time?

"She said, 'I don't think I can do it again,'" Coulter recalls. "And I said, 'Okay.' A lot of actors would have complained, 'Why do you have to do it on a Steadicam? Why does it have to be one shot?' Not Edie."

For all the praise she's received by the show's crew and fellow cast members, Falco is humble when asked about her professionalism and craft, suggesting that it's really all in a day's work. "It's practice," she says. "It's years and years of doing it. It wasn't something that was easy to come by in my early days as an actress. I thought it was more intellectual than it turned out to be." Over time, Falco developed the chops that enabled her to

Coulter says, "She's the consummate professional. I used to say that Edie was like a lunchbox actress. She would fill out her timecard, sit and wait to do her job, and then go home. Not literally, of course. It relates to her skill and willingness to put up with things."

Coulter cites another example of Falco's work in a scene from "The Knight in White Satin Armor" (Season Two, Episode Twelve), where Carmela is

turn the emotion on and off, as needed. "It's my job to be able to gain access to those emotional places, if that is what's called for," she says. "It doesn't come home with me. I am accessing those places in the service of a script."

Falco also agrees that the connections fostered between cast and crew were reminiscent of a family, particularly when it came to her costars and on-screen children Jamie-Lynn Sigler and Rober Iler. "I loved those kids—I still do in this very maternal way," she says. "I was thirty-five when we started the show. I wasn't married and didn't have kids, and here I was being the wife and mother of this very established family and community. My biggest worry was that I wouldn't be able to pull it off, but that stuff kicks in. Now here it is all these years later and they *still* feel like my kids who have grown up."

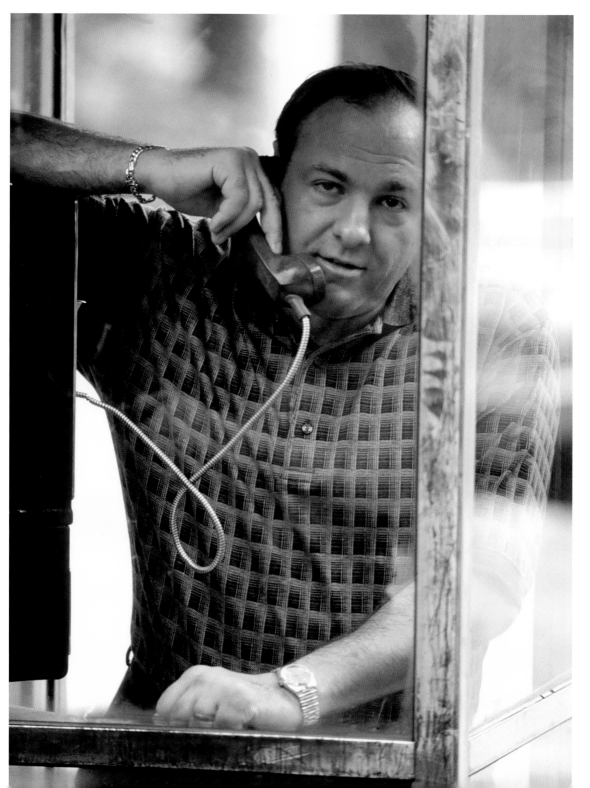

Opposite top: Director Allen Coulter and James Gandolfini on location while shooting "College" (Season One, Episode Five). In the episode, Tony spots an FBI informant in witness protection, whom he decides to take out between driving Meadow to school visits.

Opposite bottom: Tony's erratic behavior during the visit to universities with Meadow makes her wonder what is going on with her dad. She can't know that he's spotted a rat and that Tony intends to take care of it.

Left: In this scene from "College," Tony calls Christopher with the news that he's found Fred "Febby Petrulio" Peters (Tony Ray Rossi).

57

Tony's other family—the main family, if you will—consist of his consigliere Silvio Dante (Steven Van Zandt), his hot-headed nephew Christopher Moltisanti (Michael Imperioli), Salvatore "Big Pussy" Bonpensiero (Vincent Pastore), Paulie "Walnuts" Gualtieri (Tony Sirico), and Tony's unofficial advisor and longtime family associate Hesh Rabkin (Jerry Adler).

At the end of the day, none of the emotional carnage that litters Tony's life can mask the fact that the man has a business to run. Organized crime requires its leader to be an energetic, detail-oriented planner in order to thrive. As *The Sopranos* moves through its first season, we get a good sense of who Tony is and the reasons, beyond his toxic mother, why he wound up in therapy. He's trying to hold things together—really, he is—but the man can't even take his daughter on a visit to colleges without seeing a guy who flipped and went into witness protection ("College," Season One, Episode Five). There are so many landmines in his life that it's nearly impossible to count them all. And sometimes, he can't help stepping on them.

Throughout Season One, there are conflicts, betrayals, and unexpected alliances within the mob world exploring themes of identity, morality, and the consequences of a life of crime. It all sets the stage for the complex, multilayered, and sometimes dreamy and surrealistic narrative that unfolds in subsequent seasons, establishing a groundbreaking exploration of the human condition within an organized crime context.

Too highfalutin? Not by a long shot.

We can already see the seeds that will sprout into the strained dynamics and broken bonds between Tony and Carmela, whose knowledge of his criminal activities and infidelities shatters any presumption of trust. Tony's wife comes to understand all too well the decadent deal with the devil she's made that pollutes her life of leisure and luxury. It also begins to dawn on Tony's

adolescent children what their father does for a living, and they both start acting out in their own ways as a result.

To be sure, Tony could never manage to run the family alone. He needs his guys working their businesses for shakedowns and filling envelopes with cash, which they do through extortion, loan-sharking, illegal gambling, drug-running, robberies, construction fraud, what have you. In the "waste-management" business, it manifests in various illegal activities related to waste disposal and environmental violations. And as much as Tony and Junior maintain their love-hate relationship, to some extent, the success of the business depends upon their mutual cooperation, so keeping the peace in the family is one of Tony's primary goals.

Meanwhile, the FBI is always lurking in the background, taking pictures, and using surveillance and wires, hoping that fear of arrest and incarceration will persuade these wise guys to rat out their friends. And these tactics seem to be working in at least one case, although Tony has yet to sniff out who the rat in the family is. We'll get to that in Season Two.

Right: In "Pax Soprana" (Season One, Episode Six), Tony toasts Junior as the new boss of the family, even though his intention is to continue to run things behind the scenes. Tony placates Junior as needed, but he also seeks Junior's counsel when he needs another opinion. The crew remains loyal to Tony and stays clear of escalating tensions between uncle and nephew.

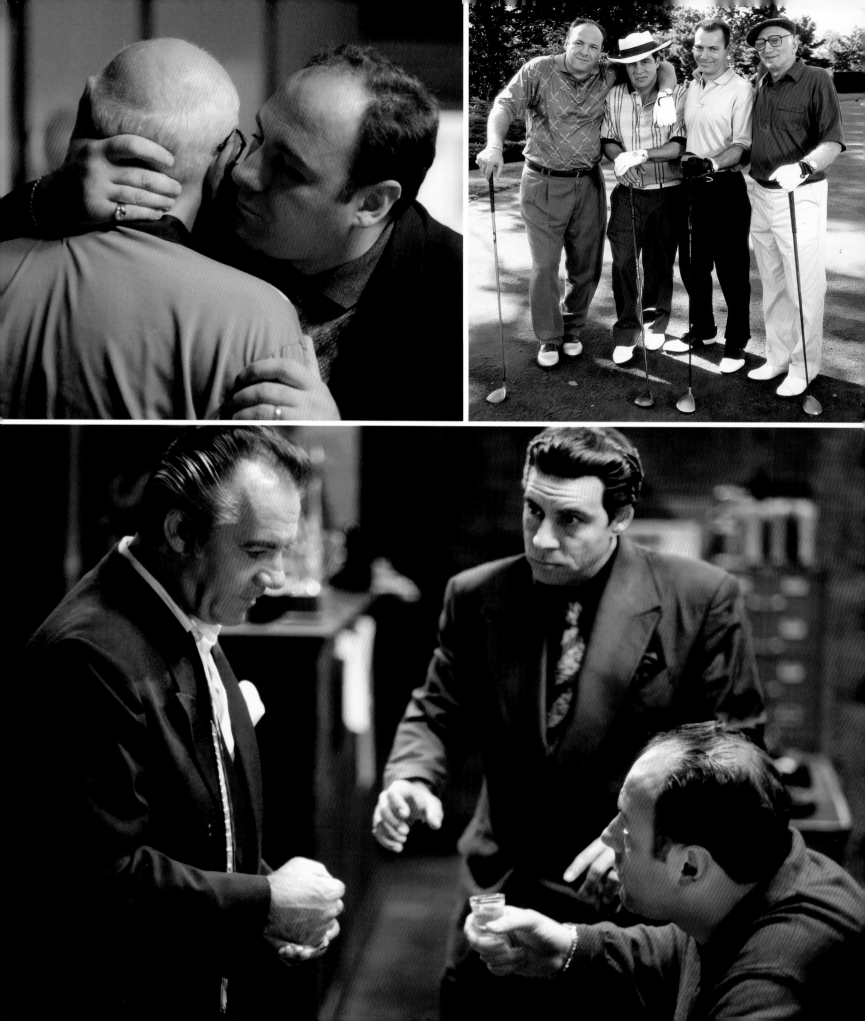

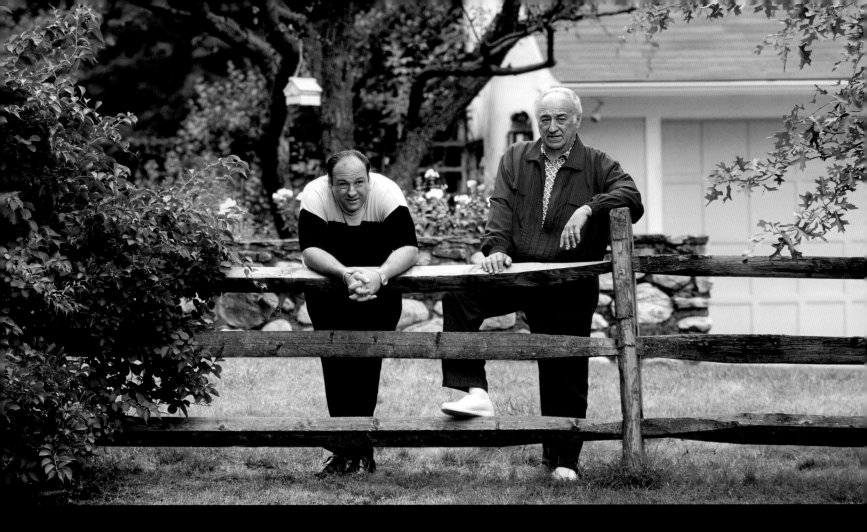

Jerry Adler as Hesh Rabkin

Hesh Rabkin is an elder statesman in the extended DiMeo crime family and a trusted financial advisor to Tony. He was a close friend to Tony's dad, Johnny Boy, and unique in that he is a Jewish man navigating an Italian American underworld. His primary area of expertise is in the music industry—something the Soprano crew know nothing about—but his experience and connections make him a valuable asset in their world.

In Season One, Hesh is cast as a mediator of sorts within the organization. He's prized for his level-headedness and capacity to provide sound advice to Tony and other members of the family. There are the occasional conflicts, like when Junior begins taxing him (at Livia's suggestion), but he is a survivor and a loyal advisor to Tony.

Originally, the character of Hesh was going to be only a cameo in the pilot, but series creator David Chase liked the character so much that Adler was given a recurring role, as he shares in an interview. "I was never under contract," Adler says, adding, "but I wound up being in forty-four episodes. Most of my episodes were just with Jim, and we had a terrific relationship. He was an unbelievable guy."

Adler's marching orders for how Chase wanted him to come across as Hesh on the series was soft-spoken but respected by everyone. "I had been on Broadway in reality, so they treated me like a star," he says. "People have recognized me on the street ever since the show. But they never holler out 'Jerry!' They holler 'Hesh!' Always 'Hesh!'"

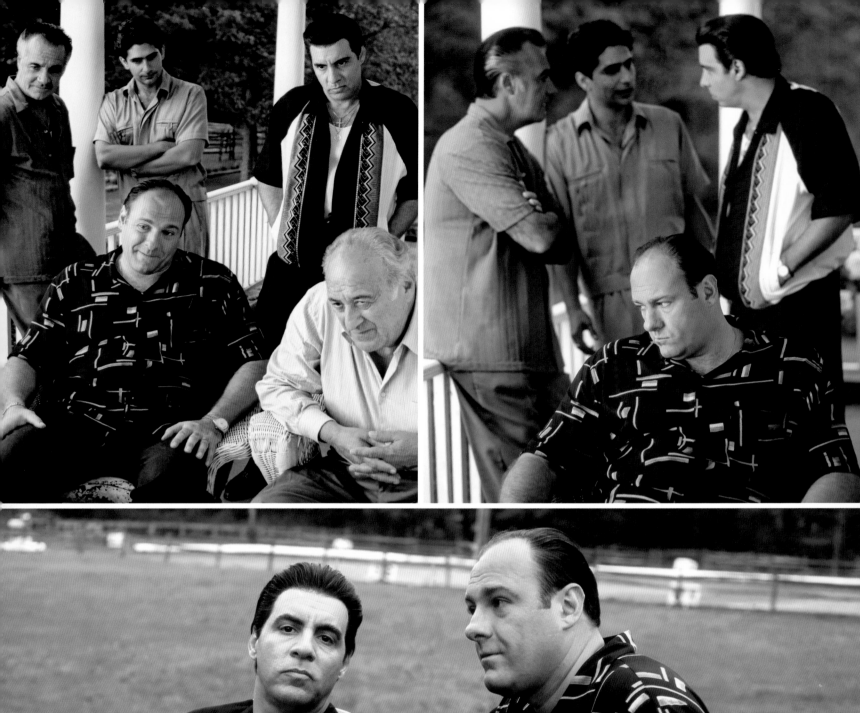
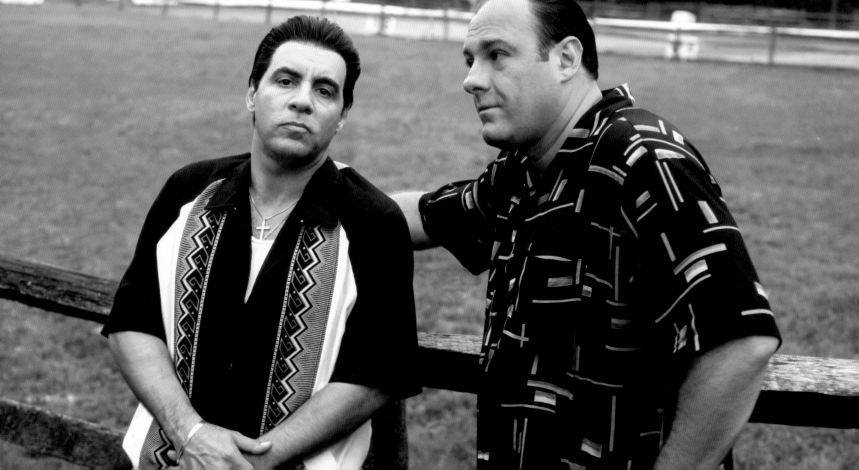

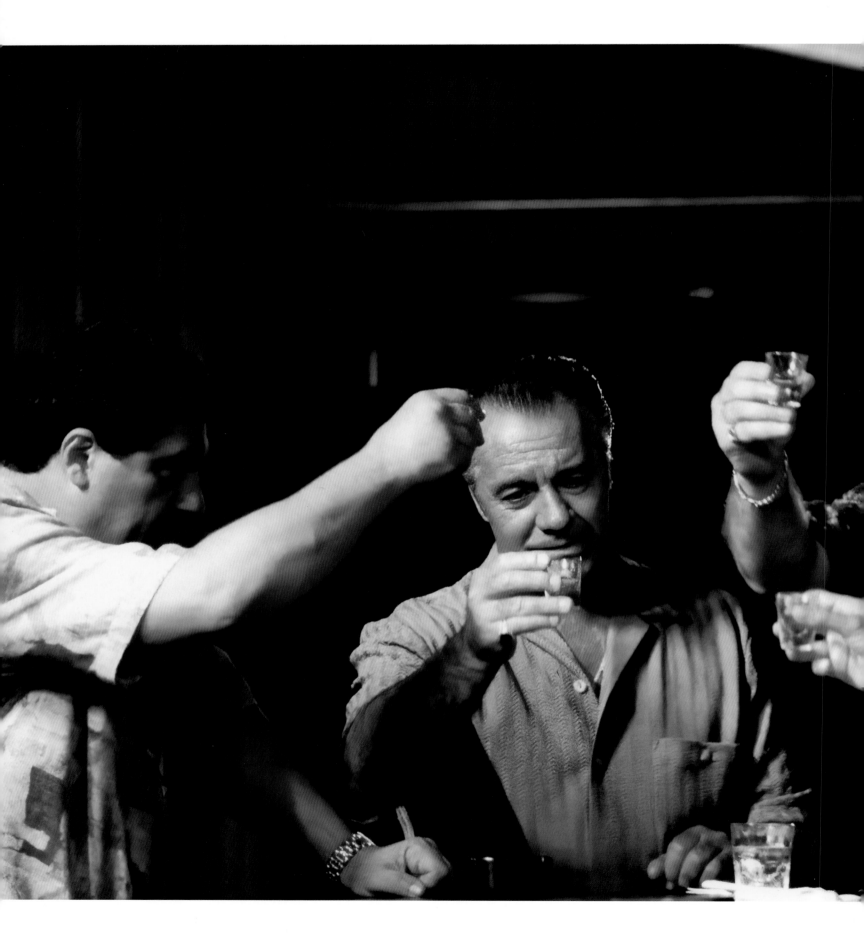

Death in *The Sopranos:* Season One

Dozens of people die on *The Sopranos,* and funerals are a regular occurrence. Some die of natural causes, but others succumb at the hands of another. Here are the memorable deaths in Season One:

Emil Kolar: Killed by Christopher over a dispute with a rival waste management company.

Hector Anthony: Killed by a stray bullet from an accidental discharge during a truck hijacking by Brendan Filone.

Brendan Filone: Killed on order of Junior for the truck hijacking.

Jackie Aprile Sr.: Died of stomach cancer.

Fabian Petrulio: Killed by Tony for being a rat.

Vin Makazian: Died by suicide.

Jimmy Altieri: Killed by Silvio for being a suspected rat.

Charles Signore: Killed for being a potential threat to Tony.

Mikey Palmice: Killed for conspiring with Junior to kill Tony.

The Episodes

Episode 1 "Pilot": A series of panic attacks triggered by a family of ducks flying away from his yard and later by his mother's refusal to move into a retirement community sends mob boss and family man Tony Soprano into therapy with psychiatrist Dr. Jennifer Melfi. Tony's nephew Christopher later executes a rival Czech gangster to impress his uncle. Meanwhile, Tony has to burn down his friend Artie Bucco's (John Ventimiglia) restaurant, Vesuvio, to prevent Uncle Junior from killing Gennaro "Little Pussy" Malanga at the restaurant and damaging his own standing.

Meet Tony Soprano.

If one family doesn't kill him ...the other family will.

The Sopranos

Episode 2 "46 Long": Livia proves herself incapable of living on her own, forcing Tony to place his mother in Green Grove Retirement Community against her will. Christopher and his friend Brendan Filone (Anthony DeSando) hijack trucks under Junior's protection. Meanwhile, Tony and Junior both look to seize control of the family from the ailing Jackie Aprile. Carmela asks Tony for a favor involving A.J.'s science teacher's stolen car. Dr. Melfi tries to convince Tony that his persistent hostility is actually misplaced anger toward his mother.

Episode 3 "Denial, Anger, Acceptance": Jackie is hospitalized to treat his ever-advancing cancer and prepares for the end. Tony's daughter, Meadow, asks Christopher to supply her with some speed to help her study for the SAT. Livia, incensed about being put in the nursing home, trashes Tony to Junior, who has Mikey Palmice (Al Sapienza) whack Brendan in the bathtub as payback for the truck hijacking. Carmela hires the Buccos to cater a dinner party, but she upsets Charmaine by bossing her around.

Episode 4 "Meadowlands": Jackie dies of stomach cancer. Tony publicly allows Junior to ascend to boss while privately telling others that he's pulling the strings. After Dr. Melfi becomes the star of his erotic dreams, Tony enlists his corrupt detective contact Vin Makazian to follow Dr. Melfi while she's on a date. But Makazian (John Heard) goes too far and beats up the guy she's with. Christopher declares war on Junior and Mikey for Brendan's death, resulting in Tony's assault of Mikey. Meadow tells A.J. that their father is a mobster.

Episode 5 "College": While Tony accompanies Meadow on college tours in Maine, his daughter peppers him with questions about his criminal life that he initially denies. On the road, Tony spots Fabian Petrulio, a former made guy who flipped. Tony tracks down Petrulio's business and settles the score. While Tony and Meadow are away, a guilt-ridden Carmela and Father Phil experience a drunken night together but fail to act on their attraction.

Episode 6 "Pax Soprana": Tony's attraction to Dr. Melfi intensifies, and he tries to kiss her. She rebuffs him, though he convinces an angry and suspicious Carmela that there's nothing there. Junior tries to throw his weight around with his captains, including Hesh Rabkin, only to have them complain behind his back to Tony. After Junior's tailor's grandson dies from a drug overdose, Junior has the dealer whacked. The FBI spies on a dinner celebrating Junior's ersatz promotion to boss, snapping up evidence that will soon come in handy.

Episode 7 "Down Neck": After A.J. and his friends steal sacramental wine and arrive drunk to gym class, he is tested for ADHD, which may explain his lack of motivation and zone-outs. A.J. is grounded and as partial punishment is forced to visit his grandmother Livia, whom he shocks by revealing that Tony is seeing a therapist. A flashback shows the day Tony realized his dad was a mobster and fears that his own genes may have corrupted his son.

Episode 8 "Legend Of Tennessee Moltisanti": Dr. Melfi meets with her ex-husband, who tries to convince her that having Tony as a patient is an awful idea. The FBI issues subpoenas, leading the Lupertazzi crime family to blow town to avoid the indictments and Tony and Carmela to hide cash in Livia's room at Green Grove to avoid detection. Livia spills the beans to Junior that Tony is seeing a shrink. Christopher is upset that he's considered too small-time to be pursued by the Feds.

Episode 9 "Boca": Junior is irate when his proficiency at a certain oral sex technique becomes fodder for intense gossip after his girlfriend spills the beans. Tony uses the info to humiliate his uncle. When Tony finds out that Meadow's high school soccer coach has assaulted one of her teammates, he plots to have the guy whacked—until Artie Bucco gets him to change his mind. The coach is arrested before leaving town for a better job.

Episode 10 "A Hit Is A Hit": Christopher tries to land girlfriend Adriana La Cerva (Drea de Matteo) a deal in music production with gangsta rapper Massive Genius (Bokeem Woodbine), but things go south in the first recording session. Things grow even more uncomfortable when Chris has a violent confrontation with the band's lead singer. Tony gets invited to play golf with neighbor Dr. Bruce Cusamano (Robert LuPone) and some of his friends, but Tony grows irritated after having to answer their questions about his being mobbed up.

Episode 11 "Nobody Knows Anything": Big Pussy is involved in a card game raid by the FBI but is instantly released. Crooked lawman Vin Makazian—who will soon die by suicide—tells Tony that Big Pussy is wearing a wire, which Tony refuses to believe. He tells Paulie to keep an eye on Big Pussy just in case, and at a bath house, Big Pussy refuses to remove his clothes, increasing suspicions. Tony ultimately comes to believe it's Jimmy Altieri (Joseph Badalucco Jr.) who is the informant. Meanwhile, Junior arranges for Tony to get whacked.

Episode 12 "Isabella": Dependent on Prozac and lithium, Tony nonetheless grows clinically depressed. The meds cause him to hallucinate meeting Isabella (Maria Grazia Cucinotta), a beautiful Italian exchange student he believes is staying next-door. Dr. Melfi explains to him that Isabella is an idealized mother image. With suspicions about him running high, Big Pussy disappears. When Junior's hit on Tony fails, Mikey kills Donnie, who contracted the hit.

Episode 13 "I Dream of Jeannie Cusamano": Tony finds out that it was Junior and Livia behind the plan to kill him, and Tony plots to take out his uncle—who is saved when he's arrested for racketeering. Livia tells Artie that it was Tony who ordered the fire that burned his restaurant Vesuvio, and an enraged Artie pulls a gun on him. After the FBI tells him they have tape of Livia convincing Junior to kill him, Tony beats a path to Green Grove with plans to smother Livia with a pillow, but she suffers a stroke before Tony arrives.

WHEN IT COMES DOWN TO IT, YOU NEVER KNOW WHO YOU CAN TRUST

"Death just shows you the
ultimate absurdity of life."
A.J. SOPRANO

"Maybe you should lamb
chop it for a while."
FURIO GIUNTA

"What kind of animal
smokes marijuana at his
own confirmation?"
CARMELA SOPRANO

"There's a lot
I could say right
now that I am not
gonna say!"
JANICE SOPRANO

"Toodle-fucking-oo?"
DR. MELFI

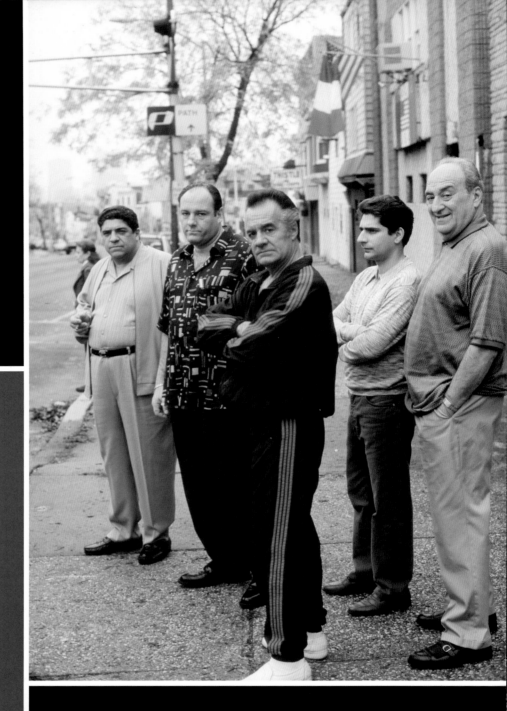

"Soldiers don't go to hell. It's war.
Soldiers, they kill other soldiers.
We're in a situation where everybody
involved knows the stakes, and if
you're gonna accept those stakes,
you gotta do certain things.
It's business . . . "
TONY SOPRANO

FAMILY MATTERS

"Emotionally, [the show] is so relatable. People are people, families are families. At the center of the show, it's a family story."

—Tim Van Patten, director

"I loved James. Sometimes I wanted to kill him, but I loved him. He was a true friend, brother, kind of everything . . . There are some people, when you act—it's just there. You don't have to talk about it. You don't have to ask . . . You just do it and they do it, and that's it. It's like if somebody's dancing with you; they get into the same rhythm. You don't have to second-guess it. You're talking to them, they're talking to you, and you believe it—and it's honest."

—Aida Turturro on working with James Gandolfini

When Janice-cum-Parvati blows into town like a dusty tumbleweed, everything changes. A tour de force of the most toxic kind, she's the bane of Tony's existence. A seasoned con artist who wants what she wants without doing an honest day's work for it, Janice uses her manipulative charm to get what she believes she's entitled to. She's always on the lookout for a quick buck and the easy way out—and, more often than not, she finds it.

From the moment she arrives in New Jersey, after a couple of decades on a quest to find herself (and never quite succeeding), Tony is less than thrilled to see his older sister. He knows her visit will cost him money and cause him agita.

Janice claims to be back to care for Livia, but what she's really focused on are the house and any potential trappings from Livia's estate—even though the old woman has yet to die.

Exasperating, lazy, scheming, and often unhinged, Janice knows how to play the angles (like mother, like daughter). At the same time, she portrays herself as spiritually enlightened—at least in the beginning—before she sloughs off the mask. But, unless you count that one yoga class where she reconnects with her high school flame Richie, we never actually see Janice engaged in anything spiritual. True, there is the moment in Season Three where she has a brief come-to-Jesus moment after getting beat up for stealing a prosthetic leg (a new low even for her), but that's yet another angle she plays in order to break into the contemporary Christian music business. What she mostly does is argue with Tony, justify her relationships with made guys, struggle to control her temper, and generally bring chaos to every situation. They sure broke the mold when they made Janice.

"It wasn't a half-ass part," says Aida Turturro of her character. "I had a major, exciting, innovative part. What they wrote . . . it was so fun. It was like, oh now I'm stealing a leg. I mean, who *does* that? And then she's going out with a fucking Bible guy [who's] falling asleep."

As fun and exciting as it was to play Janice, Turturro notes that the magic of the show—even the very success of her character—was due in large part to the wider machinations of the enterprise. It worked not because of individuality, but because of the ensemble of cast and crew. "It was a group effort, although I will point out Nancy [Marchand]—talk about a strong woman—but it's a team show, and I think that's what made it work. The energy—that's what made us all so happy. It's a lot of work and a lot of time, but it was a wonderful bunch."

But let's get back to that stolen leg. Bob Shaw, a production designer who came on board in Season Three, recalls how that storyline—and another that involved burning down Artie Bucco's restaurant to prevent a shooting from taking place

Opposite top: In this scene from "Toodle-Fucking-Oo" (Season Two, Episode Three), after Meadow and her friends trash Livia's vacant house during a party, a frustrated Tony and Carmela take a hard line and revoke her credit card privileges for two weeks.

Right: When Janice arrives on the Sopranos' doorstep, Tony is none too pleased. He knows that before the end of her visit, she'll wreak havoc on his life in ways only she can.

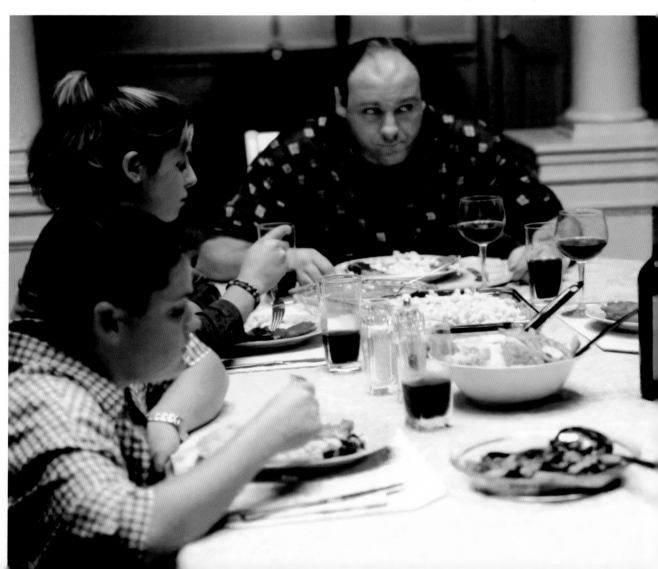

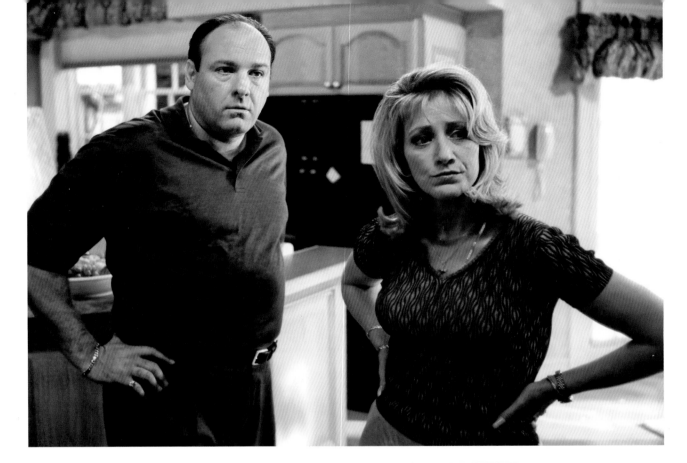

"There are men in the can better looking than my sister."
TONY SOPRANO

75

there—came to be: "My high school gym teacher married David [Chase's] cousin. She told me that her first husband, or ex-husband, told David a story of the time they burned down a restaurant in order to keep there from being a mob hit [at the location]. And I think it was [writer] Robin Green who told me that David had come across a story in the Pacific Northwest about some law where it was illegal to steal someone's prosthetic limb." Chase, says Shaw, held onto that story until he developed the Svetlana Kirilenka (Alla Kliouka) character. She is Livia's—and later Junior's—Russian caregiver with a prosthetic leg, which Janice steals in retaliation for Svetlana refusing to return Livia's vintage record collection. "He would put a pin in something, save it, and use it like twenty years later," says Shaw. "It's, I thought, one of the great *Sopranos* moments."

Some of Janice's other hijinks in Season Two and later seasons include collecting disability checks for carpal tunnel from the state of Washington, planting a bug in Richie's ear to kill Tony, pursuing Ralph "Ralphie" Cifaretto (Joe Pantoliano) while he was in a relationship with Rosalie Aprile (Sharon Angela), kicking Ralph down the stairs when he announced he had left Rosalie for her, demanding $3,000 from Tony when he asked about Ralph's sexual proclivities, and attacking a soccer mom at Sophia Baccalieri's (Miryam Coppersmith) game.

And that's just for starters.

When it comes to Tony and Carmela's parenting methods, Janice can be counted on to offer her unsolicited opinions. At first, she suggests that her brother and his wife are too hard on their kids when she posits, "There's a Zuni saying: 'For every twenty wrongs a child does, ignore nineteen,'" to which Tony responds, "There's an old Italian saying: 'You fuck up once, you lose two teeth'" ("Toodle-Fucking-Oo," Season Two, Episode Three).

But Janice being Janice—and being a Soprano at that—completely loses it when the situation at hand disrupts her own agenda. The moment comes when Janice accuses Tony and Carmela of being too lenient with Meadow after Meadow and her friends trash Livia's house during a party. During her tirade, Tony blows his top and storms out of the room. Carmela tries to diffuse the situation, but Janice doubles down on her judgmental criticism of their parenting skills, which prompts a swift and severe reaction from a normally calm Carmela:

"Mother of God, Janice, are all of you Sopranos the same? I asked you nicely to stay out of it; you're pretending you don't hear me. Well, maybe you're gonna hear this. Mind your fucking business. Keep your mouth shut when it comes to my kids, all right?!"

Janice is certainly no role model when it comes to parenting, as we learn later in the series. She has no profession, no ambition, no plan. What she wants is a big fancy house in a big fancy neighborhood and all the other symbols of wealth. In Season Two, her cunning involves attaching herself to the first guy who has the potential to provide that affluence and security.

Enter Richie Aprile.

...ooking at him
...d reason, as you'll
...ntil she blew town
He went to prison
a man a minute to
reflec... in the DiMeo crime
family. And o... released, he's ready to
reclaim his former position and power. The only
thing that exceeds his impatience, impulsiveness,
remorselessness, and defiance is his predilection
toward savage violence. It doesn't help that the
man respects nothing and no one. That goes
triple for how Richie feels about Tony, a onetime
subordinate whom he resents as being way too
young to be the boss.

No sooner is Richie released from prison than
he goes after his former associate Peter "Beansie"
Gaeta (Paul Herman) to reestablish his income and
street cred. Beansie, a friend of Tony's, is now a legit
pizzeria proprietor. But Richie doesn't care about
any of the new ways of doing business. Instead,
he goes after Beansie with both fists and a hot
pot of coffee when Beansie stands up to Richie's
shakedown. Later, Richie attacks Beansie with his
car, smashing the man's legs. And just in case the
message wasn't clear, Richie proceeds to drive over
him, hit reverse, and back up over the crumpled
body. He doesn't kill Beansie—the poor guy
probably wishes he had—and Beansie is confined
to a wheelchair for the rest of his life.

Still, aggression alone isn't going to put Richie back
in the criminal saddle. He figures he needs to take
on the king to get his point across, so he locks horns
with Tony. Short as he is, Richie isn't intimidated
despite their height and power differences. Instead,
he defies Tony by selling cocaine on the same
garbage routes managed by Barone Sanitation—
Tony's waste-management outfit.

Opposite: In "The Knight in White Satin Armor" (Season Two, Episode Twelve), Tony reluctantly throws an engagement soiree for Richie and Janice, although he loathes the idea of Richie as his brother-in-law. Fortunately, the big wedding day never comes to pass.

Left: Richie's first order of business upon his release from prison is to pay a visit to Beansie Gaeta at his pizza and sub shop. Richie is ready to pick up where he left off ten years ago, which means Beansie better prepare to pay up, or else ("Toodle-Fucking-Oo," Season Two, Episode Three).

Among Richie's other offenses are disrespecting Tony's executive card game by physically attacking David "Davey" Scatino (Robert Patrick) over unpaid gambling debts and conspiring with Junior to take Tony out—with Janice's full support, by the way. When Junior decides that backing Tony is the better option, he fills his nephew in on Richie's plan—claiming Richie's been playing him all along. Tony realizes Richie's got to go.

But he who lives by the sword (or in this case, the gun) ultimately must die by it. Richie's major mistake is thinking that being Janice's fiancé means he can knock her around as he sees fit. And once he hits her, she doesn't hesitate to shoot him at point blank range. It was all over but the cleanup. And while Tony is secretly grateful to Janice for doing his dirty work, he's not happy about having to clean up another of her messes. Right before putting her on a bus back to Seattle, while Janice thanks him profusely, Tony quips, "All in all, though, I'd say it was a pretty good visit."

The truth is, actor David Proval "is radically different from the character he portrayed," says Steve Schirripa, who plays Bobby "Bacala" Baccalieri. "David was a very, very nice guy and a very scary guy on camera. When he appeared on-screen as Richie, you were immediately uneasy. I grew up in Bensonhurst, Brooklyn, and at that time in the 1960s and '70s, there was a big mob enclave there. And so those kind of guys were around my neighborhood. You'd say, 'How ya doin'?' and then keep on moving. They may not necessarily have been big, strong guys, but they were just scary and capable of stuff. So you just kept on moving. And when you saw David come on camera, you felt that same vibe. David's not a big guy, but [Richie] went toe-to-toe with Tony Soprano. He didn't blink. He didn't back off for a second. He didn't smile. He didn't frown. He just stared. And it was so unsettling," Schirripa says.

"David told us a story on our podcast [Talking Sopranos] about when he auditioned for the show. He'd been out there working as an actor for a long time, going back to Mean Streets in '73 and The Shawshank Redemption in '94. He had to come out to New York on his own dime to audition. I guess he read a couple of times, maybe a test reading with Jim [Gandolfini]. By the time he got back to his

"What's mine is not yours to give me."

RICHIE APRILE

hotel room, the phone was ringing when he walked in. He runs to answer the phone, and it's his agent telling him he got the part of Richie. And he said he just broke down and cried. The crying was just the culmination of so many career frustrations finally resulting in getting this overdue recognition. He said, 'I deserved this. I was entitled to this.' He felt he had worked so fucking hard. It was no secret in the business what a great actor he was. And now, at last, he was getting the recognition. It was very moving. I totally understood what he meant," says Schirripa.

"Schirripa continues, "and . . . then once David landed in the show, it was clear this was perfect casting. He's such a smart actor, and you can see it right there on the screen. He just killed it. Richie was a perfect fit. He was amazing portraying a guy who stood out even among a group of murderers. He took on anybody, no remorse, didn't give a shit. He was exactly what the show needed in that role."

When Janice off'd Richie, it could have been the end of the road for her character too, but Schirripa tells us how Janice came to be a fixture. "As we discussed on our Talking Sopranos podcast, Aida was going to be gone after Janice killed Richie. She was put on the bus to Seattle and was never coming back. But then Nancy Marchand passed away, and they needed Janice back. In my opinion—and I've said this before—I think Janice was the most evil character of them all. I mean, she was a manipulator. She was a murderer. She did not give a crap. She was Livia and Tony wrapped into one. You talk about Richie and Ralphie being the worst of the bad guys, but I think Janice was worse than all of them," he says.

"Aida was so good on the show that I can't even begin to tell you, and I enjoyed every single

Richie Aprile resents that the friend of his kid brother, Jackie Sr., is now the guy running things. In a bid to reassert himself, he pledges allegiance to Junior and tries to rally the troops behind him, but his plans for a coup go south when Janice kills him for punching her.

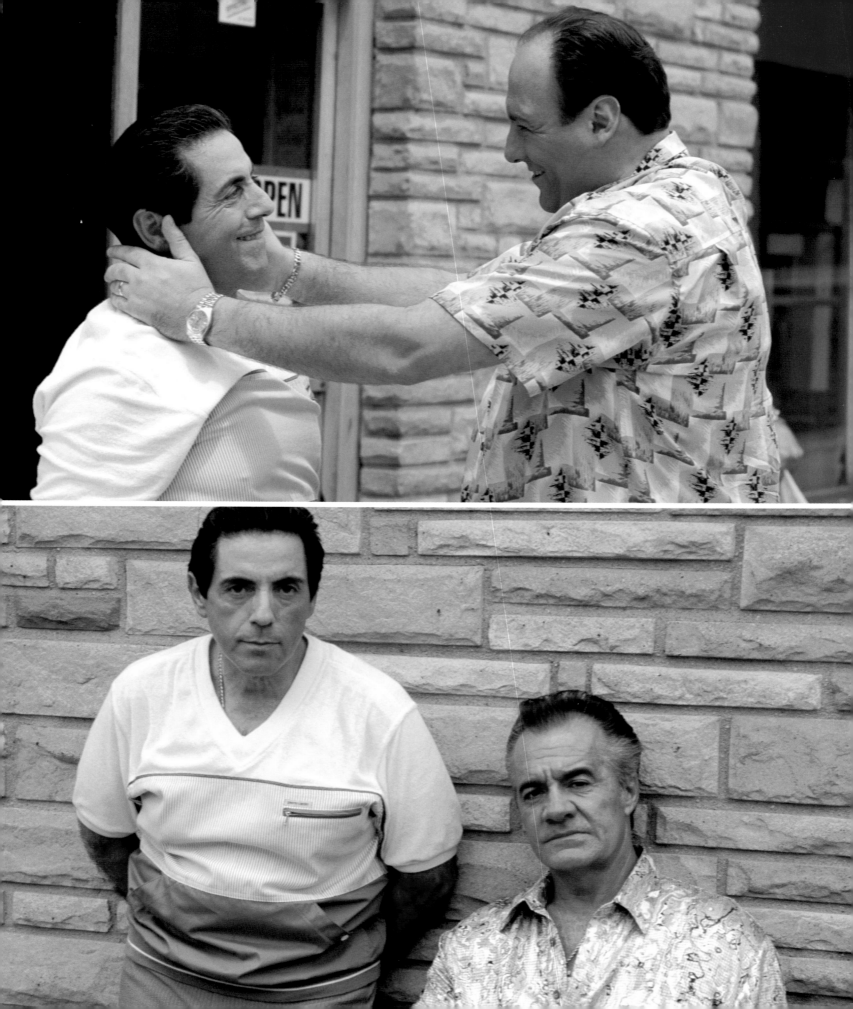

moment of working with her. She's a really good, really smart actress and as different from Janice and sweet as could be," Schirripa says, adding, "but . . . she and Jim Gandolfini could fight in real life like the brother and sister they were playing on the show."

Schirripa tells a story of art imitating life on set—or maybe it's life imitating art. "It was ironic because she was just coming off anger-management classes in the show. But Jim wasn't fully paying attention. When the camera rolled, Jim was kind of ignoring her as she's delivering her dialogue and she's like, 'What the fuck are you doing?' And they went at it. Ooh, man, did they ever. It really was like a brother and sister fighting. And they were both coming up to me asking, 'Am I right?' And I didn't know what to say. I was caught in the middle. I'm not sure if people thought it was part of the scene or what. And then they were like, 'I think they're really fighting.' And they were," Schirripa says.

"But Aida, oh my god, she's an underrated actress. She was nominated for a couple of Emmys for the show, and that was justified, because she was absolutely nothing at all like Janice."

Tony's childhood buddy David Scatino got himself indebted to Richie for more than "eight large," or $8,000, playing poker. Before he could pay it back, he got himself even deeper in debt to Tony for "forty-five boxes of ziti," or $45,000. David's excessive gambling debts ultimately cost him his business, his son's SUV, his son's college fund, his son, and his wife. After the "bust out" of the business to Tony, David moves out West to work on a ranch near Las Vegas. Meadow reveals in Season Three that David eventually winds up in a mental health facility in Nevada.

A Conversation with Aida Turturro

You appeared with James Gandolfini in 1992 in *A Streetcar Named Desire* on Broadway with Alec Baldwin and Jessica Lange, so you had this history together before you even started on *The Sopranos*.

Aida Turturro (AT): Oh yeah, and after *Streetcar* we stayed good friends.

So, you didn't need to manufacture chemistry.

AT: Not at all. We had it from the time we met. Sometimes you meet someone, and before you even know them that long, you feel a connection. James and I had that connection from the start. And I was a little attracted to him, but we had to do the show.

This was when you were doing *Streetcar?*

AT: Yes. I would rather be friends with him, because if you mess around, then you can't be the friend that you're meant to be.

Was there any day on the set that you remember being particularly memorable or intense?

AT: Well, there was the day when I had the scene where Richie punched me in the face, and I got the gun and shot him. And then I was on the phone with Tony hyperventilating over a dead body. It was way over the usual time for a normal shoot day. It was very intense and difficult, but everybody did well. David Proval and I had great chemistry—and what an amazing actor.

How did you find the atmosphere on the set?

AT: The energy, kindness, and sense of fairness of everyone was incredible. Very supportive. And that all came from the top, from James. I can tell you that James would have loved it if he weren't the star. He didn't love the attention. But he came from a place of generosity. He didn't come to it with a heavy ego.

I know it was long hours.

AT: Oh God. It wasn't like eight days of [shooting] an episode. Sometimes it was like three weeks. But it was such phenomenal writing. And David Chase watched over every detail, the music choices, everything. He was there 110 percent for every aspect of the show.

And the people you got to work with. Not just James but Edie and Dominic and Michael and . . .

AT: Nancy Marchand! Everything she did was just consummate. We forget because she died after the second year, which sucked. But I got to work with her, which was incredibly special. She was just amazing.

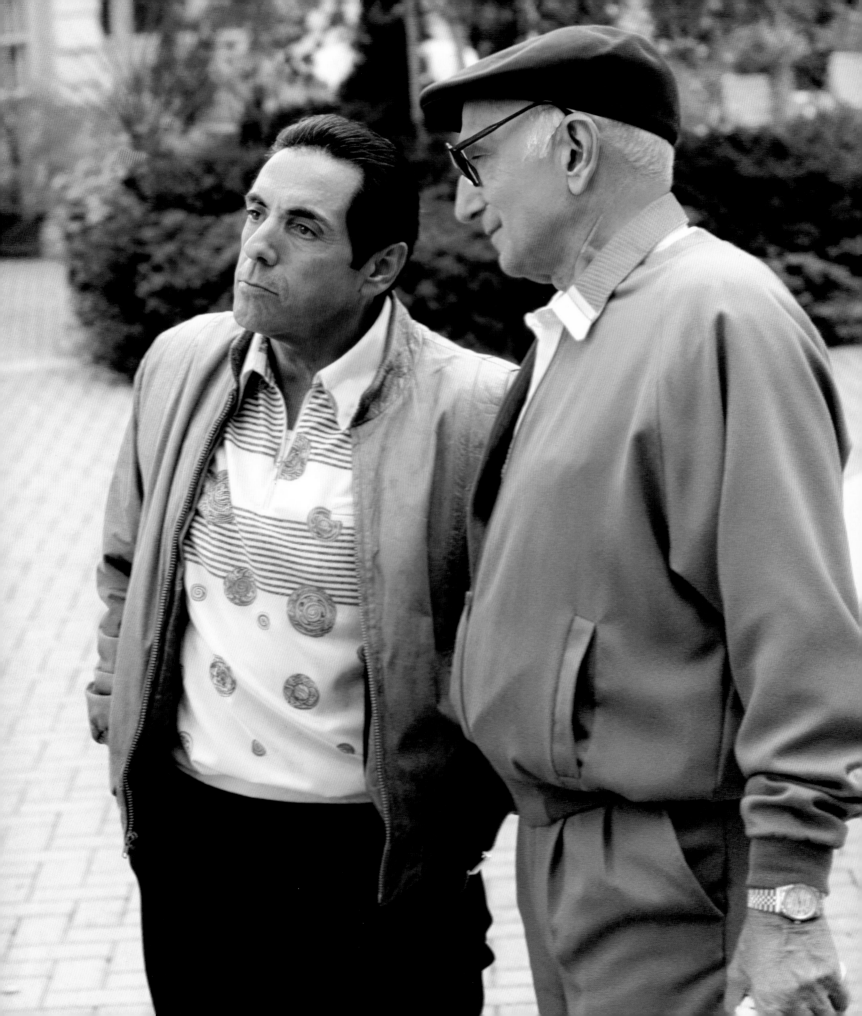

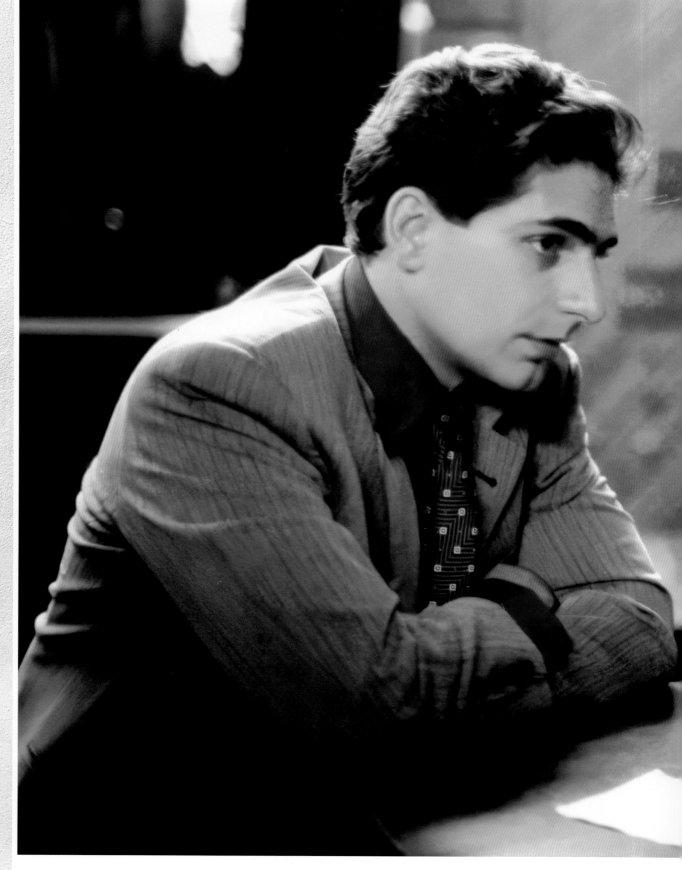

Christopher and Adriana have their share of ups and downs, but they never stay mad at each other for long. In Season Two, Christopher's hopes and dreams for becoming a screenwriter all but fall apart, and he takes his frustrations out on the only woman who loves him. It's nothing a big shiny ring can't fix though. The couple get engaged and stay together through many more tribulations, including a near-death experience (Christopher's), drug addiction (also Christopher's), and irritable bowel syndrome (Adriana's). Ultimately, it doesn't end well for these lovebirds, but the full extent of that doesn't emerge until Season Five.

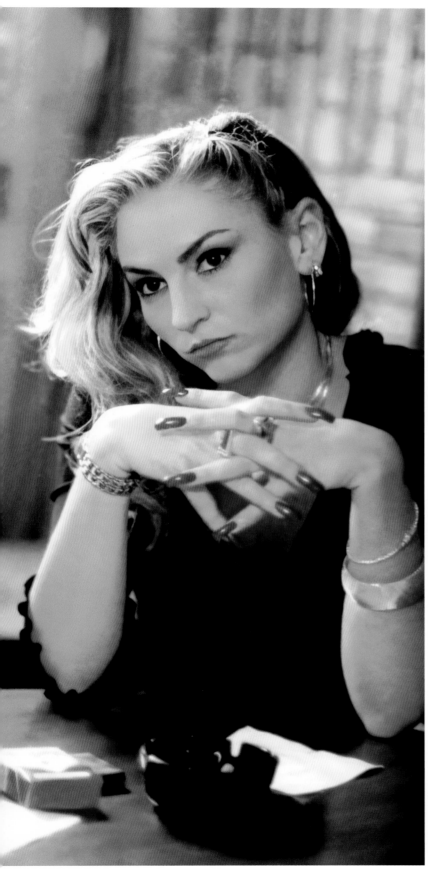

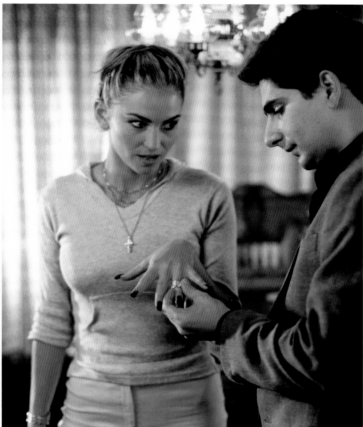

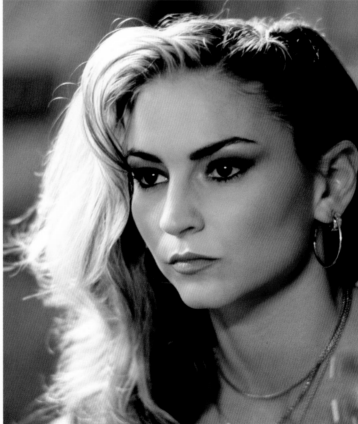

End of the Road

Tony has been fighting to admit to himself what he's known for more than a year: that his trusted friend, confidant, and godfather to his only son is a big, fat government rat. He was told the news straight out by his detective contact Vin Makazian near the end of Season One. First Tony dismissed it as nonsense because he didn't trust the source (and, mostly, because he didn't want to believe it was possible). Then Tony decided that Vin's source got his wires crossed and that Jimmy Altieri was the real rat. Silvio and Christopher handled the Jimmy problem, which bought Big Pussy some time. But only a little.

It doesn't take a genius to understand why Big Pussy flipped—his day job wasn't enough to support a wife and three children, so he moonlighted in the heroin trade. After getting popped, the FBI gave him a choice: serve thirty years to life or cooperate. He chose the latter. When Vincent Pastore took the role of Big Pussy, he wasn't expecting that his character would be killed off quite so soon. "I thought I had a seven-year contract to do the show," Pastore says. But David Chase had other plans after seeing the audience's reaction to Big Pussy's disappearance at the end of Season One. "[Chase] called and said, 'Vinny, the internet's blowing up. They want to know, *Where's Pussy?* Well, Pussy's really the rat.' And I figured now I'm in witness protection, but he says, 'No, no, no . . . I have to kill you.' I said, 'Okay, David, if that's what you want.' He says, 'I'm going to write you some good stuff, Vinny. You'll come back in the future as a ghost.'"

Writer-producer Terence Winter recalls how fans reacted to Big Pussy's betrayal. "When it was revealed that Pussy was a rat, Vinny Pastore would be walking down the street and people would say stuff to him. I think there was, in some social club, a cast picture and his face was crossed out." Pastore may have become a source of ridicule thanks to his character's actions, but the storyline made for brilliant TV.

When Big Pussy returns at the start of Season Two, Tony suspects he's working for the Feds, but Tony doesn't take action until he finds irrefutable proof. Big Pussy tries to play it cool, but Tony isn't convinced that his friend hasn't gone to the dark side.

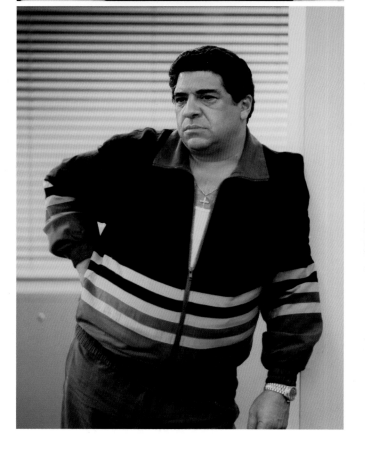

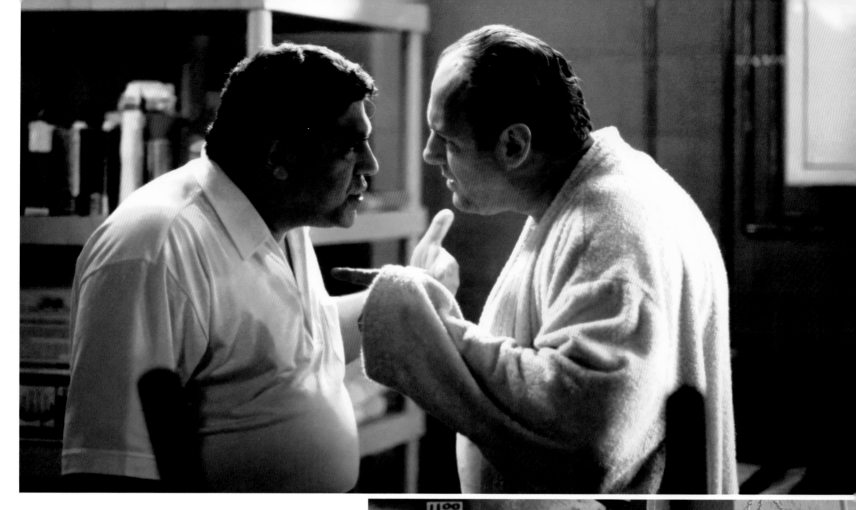

Ultimately, it's Tony's subconscious that makes the truth inescapable. It comes in "Funhouse" (Season Two, Episode Thirteen), when a fever dream brought on by food poisoning features a talking fish in the voice of Big Pussy. It's one of the most memorable scenes in TV history:

Fish: You know I've been working with the government, right, Ton'?

Tony: Don't say it.

Fish: C'mon, Ton'. Sooner or later, you got to face facts.

Tony: I don't want to hear it.

Fish: Well, you're gonna hear it.

Tony: Fuck.

Fish: You passed me over for promotion, Ton'. You knew.

Tony: How much shit you give 'em?

Fish: A lot.

Tony: Jesus, Puss . . . Fuck of a way for it all to end, huh?

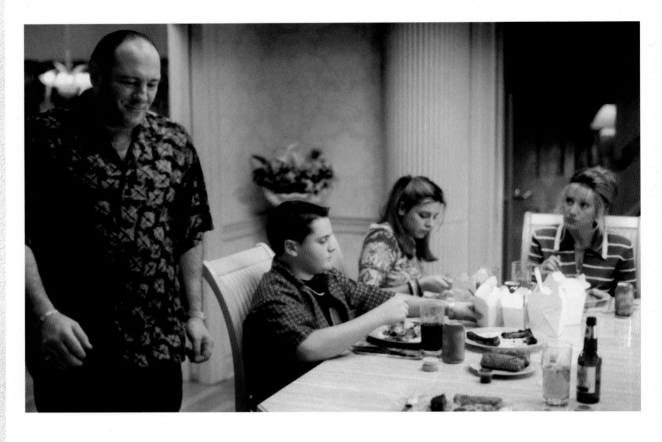

Upon waking up, Tony and Silvio pay an unexpected visit to Big Pussy's house. Big Pussy, still upstairs in bed, hears them downstairs, but before he can do anything, they are in his bedroom. Silvio asks for a cup of coffee while Tony pays a visit to Big Pussy's bathroom on the pretext of illness. When Big Pussy and Silvio go downstairs, Tony searches the room and finds the telltale wire equipment in Big Pussy's cigar box. The disappointment on Tony's face is unmistakable, as his initial reaction to the discovery that his closest friend has betrayed him isn't anger or even rage—it's hurt and pure disbelief.

The essential deed is done on a boat that Tony says he is thinking of buying—it's the ruse he employs to get Big Pussy to go along with him and Silvio. When they arrive at the dock, Paulie is there waiting. The four take the boat out on the water, and Tony confronts Big Pussy about flipping. Resolve replaces fear—Big Pussy knows there's no getting out of this one. After a few awkward laughs and a shot of booze, Big Pussy musters up the courage to ask them not to send a "message job" to his face. Tony, Silvio, and Paulie unload dozens of

rounds into Big Pussy's body, strip him of his watch and jewelry, bag the corpse, wrap it in chains, and then push it off the back of the boat. They watch as he sinks down for his eternal sleep with the fishes.

As the Season Two finale winds down, we are shown vignettes suggestive of the destruction and decay upon which Tony's lifestyle depends—gambling, drugs, scams, and shams—interspersed with fun, lighthearted images of the Soprano family and their friends celebrating a joyous occassion: Meadow's graduation from high school. We're reminded of the scene from the Season One finale ("I Dream of Jeannie Cusamano") when, over a candlelit dinner at Vesuvio during a thunderstorm and power outage, Tony says to his children, "Someday soon you're gonna have families of your own, and if you're lucky, you'll remember the little moments like this that were good"—a sentiment repeated in the final moments of the series finale.

BALANCING ACT

"Livia's funeral scene when we're all at the house . . . Christopher is so high, and he's telling his story. I was standing in the back with the guys, and—oh, my God—we were praying off camera at one point because we just wanted to break down and laugh—it was so fucking funny. Michael [Imperioli] was hysterical."

—Aida Turturro on the scene from "Proshai, Livushka"
(Season Three, Episode Two), where Janice asks
guests to share memories of Livia.

The Sopranos really hits its stride in Season Three, and there is much to unpack considering it covers the death of Livia, Christopher's promotion, Adriana's new friendship with "Danielle Ciccolella," the introductions of Ralph Cifaretto and Jackie Aprile Jr. (Jason Cerbone), Tony's relationship with Gloria Trillo (Annabella Sciorra), a new revelation about Big Pussy, and the famous "Pine Barrens" episode (Season Three, Episode Eleven). But let's start with one of the main themes that winds its way through this season: Tony as father and father figure.

The season marks a significant turning point for Tony and Carmela's no-longer-little kids, Meadow and A.J. Parenting a strong-willed, independent, college-age woman and an undisciplined teenage son isn't easy for the best of parents, let alone Tony and Carmela. Episode Two, "Proshai, Livushka," opens with Tony on the floor of the kitchen. He's just suffered another panic attack, which we soon discover is because of Meadow—or, rather, Meadow's new friend from college, Noah Tannenbaum (Patrick Tully).

You see, Noah is half Black and Jewish—and this triggers Tony's racism as nothing else could. Before Meadow returns from upstairs to fetch a Barenaked Ladies CD, Tony manages to interrogate, insult, and instruct Meadow's new friend to break up with his daughter. But the exchange doesn't yield the results Tony

was hoping for. Instead, Noah curses at Tony and storms out.

Meadow's only mistake is believing her father is evolved enough to handle her bringing a mixed-race friend home to screen a movie for film class. Or maybe her mistake is in testing him. Either way, the rift between father and daughter lasts through the entire season and well into Season Four. The disconnect between them is further compounded later in the season by the suspicious events surrounding the death of Meadow's childhood friend and brief fling, Jackie Jr. In Season Three and Season Four, Meadow is forced to confront certain truths about her family of origin. And much like her mother, she straddles the line between acceptance and denial. As she continues to move toward independence, we see Meadow make choices that suggest she is open to exploring a means of atoning for the sins of her father by exploring career options in law—a line of work that holds her interest until the end of the series.

Meadow isn't the only kid challenging the limits of Tony's patience. Things go from bad to worse with A.J., who, in addition to lacking serious direction, will soon add anxiety disorder to his dysfunctional mix because, well, the apple doesn't fall far from the tree in this family. Consider the moment A.J. was publicly praised by his high school football coach and named defensive captain of the team—only to have a panic attack right there on the field and pass out. This trait seems to be in the bloodline.

When A.J. and his friends vandalize the school, punishment is deferred by the administrators because he's a valuable football player. By the end of the season, however, he's expelled for stealing answers to a test. Incensed, Tony wants to send A.J. to military school, and the family even visit one; however, Carmela is adamant that military school isn't the path for their son, and this leads to an explosive fight between the couple.

After Jackie Jr.'s funeral, however, Carmela reconsiders her position. But as a chastened and regretful A.J. tries on the military uniform, he suffers another panic attack, and this event precludes him from going. These issues are merely the tip of the iceberg for Tony, who has a lot more to deal with beyond his own children. As it turns out, there are *a lot* of people who need parenting this season—it just comes with the territory of being boss.

In these scenes from "The Army of One" (Season Three, Episode Thirteen), Tony reviews pamphlets for military schools. Moments later, the phone rings—Jackie Jr. has been shot dead in the Boonton Projects. Later, Carmela and Tony meet with the director of the Hudson Military Institute, but Carmela isn't convinced it's the best option for A.J.

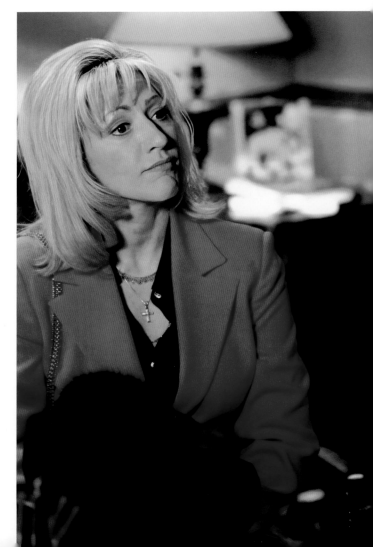

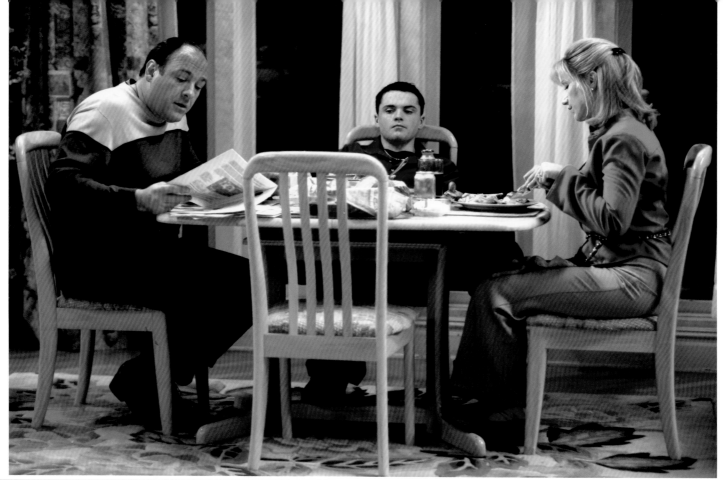

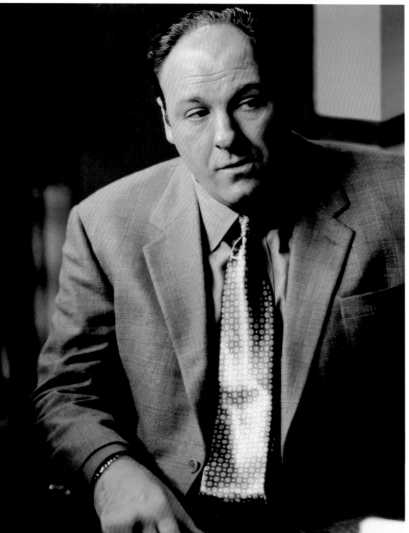

Tony: You're going to be on that school bus to DC tomorrow. You're all packed and paid for, and you're gonna pay attention and you're gonna learn something for a change.
A.J.: We're going to FBI headquarters.
Tony: So?

Goodbye, Little Livia

Livia's passing comes unexpectedly on the heels of another snippy exchange between mother and son over a matter of stolen airline tickets. The argument once again spikes Tony's stress levels. Hours later, he gets the news that Livia has passed away in her sleep. It levels a powerful blow to Tony, who must now deal with the aftermath of her death added to the pile on his overflowing plate, which also includes his most recent business problem named Ralph Cifaretto in addition to the continued hostilities of his daughter ("Proshai, Livushka," Season Three, Episode Two).

Livia might be dead, but she's far from gone. She lives on, in a manner of speaking, in Tony's relationships with women this season, including his sister Janice. After splitting town at the end of Season Two, Janice returns from Seattle following Livia's death. And once she's back, she wastes no time getting under Tony's thin skin. First, she insists on having a wake and funeral for Livia, both of which are against Livia's wishes. Then she begins planning the events of the day:

Janice: I want you to know, Tony, that this all won't fall on you. I'll do a painting for the overleaf of the program at the service. Motifs from the Mexican Day of the Dead. Oh, one thing that I'd like to suggest very strongly is, at the house, everyone gathers, and each one can voice a remembrance or a feeling about Ma.

Tony: No, no, no, I don't want any of that California bullshit. People can drink, they can eat some gorgonzola. They want to yak about Ma, that's their business.

Later while Tony and Janice are going through boxes in Livia's basement, they discover Tony's old school papers, report cards, baptism and communion certificates, and high school football letter. Janice observes that Livia only kept Tony's items from childhood but nothing of hers or of their sister Barb's ("Proshai, Livushka," Season Three, Episode Two). The discovery must have planted a seed of resentment because during the reception at Tony and Carmela's house, Janice goes against

The FBI sent a flower arrangement to Livia's wake—a stark reminder that they're always watching.

When Meadow and A.J. were born, Carmela gifted Livia with memory books that she could fill out for the kids to have as keepsakes. Years later, the books remained empty, and Svetlana was tasked with getting Livia to fill them out as a hobby. Alas, Livia died before she ever put pen to paper. "Those granny remembers books," Tony says to Carmela, "she never touched them."

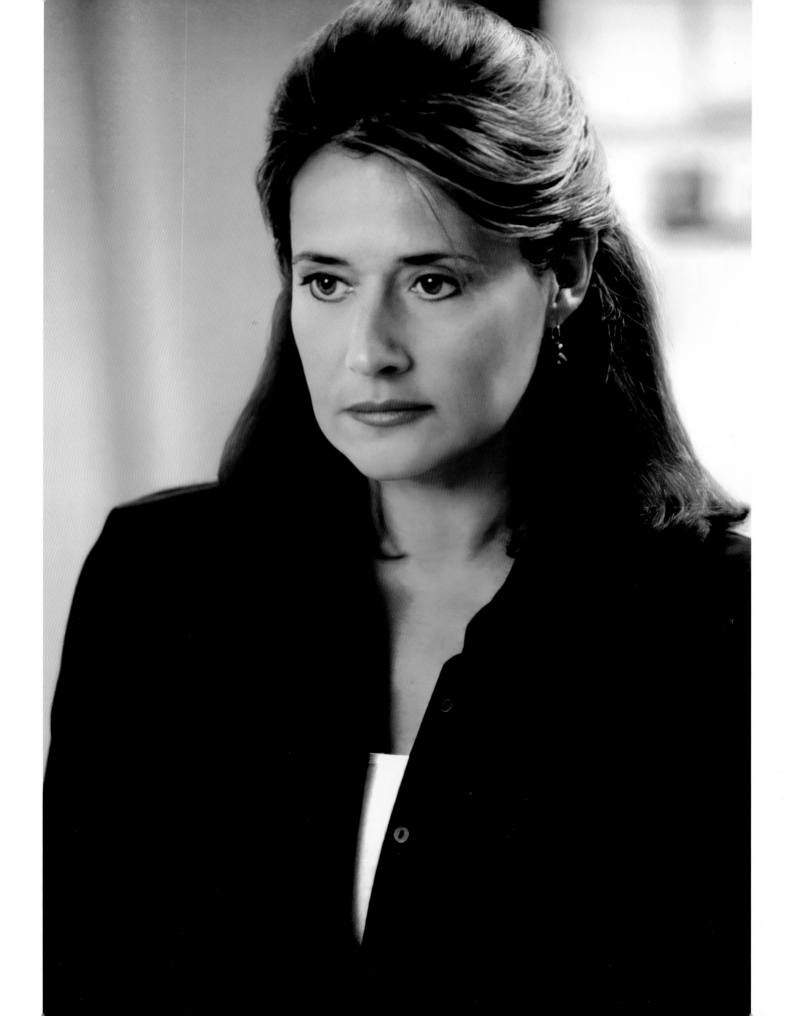

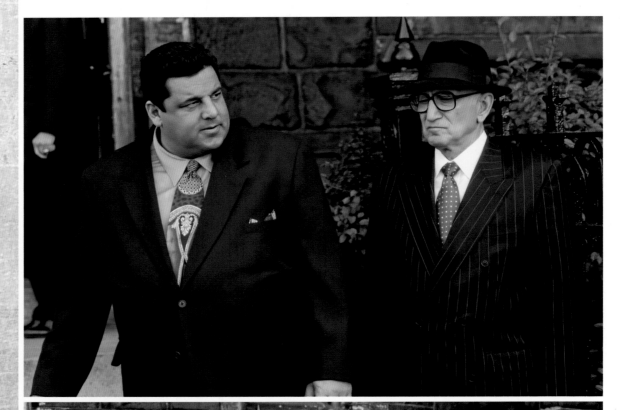

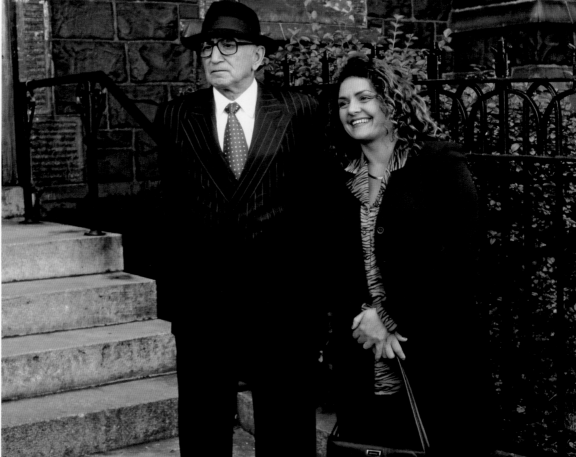

In "Another Toothpick" (Season Three, Episode Five), the family attend the funeral for Carmela's uncle, Fabrizio Viola, who passes from cancer. In the scene, Janice reveals that Livia once described a person afflicted with cancer as "another toothpick" due to the toll cancer takes on the body. The story hits a nerve with Junior, who also has cancer.

Death in *The Sopranos:* Season Three

Deaths were abundant in Season Three, starting with Livia Soprano, who passed away in her sleep from a massive stroke. Here are the other significant deaths in Season Three:

Fabrizio "Febby" Viola: A relative on Carmela's side of the family who died of cancer.

Salvatore "Mustang Sally" Intile: Killed by Bobby Baccalieri Sr. on the order of Gigi Cestone for beating Bryan Spatafore within an inch of his life.

Carlos: Killed by Bobby Baccalieri Sr. for being a witness to the Mustang Sally murder.

Bobby Baccalieri Sr.: Already suffering from lung cancer, he died from asphyxiation in the car after carrying out the hit on Mustang Sally.

Tracee: Bada Bing dancer who was beaten to death by Ralph Cifaretto.

Gigi Cestone: Died on the toilet from a heart attack.

Sunshine: Killed during a hold-up of Ralph's poker game by Jackie Aprile Jr., Carlo Renzi, and Dino Zerilli.

Carlo Renzi: Associate of Jackie Jr.'s, killed after attempting to take down Ralph's card game.

Dino Zerilli: Associate of Jackie Jr.'s, killed after attempting to take down Ralph's card game.

Jackie Aprile Jr.: Killed after attempting to take down Ralph's card game.

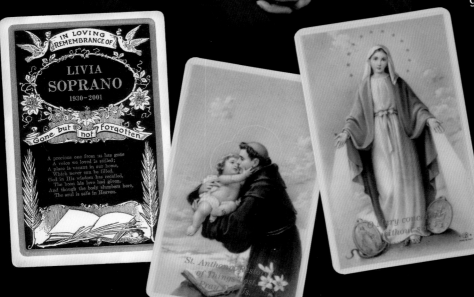

Lorraine Bracco as Dr. Jennifer Melfi

Lorraine Bracco admits she had no interest in appearing in another Mafia project after having costarred in Martin Scorsese's *Goodfellas*.

"I'd been offered four thousand mob movies, TV things, you name it, and I was not interested in doing any of them," Bracco says. "Then *The Sopranos* casting people, Sheila Jaffe and Georgianne Walken, said to me, 'Just read the fucking script.' So I finally did. And I was shocked at how much I liked it."

But there was a caveat. Bracco wanted to play Dr. Melfi, not Carmela. When she met with creator David Chase, he was shocked. "I assured him I was a very different woman than I was when I made *Goodfellas*." Bracco also thought it would be "nice to show an educated Italian woman. I'd never seen it before and wanted to demonstrate it." Before long, Chase was convinced. He had his Dr. Jennifer Melfi.

Not only was it important to Bracco that she portray a smart, sophisticated Italian woman, she also wanted the therapy to feel authentic. "Therapy had helped me get through some really hard times in my own life and get to know myself a lot better. I thought if we did it real, people would see that it's not scary."

At the same time, Dr. Melfi's constrained personality was totally removed from that of the actress portraying her. "I'm not sure I was ready for how fucking hard it would be to play her," Bracco admits. "I had to sit on and tamp down my every emotion. That's literally the opposite of how I actually am in my life. I was lucky that they edited me very well because there were moments when I was frustrated and I'd yell. Then they would say, 'Cut. We can't use that, Lorraine. You know that.' I'd say, 'I know, but I had to get it out.' Yeah, it was hard."

Writer-producer Terence Winter confirms that Bracco was nothing at all like the button-down doctor she portrayed. "Lorraine was essentially the opposite," Winter maintains. "It was party time whenever she came around. The problem is, she was usually scheduled to work on Friday night at ten o'clock. It was the last thing we would do for an episode. The crew was exhausted, and we'd be working until three in the morning. By the time she got there, we hadn't seen Lorraine for a couple of weeks, so she really energized everyone. But yeah, she's really fun and effusive, and Dr. Melfi is 180 degrees from her."

On the other hand, Dr. Melfi was written perfectly from Bracco's perspective. "I liked that she was tight and bottled up," she acknowledges. "If I didn't play it that way, [Tony] would have eaten [her] up because he was the kind of guy, if you gave him a hand, he'd take your arm. He was charming and adorable and sexy, and I had to tell myself, 'Ah, don't get caught up. Don't allow him in.'"

Bracco recalls her time working with James Gandolfini as a consistent and unqualified joy. The word she uses is "delicious." She adds, "He was always there 120 percent with me."

Dèjá Vu

In "He is Risen" (Season Three, Episode Eight), Tony meets Dr. Melfi's attractive and monumentally troubled patient Gloria Trillo in the doctor's waiting room. His attraction to the Mercedes-Benz salesperson from Globe Motors is instant, but in pursuing her, Tony winds up getting significantly more than he bargained for.

From the outside, Gloria is smart, self-sufficient, and spiritually driven by Buddhist philosophy—qualities Tony finds intriguing and admirable. He is taken in by her seductive spell and is surprised by the intensity of his attraction and the passion of their liaisons. She's equally smitten with Tony's charm, power, and bad-boy charisma. Tony even seems less hostile toward Carmela while carrying on behind her back with Gloria. What isn't immediately apparent to Tony is the depth of Gloria's mental illness. And what he mistakes for fiery passion and intensity is actually psychopathological behavior that manifests as hostility, rage, and possessiveness. Tony eventually outs himself to Dr. Melfi when he quotes from someone very obviously outside his normal circle:

Tony: You have to joyfully participate in the suffering of the world.
Dr. Melfi: Your thoughts have a kind of Eastern flavor to them.
Tony: Well, I've lived in Jersey my whole life.
Dr. Melfi: I mean Eastern in terms of Asian, like Buddhist or Taoist.
Tony: Sun Tzu. I told you about him.

When Tony finally admits to Dr. Melfi that he is seeing Gloria and describes her unreasonable outbursts—including throwing a steak at the back of his head—the psychiatrist is quick to draw parallels between his relationship with Gloria and his recently deceased mother Livia. Despite her allure and vivacious nature, Gloria is infected by the same blackness that consumed Livia, and her drama substitutes as a type of love Tony has been subconsciously conditioned to recognize.

The initial thrill of their assignations rapidly devolves into acrimony between the two clandestine lovers in "Amour Fou" (Season Three, Episode Twelve). When Gloria learns that Carmela is getting her car serviced at Globe Motors, she offers to give her a ride home. Gloria later calls Carmela at home under the pretext of selling her a new Benz. Tony flies into a rage and confronts Gloria at her office, where he ends the relationship. Later that night, a hysterical Gloria calls Tony begging him to come see her. At first, she seems remorseful, but her mood changes in a flash and she starts a vicious tirade of verbal abuse that Tony instantly recognizes as Livia. "My mother was just like you," he says. "A bottomless black hole." As Tony turns to leave, a desperate Gloria threatens to tell Carmela about their affair, which activates his monster within. The conflict turns physically violent, and Tony nearly strangles Gloria to death as he descends further into a rage. He only comes to his senses when he realizes that Gloria is literally begging him to end her life.

Actress Annabella Sciorra recalls, "In the script, it wasn't that Gloria was begging for him to kill her. It was more like a taunt, a you-don't-have-the-guts kind of thing. It was like, 'I can't let him out of the room until he's done it.'" During the harrowing scene, Gloria punctuates her breathless command of "Kill me . . . kill me . . . kill me" by spitting in Tony's face, which was improvised by Sciorra on the spot.

Was James Gandolfini surprised?

"Oh yeah," she replies. "He was like, 'Did you just f–ing spit at me?' And I was like, 'Yeah, I'm so sorry.' But I knew it was the right thing."

Gloria is a smart, beautiful, sophisticated woman with a dark side. Her insecurity manifests as rage and control soon after she and Tony get involved.

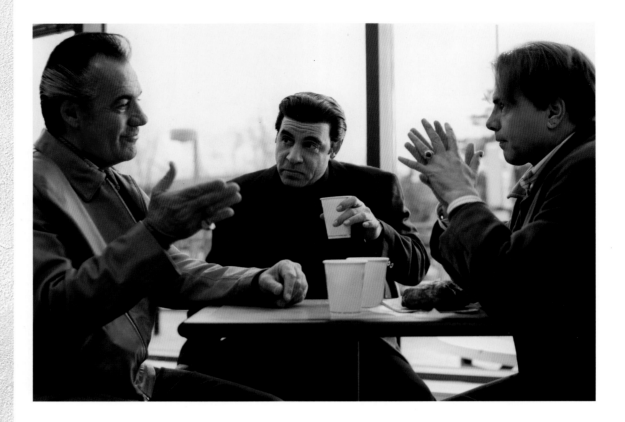

Ralph the Man-Child

It speaks volumes that on a series filled with abhorrent people behaving abysmally, Ralph stands out as a special kind of monster. It's emblematic in the sense that *The Sopranos* was about so much more than the endearing charisma of tough guys and really wove into its fabric a wider tale about inherited trauma, mental illness, toxic masculinity, and the impact of the mother figure on the psyche.

Ralph returns to New Jersey from Miami after the "mysterious" disappearance of Aprile crew capo Richie Aprile. A childhood friend of Tony's, Ralph is notorious for getting in his own way thanks to his arrogance. Despite their history, Ralph tests Tony's patience as the boss like few others can. Tony sees Ralph as a developing liability—an immature man-child with an evil streak whose impulsivity risks exposure for the family. This is exactly what happens in "University" (Season Three, Episode Six) when he kills his stripper girlfriend Tracee to death in the Bada Bing parking lot.

Little can prepare the viewer for what befalls Tracee, who is pregnant with Ralph's child. When Ralph taunts her cruelly about the pregnancy, she spits in his face. This unleashes his rage, and he beats her in the most vicious fashion imaginable. It's nearly unbearable to watch, and yet the scene serves as essential connective tissue for the show—reminding us that these people are not just dangerous; they are psychopathic. The sheer casualness of the violent act proves a watershed moment not only in the series but for TV in general. It had been a medium where hateful characters had mostly heretofore been verboten.

Ralph is perhaps one of the most contemptible characters series TV has ever produced, and while the reaction of those around him involves some measure of shock and revulsion, the response to Tracee's agonizing killing does not leave the audience with anything approaching catharsis. Tony feels a measure of fatherly like guilt for not treating Tracee with more compassion in the days

Ralph lacks a moral compass, which makes him incredibly good at his job. However, his antics get under the skin of everyone he crosses paths with, including Paulie, who feels he gets the raw end of the deal when Tony rules against him in favor of Ralph on a financial settlement in "The Army of One" (Season Three, Episode Thirteen).

leading up to her death, but it's ultimately the act of disrespect against the Bada Bing that Tony takes issue with—and that Ralph's actions have risked bringing heat to their doorstep. It is revelatory of the indifference with which these men regard the suffering of women, particularly those whom they consider disposable.

The story also serves to juxtapose the lives of two young women in Tony's immediate orbit: his daughter, a privileged student at an Ivy League university, in contrast to Tracee, who is beaten and left like trash. "That moment where she's beaten was maybe the hardest thing I had to write in the entire show," says writer-producer Terence Winter.

"That's one of those examples of, 'You think these guys are funny teddy bears? Well, watch this.' And then the big insult was not that he killed this girl but disrespected the club."

As sadistic as Ralph is, his behavior toward women isn't wildly different from that of his associates. Tracee's tragic death is the demarcation line between who we *hope* these people are—indeed, who they *pretend* they are in the company of their wives—and who they really are. Ralph emerges from the killing relatively unscathed. But his mouth will continue to get him into trouble as we will see in Season Four.

"*Tomorrow I can be on time, but you'll be stupid forever.*"
RALPH CIFARETTO

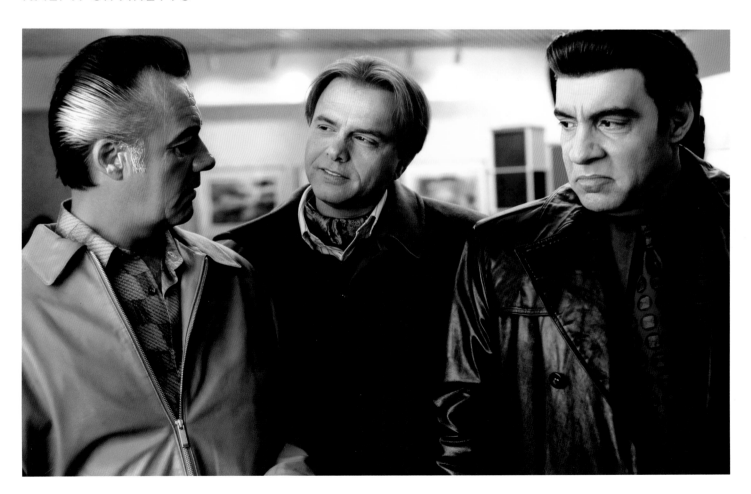

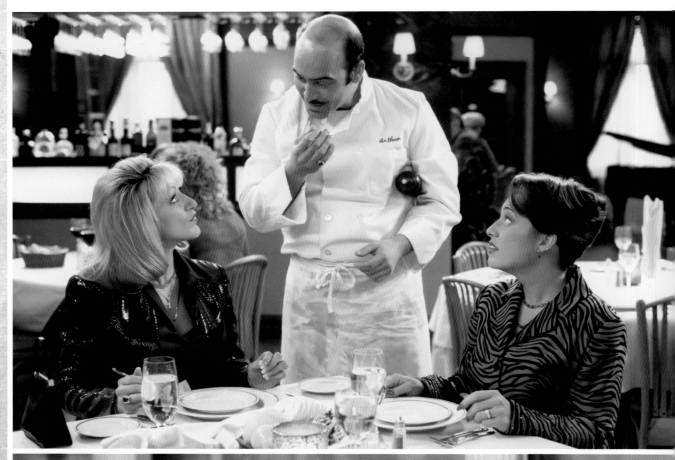

The dinner table is like another character in *The Sopranos*. Whether it's friends dining out casually, associates gathered for business, or family enjoying Sunday dinner at home, the place settings are often formal, and meals are frequently elaborate and replete with wine. The underlying message is that the table brings family together; although in these families, the conversations are often anything but warm.

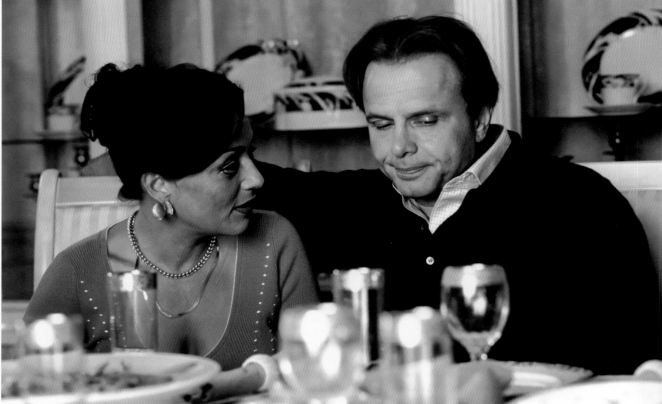

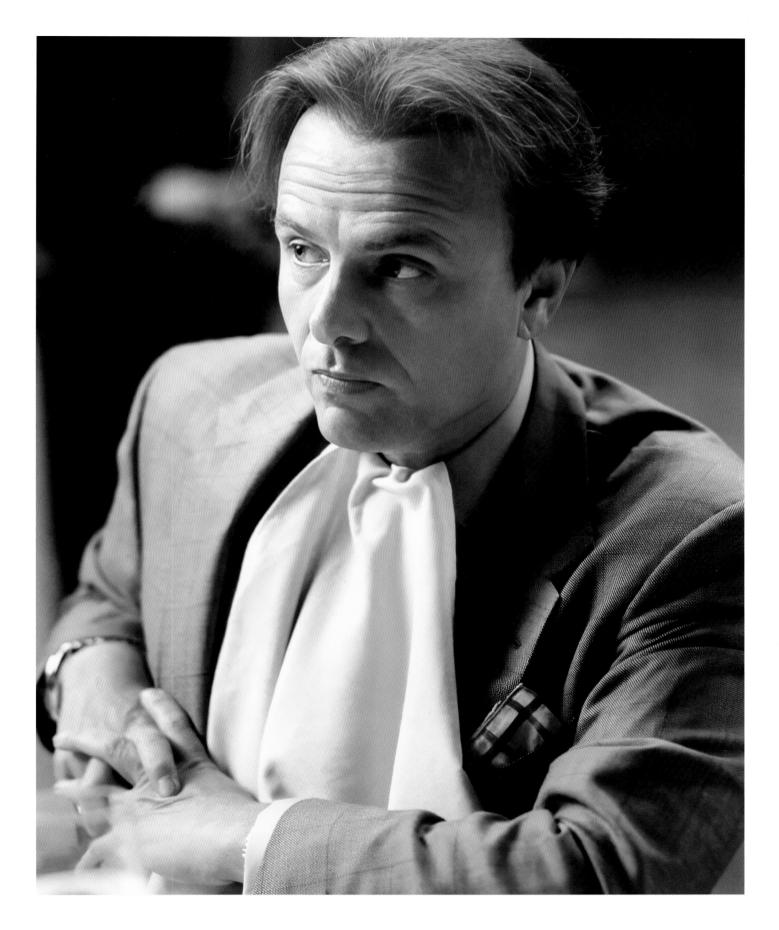

Something's Fishy

While Tony did what he feels he had to do in whacking Big Pussy, the reverberations of his friend's betrayal continue to play on an endless loop in his head. This proves especially true as Christmas comes around—it's the first year Big Pussy isn't going to play Santa Claus for the neighborhood kids ("To Save Us All From Satan's Power," Season Three, Episode Ten). Instead, it's shy and reserved Bobby who is drafted to play Santa, and he proves to be miscast for the role.

In a flashback, Tony returns to an incident a few yuletides earlier when Big Pussy was sensitive to anyone touching his Santa suit. Why? Because he was likely wearing a wire underneath it. This occurs to Tony as he reflects on the past and begins to put the pieces together. He suspects that the FBI flipped Big Pussy when he was down in Boca Raton—that's the time Big Pussy failed to show for a sit-down that he brokered between Jackie Aprile Sr. and Junior.

While Tony would love to be able to close this chapter in his life, he continues to be haunted by his dream in which Big Pussy appears to Tony as a talking fish—thanks to a singing Big Mouth Billy Bass novelty gift. The first time the fish appears is at the Bada Bing. When it's turned on, the fish sings "Take Me to the River," and Tony thinks it's kind of funny—that is, until the fish lifts its head and sings directly to him. Tony asks where it came from, and when Silvio says that it was Georgie (Frank Santorelli), Bada Bing's hapless bartender, Tony grabs the toy and beats Georgie with it.

That could have been the end of the story were it not for Meadow gifting an identical Big Mouth Billy Bass to Tony for Christmas. Forced to watch while the fish sings "Take Me to the River" in front of his family, Tony fights off a panic attack while forcing a smile to his lips and enduring his own private hell.

In "To Save Us All from Satan's Power," boss Jackie Sr. appears in Tony's flashback. Jackie agrees to a sit-down with Junior, but Big Pussy—who brokered the deal—is a no-show. In this sequence, Tony recalls Big Pussy's strange behavior and determines he must have been flipped by the FBI during the time of the meeting.

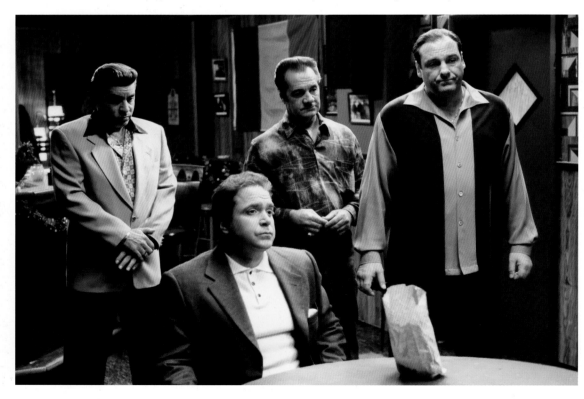

Season Three Memorable Moment

Episode Seven: "Second Opinion"

Carmela and Dr. Krakower (Sully Boyar)

Carmela: His crimes. They are organized crime.

Dr. Krakower: The Mafia.

Carmela: Oh, Jesus. [Crying] So what? He betrays me every week with these whores.

Dr. Krakower: Probably the least of his misdeeds.

[Carmela rises to leave]

Dr. Krakower: You can leave now, or you can stay and hear what I have to say.

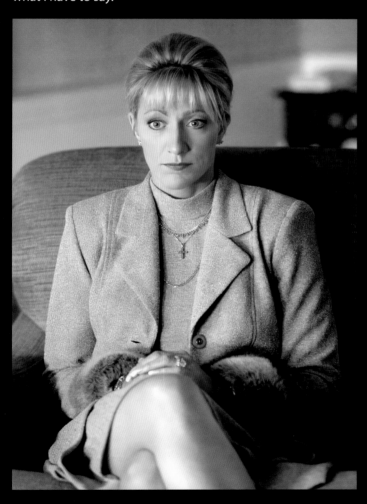

Carmela: Well, you're gonna charge the same anyway.

Dr. Krakower: I won't take your money.

Carmela: That's a new one.

Dr. Krakower: You must trust your initial impulse and consider leaving him. You'll never be able to feel good about yourself, you'll never be able to quell the feelings of guilt and shame that you talked about as long as you're his accomplice.

Carmela: You're wrong about the accomplice part though.

Dr. Krakower: Are you sure?

Carmela: All I do is make sure he's got clean clothes in his closet and dinner on his table.

Dr. Krakower: So, enabler would be a more accurate job description for you than accomplice. My apologies.

Carmela: So you think I need to define my boundaries more clearly. Keep a certain distance, not internalize my—

Dr. Krakower: What did I just say?

Carmela: Leave him.

Dr. Krakower: Take only the children—what's left of them—and go.

Carmela: My priest said I should try and work with him, help him to be a better man.

Dr. Krakower: How's that going?

[Pause]

Dr. Krakower: Have you ever read *Crime and Punishment?* Dostoyevsky. It's not an easy read. It's about guilt and redemption. I think were your husband to turn himself in, read this book, and reflect on his crimes every day for seven years in his cell, then he might be redeemed.

Carmela: I would have to get a lawyer, find an apartment, arrange for child support.

Dr. Krakower: You're not listening. I'm not charging you because I won't take blood money. You can't either. One thing you can never say: that you haven't been told.

Carmela: I see. You're right. I see.

Pine Barrens

If there is one thing that *Sopranos* aficionados can agree on, it's that "Pine Barrens" (Season Three, Episode Eleven) is one of the most iconic and beloved episodes in the series. And instead of a strip club or a house or a restaurant or a gritty boulevard of broken dreams, much of the episode takes place in the frozen New Jersey wilderness in the dead of winter.

The basic plot finds Paulie and Christopher lost in the snowy forest after Paulie escalates a routine collection from a Russian associate, Valery (Vitali Baganov), into a violent encounter. After the brawl, the pair think they've killed the man and plan to cart his body out to the New Jersey Pine Barrens's secluded forest. Except that when they arrive and pop the trunk, the guy isn't dead.

Paulie and Christopher march the guy into the forest, intent on shooting him—but not before forcing him to dig his own grave; however, when Christopher and Paulie are distracted, Valery clocks Christopher in the head with the shovel and kicks Paulie in the gut. Then he flees into the woods. A chase ensues, Paulie loses a shoe, and Christopher can barely stand upright from what is most certainly a concussion. Paulie shoots at and hits a fleeing Valery on the side of his head, but when they catch up to where he went down, he's nowhere to be found. They search for him for a few minutes, but as it grows colder, they decide to head back to the car. Except now they are so turned around, they don't know which direction to go in.

As night falls, things grow more desperate for the men and more hilarious for the viewer. It's unclear whether the elements or their contempt for one another will do them in first. They find a deserted van that they hole up in for the night, but their tempers remain short. It doesn't help when they're reduced to dining on ketchup and relish packets they found in the car. Somehow, they both survive the wilderness and the overwhelming temptation to kill each other.

The idea for "Pine Barrens" originated from the mind of Tim Van Patten, whose typical role on the

While trying to find the escaped Russian, Christopher and Paulie get hopelessly lost in the snowy woods of Pine Barrens, requiring Tony and Bobby to come to their rescue.

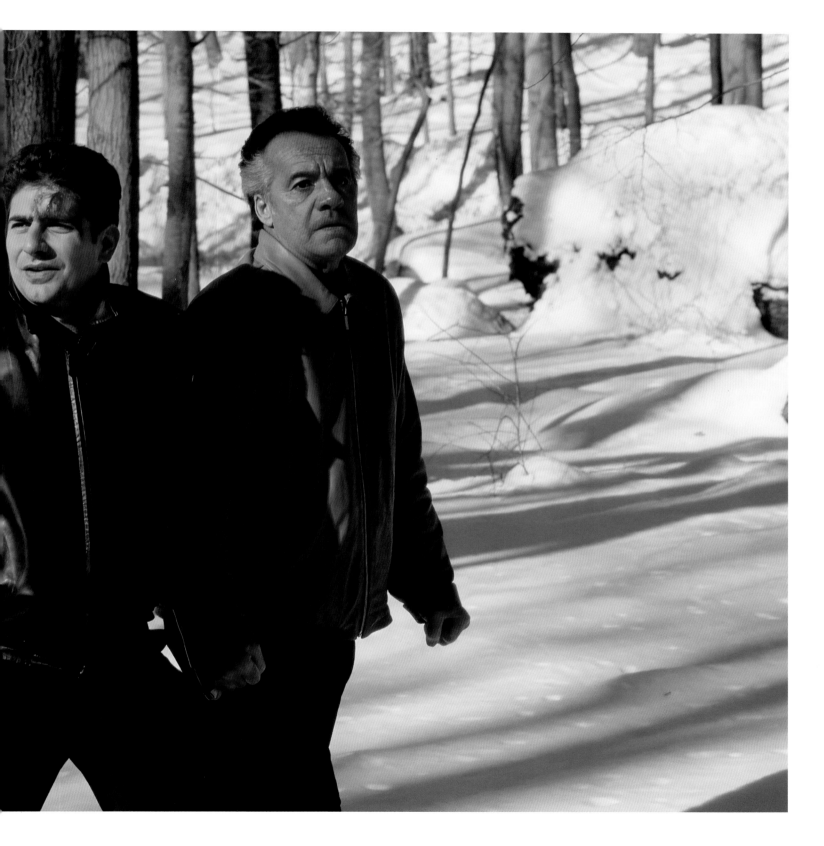

> *"Fuck you, Paulie. Captain or no captain, right now we're just two assholes lost in the woods."*
>
> CHRISTOPHER MOLTISANTI

show was director. He received co-story credit for the episode because it came to him in a waking dream, as he describes it. "I was just thinking about my father, how he used to take us to the racetrack in Atlantic City, and he'd take us on these little detours to areas like the Pine Barrens and make up stories and spin yarns about the Jersey Devil inhabiting the area," Van Patten recalls. "So, I thought, wouldn't it be interesting if Christopher and Paulie went out there to take care of business and the guy got loose?"

Van Patten remembers that he pitched the idea to David Chase and Chase said, "Great. We're doing it."

"Was I surprised? Yes," Van Patten admits. "I was just like, 'Jeez, that was easy.' Then Terry [Winter] went off and wrote a killer script, and Steve Buscemi directed it. And we got lucky: an actual snowstorm occurred, and it's kind of a character in the show. It was really those guys that did it—not me. I only had the idea. And I think it stands out today because it was a bit of a sidestep from the usual business. It was like another world."

Father Figure

Tony refers to Christopher as his nephew due to his close relationship with Christopher's father, Dickie Moltisanti, while he was growing up. But, in fact, Christopher is first cousin once removed to Carmela and second cousin to Meadow and A.J. In many respects, however, Christopher is more like a son to Tony, and his immaturity makes him yet another problem child for Tony to manage.

Since early in Season One, Christopher has been in a romantic relationship with Adriana La Cerva. It's a love pairing that blossoms—in fits and starts—alongside Christopher's eager participation in hijackings, thefts, and executions driven by his desire to be made. His ambition is matched only by his hot-headed personality and tendency to overreact. And he faces conflicts along the way, particularly with Paulie, in part due to his lack of self-control.

Christopher is seduced by the allure of showbiz, briefly venturing into music production in Season One and attempting to write a screenplay in Season Two (his Hollywood aspirations eventually take flight later in Season Six). For now, though, Christopher is content: he's finally earned his button and takes his oath—the omertà—alongside Eugene Pontecorvo (Robert Funaro) in a dimly lit basement ceremony ("Fortunate Son," Season Three, Episode Three). During the initiation, Christopher looks over to the window where he spies a crow on the sill. He takes this as a bad omen, and the viewer is right to assume it's a foreshadowing of events to come. Christopher has already survived an attempt on his life in Season Two, but his own reckless behavior suggests his house of cards will fall eventually.

Christopher has dabbled in drugs for a while, but after discovering heroin in Season Two while visiting Italy, his recreational use escalates into full-blown addiction that takes over his life. It peaks in Season Four when he accidentally sits on, and suffocates, Cosette, Adriana's dog. The family stage a "nonjudgmental" intervention that goes south as soon as Christopher starts to mouth off. Tony's

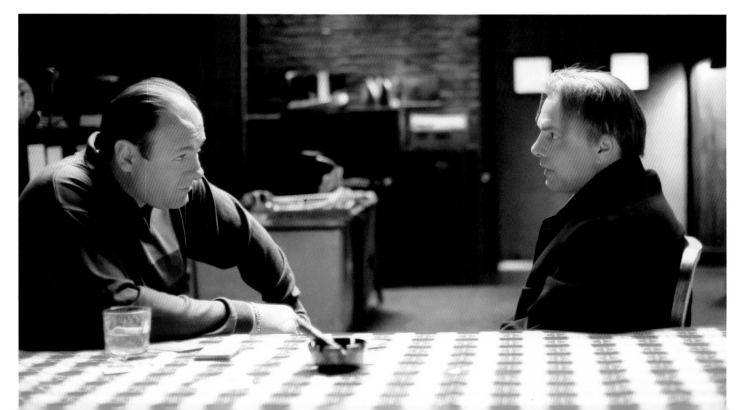

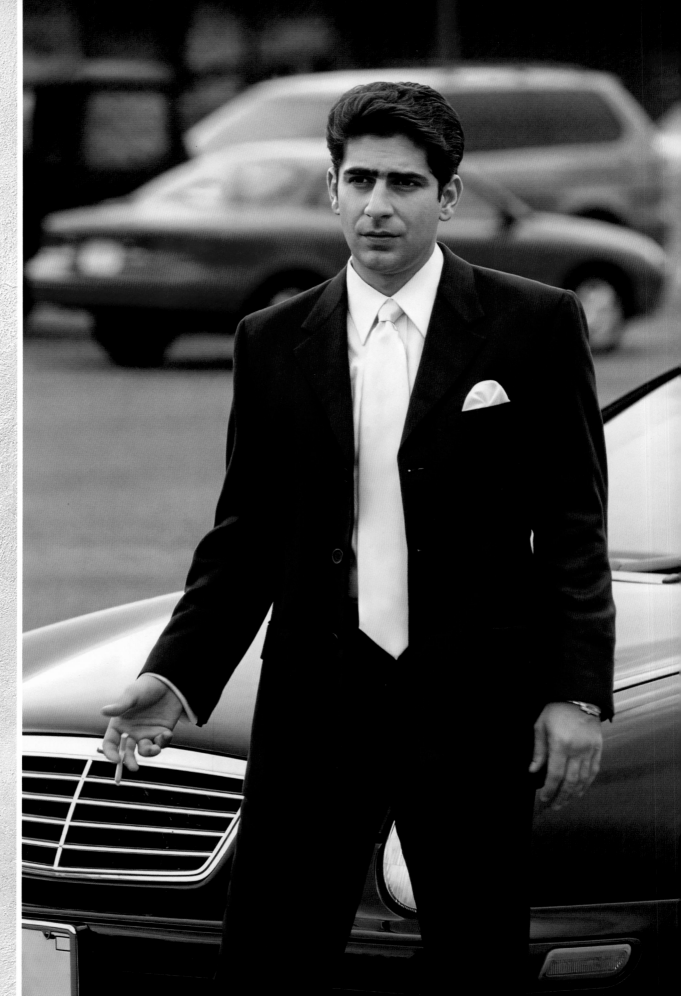

Right: In "Fortunate Son" (Season Three, Episode Three), Christopher gets dressed to the nines and meets up with Paulie and the guys who escort him to the ceremony where he finally becomes made.

Opposite: Family and friends gather to say farewell to Jackie Aprile Jr., whose misguided attempts to follow in his father's footsteps cost him his life.

threat of excommunicating him from the family—or more explicitly, excommunicating him with a bullet to the back of the head—propels Christopher to reluctantly agree to rehab. The results are positive, and in time, he's attending meetings, working out, reading, and singing the song of sobriety.

We meet Jackie Aprile Jr. in Season Two, but his real story begins and ends in Season Three. Jackie Jr. is a screw up, but that wasn't always the case. When his father Jackie was still alive, the young Jackie seemed to be on the straight and narrow—and he was the pride of his father. But with his father's passing combined with his Uncle Richie's influence, Jackie Jr. begins to falter. Tony wants to keep the kid out of trouble, but let's face it: he was born with two strikes against him going in. The third strike comes in the form of his would-be stepfather, Ralph Cifaretto, a terrible influence who counteracts Tony's vaguely threatening tough love.

Jackie is a good-looking kid with a colorful personality. He attends Rutgers and starts dating Meadow. But he's already heading down the dark path—he deals Ecstasy to the Columbia students and even supplies Meadow. He's not particularly bright, so school is a challenge for him. Plus, the calling of life in the family is just too tempting to resist. Eventually, Jackie flunks out of school, forms his own little crew (working for Ralph), and begins to see himself as a player. Things come to a head when Jackie Jr. suffers delusions of grandeur after hearing Ralph tell tales of how Jackie Sr. and Tony made names for themselves taking down Feech

La Manna's (Robert Loggia) card game. Jackie Jr. gathers his buddies and holds up a high-stakes poker game—where Christopher and Furio are in attendance. It goes terribly wrong, ultimately leading to a gunfight that gets his two mates, Carlo Renzi (Louis Crugnali) and Dino Zerilli (Andy Davoli), killed and Furio shot in the leg ("Amour Fou," Season Three, Episode Twelve).

Christopher is livid and implores Tony to let him take Jackie Jr. out that same night, but Tony hesitates. Christopher reacts impulsively and accuses Tony of being a hypocrite:

Christopher: He took a shot at me! He tried to kill Furio. We're made.

Tony: Every person you whack, you risk exposure. Major murder is what the Feds ask for Christmas.

Christopher: Bullshit! You're a fuckin' hypocrite . . . You preach all this wiseguy shit and meanwhile the only ones who've got to play by the rules are us. I loved you.

Tony: What happens I decide, not you. Now you don't love me anymore? Well that breaks my heart, but it's too fuckin' bad. 'Cause you don't got to love me, but you *will* respect me."

Meanwhile, as Jackie Jr. hides out in the Boonton Projects, Ralph wants to give him a pass, but in reading Tony, Ralph comes to realize there's no way to realistically protect Jackie Jr. from what he's done. He enlists Vito Spatafore (Joseph R. Gannascoli) to do the job. The story of record, however, is that Jackie Jr. is killed by "Black drug dealers." It proves an inglorious end to a wasted life.

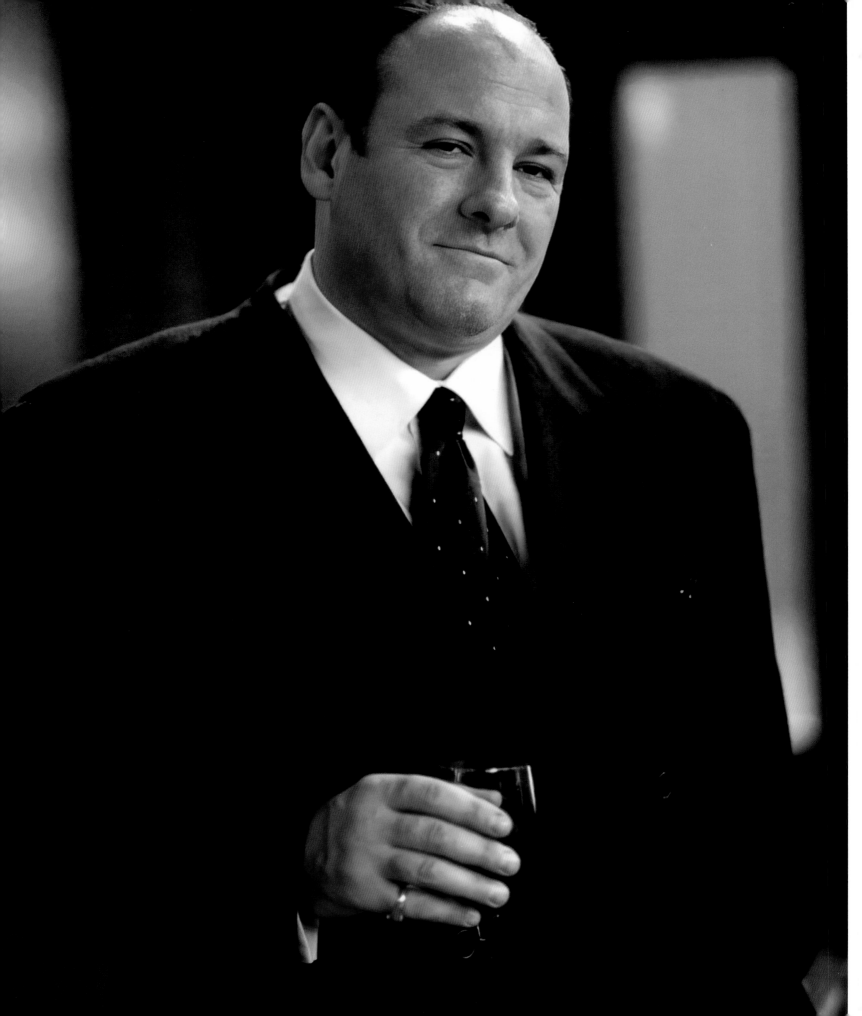

WISHING AND HOPING AND THINKING AND PRAYING

"More is lost by indecision than by wrong decision."
CARMELA SOPRANO

"We bend more rules than the Catholic Church."
JOHN SACRIMONI

"Mom really went downhill after the World Trade Center. You know, Quasimodo predicted all this."
BOBBY BACCALIERI

"A don doesn't wear shorts."
CARMINE LUPERTAZZI SR.

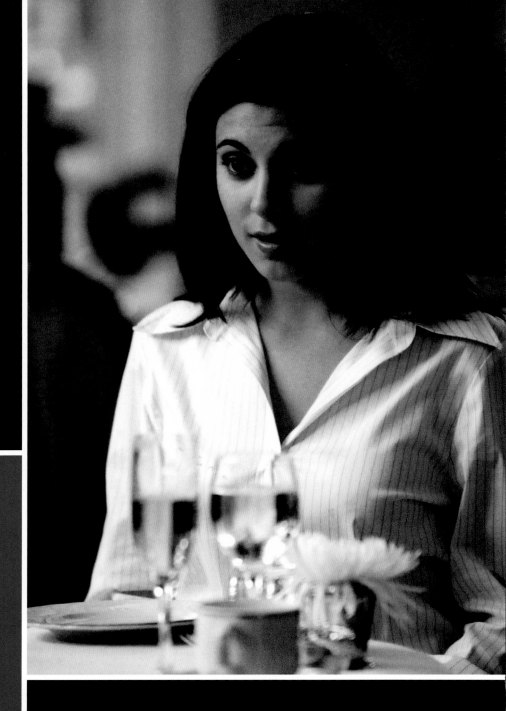

"The only [step] I haven't exactly done is go around to all the people I fucked over while I was usin' and apologize."
CHRISTOPHER MOLTISANTI

THEY SAID IT IN SEASON FOUR . . .

"Wow, listen to Mr. Mob Boss."

MEADOW SOPRANO

"My happiness really drives you crazy, doesn't it, Tony?"

JANICE SOPRANO

"You're only as good as your last envelope."

SILVIO DANTE

"What are you, a vegetarian? You eat beef and sausage by the fucking carload!"

RALPH CIFARETTO

"When I was a kid, you two were old ladies. Now I'm old, and you two are still old."

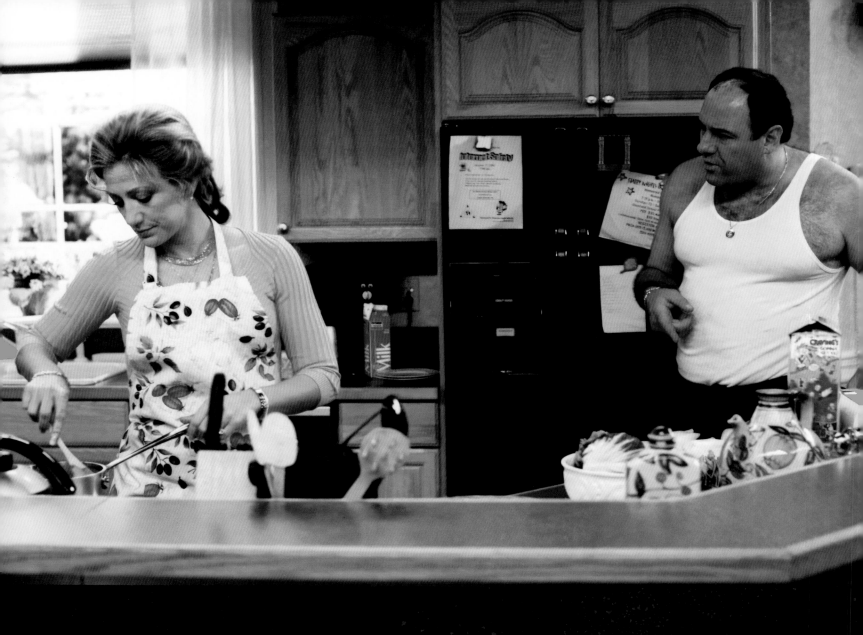

"I don't love you anymore. I don't want you.
You are not sleeping in my bed, Tony.
The thought of it now makes me sick."

INTRODUCTION TO SEASON FOUR

Oh, what a tangled web we weave. Loyalties are put to the test this season, which opens with Paulie in jail on a firearms charge. He whines to John "Johnny Sack" Sacrimoni (Vincent Curatola) that Tony never visits him. Sniffing out opportunity, Johnny uses the occasion to play Paulie like a mandolin, gaining his trust to glean information about the goings-on in the New Jersey family.

Adriana discovers that her new best friend Danielle (Lola Glaudini) is an FBI agent when Adriana is picked up by the Feds and threatened with jail time on drug charges unless she cooperates; meanwhile, Christopher's heroin use continues to ramp up. While under the influence, he accidentally sits on and kills Cosette, Adriana's beloved dog. While out trying to score drugs, he's beaten, robbed, and delivered home by a fellow junkie. When Adriana mentions rehab, Christopher beats her up. A family intervention gone awry ultimately forces Christopher to choose between rehab or a bullet in the back of the head. He chooses rehab.

Tony becomes attached to Ralph's racehorse Pie-O-My and is devastated when the horse is badly burned in a stable fire, requiring it to be euthanized; however, Ralph is in the grips of his own grief after a horrible accident leaves his son with permanent brain damage. It occurs to Tony that the insurance payment from the stable fire would cover the boy's medical bills. Ralph denies the accusation, but his lack of feeling for Pie-O-My triggers a violent altercation that doesn't end well for Ralph or his toupee.

Carmela and Furio find themselves growing close though neither confesses their feelings to each other in so many words. They both understand the stakes and that acting on their feelings would be disastrous, not to mention potentially deadly. Meanwhile, Bobby Baccalieri is consumed with grief over the death of his wife, Karen (Christine Pedi), whose body hasn't even gone cold before Janice goes to work on him. In the end, Janice emerges victorious in securing herself a new man.

Tony's anxieties over juggling one mistress after another—both past and present—finally blow up in his face when Irina calls the house and tells Carmela about Tony's tryst with Svetlana. Let's just say it doesn't go well for Tony or for his golf clubs.

Key Plot Points
* **Adriana's new friend—Danielle, from Whippany—gets Tony's attention, but there's more to her than meets the eye.**
* **Christopher's drug addiction triggers a family intervention and rehab—or else.**
* **Paulie gets played by Johnny Sack, causing tension in the family.**
* **Tony's extramarital affairs and incessant lies finally catch up to him.**

likely a cold or flu. On the way home, Tony takes a detour—he's got a surprise for his wife and its name is Whitecaps: a beautiful beach house right on the Jersey Shore. Carmela's spirits seem to lift as she considers this new distraction. It's another consolation prize in a long line of prizes that she's received for being the wife of Tony Soprano ("Whitecaps," Season Four, Episode Thirteen).

> *"You know what I don't understand, Tony? What does she have that I don't have?"*

CARMELA SOPRANO

Furio Giunta is both a source of pleasure and pain for Carmela, who falls in love with him knowing that there will never be a chance for a future together.

A Marriage in Freefall

By any measure, "Whitecaps" (Season Four, Episode Thirteen) is a masterpiece. It features two powerful moments between Tony and Carmela—the most intense scenes between them in the entire series. It's a knock-down drag-out of epic proportions, and while there's not a drop of blood drawn, there is a death, albeit metaphorical.

The showdown that leads to Tony and Carmela's separation has been brewing for years and finally detonates in a tsunami of accusations, grievances, and raw rage. It's an exquisitely harrowing rendering of one of those long-simmering explosions where a couple hurls every stick of dynamite at one another, and it's gut-wrenching to witness. James Gandolfini and Edie Falco were never better, but it takes a while in the episode to arrive there.

With Tony's surprise for Carmela of the prospect of buying Whitecaps, he seems genuinely sincere in his efforts to please her—perhaps he's even trying to renew the spark in their marriage. Although Carmela is not sure about it at first, her enthusiasm grows quickly. It feels like a magical spot for them, promising moonlit walks on the sand with the surf crashing in the background. The house is initially committed to another buyer, but the owner of Whitecaps, attorney Alan Sapinsly (Bruce Altman), maneuvers his way out of the contract when Tony offers cash and a short escrow. Naturally, it's all too good to be true. Just as things are looking potentially rosy, Tony's former Russian girlfriend Irina drunk-dials the Soprano home. When Carmela gets on the line, Irina proceeds to tell her that she used to "fuck" her husband. A startled Carmela hangs up, but Irina's not done exacting her revenge. She calls back to reveal that she and Carmela "have some sadness in common" because Tony also slept with Svetlana, Irina's cousin. It's the tipping point for Carmela.

In the next scene, Tony is pulling up the driveway in his Suburban when he runs over his golf clubs. He gets out of the car, confused, and glances up to see Carmela throwing his clothes and possessions out of their second-story bedroom window. When he runs into the house and demands an explanation, she calls him a "fucking shitbag." After initially denying Irina's accusation about Svetlana, Tony realizes he's not going to be able to lie his way out of this one. Thus begins an exchange of heated rhetoric from both sides, each tossing bombs that carry extra hurt in every explosion.

The tension carries over well into the next day and escalates into another emotional scene:

Carmela: You know what, Tony? What's done is done. We are where we are; it's for the best. But just for the record, or it might even interest you to know, that I might actually have gone on with your cheating and your bullshit, if your attitude around here had been even the least bit loving, cooperative, interested.

Tony: Whose idea was Whitecaps?

Carmela: It's just a bigger version of an emerald ring, so that you can keep on with your other life.

Tony: You don't know me at all.

Carmela: I know you better than *anybody*, Tony, even your friends. Which is probably why you hate me.

Tony: Hate you? But don't worry. I'm going to hell when I die. Nice thing to say to a person heading into an MRI.

Carmela: You know, Tony, I've always been sorry I said that. You were my guy; you could be so sweet. Nobody could make me laugh like you . . .

Tony: Carmela, who the fuck did you think I was when you married me, huh? You knew my father. You grew up around Dickie Moltisanti and your Uncle Eddie. Where do you get off acting all surprised and miffed when they're women on the side? You knew the deal!

Carmela: Deal?

Tony: And your mother can talk all she wants about what's-his-name and his fucking chain of drugstores. You and I both know that the other

The peaceful, idyllic setting of Whitecaps stands in stark contrast to Tony and Carmela's tempestuous marriage and subsequent breakup.

boyfriend you were debating marrying was Jerry Tufi, with his father's snowplow business. And we now know that *that* wouldn't have suited you at all.

Carmela: You really don't hear me, do you? You think for me, it's all about things.

Tony: Oh no, I forced all this shit on you. What you really crave is a little Hyundai and a simple gold heart on a chain.

Carmela: You are so fucking hateful.

Carmela might have ended the conversation here. She turns to walk away, but then stops, turns, chambers a new round, and fires:

Carmela: Can I tell you something, Tony?

Tony: Don't pretend like I got a choice.

Carmela: The last year I have been dreaming and fantasizing and in love with Furio. Every morning, when he'd come to pick you up, I would look forward to it all night long in bed next to you. Those nights when you were actually in the bed. And he would ring the doorbell. I felt like my heart would come out of my chest. He would smile and we'd talk. And then you would come down the stairs. And I felt probably like someone who is terminally ill and, somehow, they manage to forget it for a minute. And then it *all* comes back.

Tony flies toward Carmela and we think we're about to see him strike his wife for the first time, but he punches the wall instead. Tony, channeling Livia, yells, "He talked to you . . . poor you!" Carmela shoots back, "He made me feel like I mattered!"

Both Tony and Carmela hit each other right where the other lives. But Carmela gets the last word when she tells Tony what he knows to be true about himself: "You're a fucking hypocrite."

It's all over but for the official separation, which will happen soon enough. By the end of the episode, Tony agrees to leave. The emotionally exhausted couple break the news to their children. The reverberations of Tony and Carmela's continue well into Season Five.

Bada Bling

From living in mansions and driving luxury cars to wearing fine Italian suits and furs, wiseguys and their wives revel in flaunting their material wealth. It's rather contradictory considering these folks would be better served flying under the radar, but then how else are you to prove you've finally arrived?

The Sopranos masterfully portrays the avarice and excess of the mob lifestyle in ways big and small, and jewelry is a cornerstone of that storytelling. Signet rings and gold bracelets are common among the men, as are gold rope and figaro chains. The women seem to live by the motto that more is better when it comes to layering on the bling. In this world, diamonds are definitely a girl's best friend.

Carmela, for example, rarely wears fewer than two necklaces at a time and often as many as four. She enjoys wearing diamond earrings, be it studs, pendants, or hoops, and she also wears a diamond Cartier watch. (Tony prefers a Rolex.)

It's safe to assume that Tony gives Carmela jewelry whenever he's feeling especially guilty. Take the extravagant sapphire and diamond emerald-cut Harry Winston ring he gives her for her birthday in Season Three. It's stunning, over the top, and Tony's way of apologizing for past, present, and future transgressions.

he ate at dinner or the zuppa di mussels he ate at Vesuvio later that night.

Food is thematic in every episode. It's often used to critique and criticize the differences between Northern and Southern Italian palates and traditions in not-so-subtle ways.

In Season One, when Artie visits Livia in the hospital, he brings her cavatelli with a duck ragu sauce from his restaurant. But when he reveals it's a Northern Italian dish, she turns her nose at it. Later in Season Five, Carmela's mother, Mary DeAngelis (Suzanne Shepherd), praises the Northern recipes she received from her snobby Italian friend as a "revelation." In the world of *The Sopranos*, not all Italians are equal.

Where there's a focus on food, however, there is also a preoccupation with weight and body size, which is another subject the show addresses through numerous characters. There is Meadow's friend, Hunter Scangarelo's (Michele DeCesare) eating disorder and Vito Spatafore's (Joseph R. Gannascoli) Thin Club diet success. In one episode, Dr. Melfi reveals to her therapist that she's gaining weight, and Tony also weighs himself at various points in the series, although nobody dares to mock him about it—at least to his face. Plenty of other characters carried around a spare tire, as it were. Big Pussy, for one. And Bobby Bacala carries around extra weight—albeit by design. During the first two seasons, Steve Schirripa, who played Bobby, was required to wear a fat suit. "Once I got the role, they sent me the script, and it included all of these fat jokes from Tony," Schirripa recalls. "I'm thinking, 'Damn, I'm not that much bigger than Jim [Gandolfini]. Kind of similar in terms of size. Maybe they got the wrong guy over here.' Then I got the call to come in a few days early to get fitted for a fat suit. Wearing that left me way bigger than Tony. But they finally let me ditch the suit for Season Three. I guess they figured I was big enough on my own by then."

In "Pie-O-My" (Season Four, Episode Five), Vito breaks a chair when he sits in it, and Ginny Sacrimoni was the subject of a cruel joke by Ralphie in "The Weight" (Season Four, Episode Four). When Johnny Sack catches wind of what's been said about his wife, he moves to defend her honor, telling Tony that her weight has never bothered him and describing her as "Rubenesque." Later, when Johnny catches his wife in the middle of a binge, he grows frustrated. He's never asked her to lose weight—it was her own idea.

What he objects to is the deception. He reassures his wife that he loves her for who she is and takes her in his arms. It's a rare glimpse into the humanity of an otherwise ruthless mobster. No more weight jokes, Johnny later tells Tony. They're hurtful and unnecessary.

Minor though she may be, Ginny plays an important role in this storyline. Johnny's vehement protection and loving kindness toward his wife not only reveals his own depth of feeling but enables viewers to see Ginny as more than the body she inhabits. It is compelling TV ahead of its time.

So why are food and weight central to the show? For one, they're useful plot devices that serve to further illustrate the undercurrent of yet another double standard that belies the old-school mentality of this specific Italian subculture: eating is encouraged, gaining weight is not.

A lot of family business goes down at the dinner table after dessert. For a formal dinner, wiseguys are required to wear dinner jackets, collared shirts, and dress slacks, at a minimum. The top brass, however, usually wear full suits and ties.

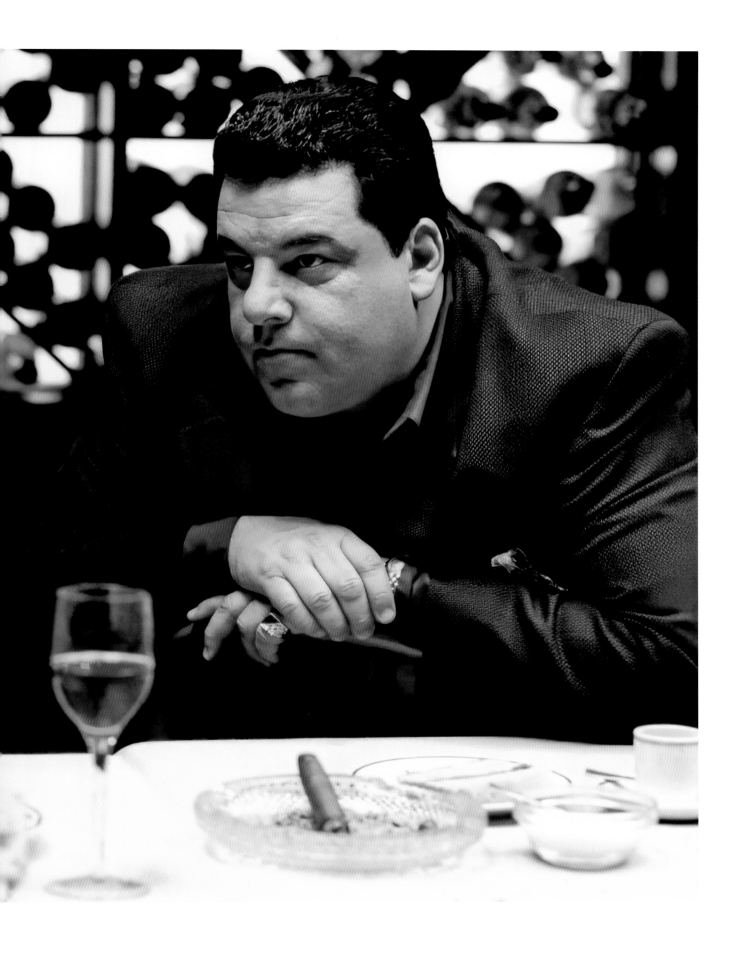

The Last Ziti

Out of all the wiseguys on the show, Bobby was as a close as any man comes to being moral and decent. He is a loving husband and never cheats on his wife Karen. He's also a devoted father. Bobby never uses his position in the family for personal gain. He is unfailingly helpful and loyal to Junior and his friends. So, when Karen is tragically killed in a car accident, we feel awful for Bobby. The loss leaves him stricken with a paralyzing grief. He is regularly moved to tears and finds it difficult to cope with everyday tasks, including assisting Junior.

Amid this anguish, Janice Soprano sees an opportunity. She sees a sweet man with a genuine heart suffering and it touches her, but she's still in a relationship with Ralph. Janice confides to her therapist, Dr. Sandy Shaw, about her unhealthy relationship with Ralph. She discloses how moved she is by Bobby's immense grief for his deceased wife. "I felt unworthy to be in his presence," she tells Sandy, confessing that she wants to break up with

Ralph because she knows she deserves a better man. Sandy encourages Janice to sit Ralph down and talk to him with the compassion and respect she is "famous for." Instead, when Ralph shows up on Janice's doorstep with suitcases in tow, she finds a reason to lash out and kicks him down the stairs while yelling for him to get out. Now, she can devote her energy to winning Bobby over, and she wastes no time.

Janice brings dinner over, picks Bobby's kids up from school, and essentially inserts herself into his life every which way to cajole him out of his heartache. In Janice's mind, a measure of success in helping Bobby relegate Karen to the past involves coercing him to eat the last frozen ziti Karen made, which she tries to do more than once. When that tactic proves fruitless, Janice seizes another opportunity.

While at Sunday dinner at Tony and Carmela's, A.J. scares Bobby Jr. and Sophia when he does a

Right: Janice's therapist, Dr. Sandy Shaw (Joy Van Patten), encourages her patient to break up with Ralph using compassion and respect. Janice responds by kicking Ralph down a flight of stairs as soon as he enters her house ("Christopher," Season Four, Espisode Three).

Opposite: Janice aids Bobby through his grief by coercing him to eat Karen's last baked ziti in "Calling All Cars" (Season Four, Episode Eleven).

fake seance with a Ouija board. Janice witnesses the event and hatches a plan to contact Bobby Jr. anonymously via an online chat room and encourages him to use the Ouija board she's planted inside their house to communicate with his dead mother. After Janice sets the bait, she awaits the phone call she knows is coming. Sure enough, Bobby calls and asks Janice to come over. He tells her the kids played with the Ouija board to contact Karen and it scared them half to death.

Janice pounces and helps convince Bobby that his ongoing displays of grief are negatively impacting his kids: "The dead have nothing to say to us," she tells him. "It's our own narcissism that makes us think they even care." She then seals the deal by encouraging Bobby to heat up and eat Karen's last ziti ("Calling All Cars," Season Four, Episode Eleven).

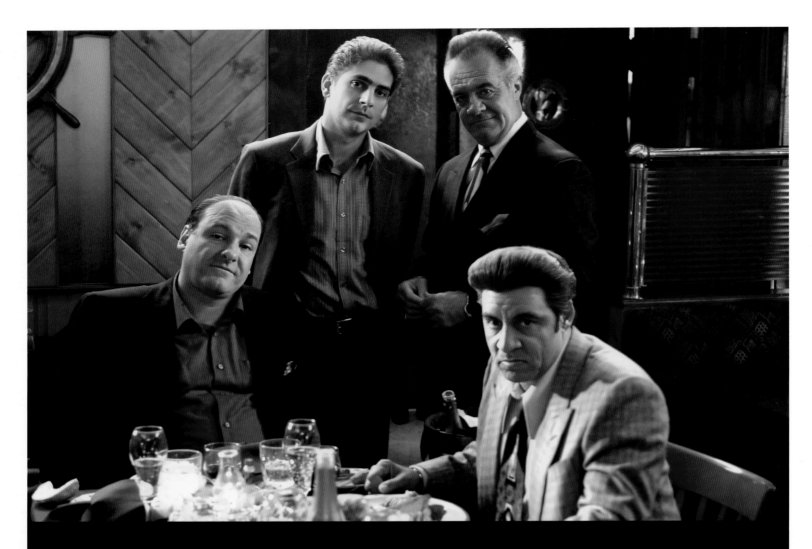

Speaking Italian

Don't know your goomar from your goombah? *Fuhgettaboudit!* Here's your passport into the linguistic world of *The Sopranos*.

Agita: heartburn, indigestion; also stress

Buona fortuna: good fortune

Chiacchierone: a big mouth/blowhard

Gabagool: capicola, a dry-cured meat

Googootz: slang for "zucchini" and a term of endearment

Goomah/Goomar: from *comare,* meaning mistress

Goombah: comrade, friend, or buddy

Fungule: swear word meaning "fuck"

Mal oik: from *malocchio,* for evil eye or curse

Manigot: manicotti, pasta tubes filled with ricotta cheese

Marone/Madone: literally "Madonna" but translated as "damn it!" Also used to register surprise.

Mezza Morta: half-dead

Moozadell: mozzarella cheese

Oobatz/ubatz: a nut or crazy

Oogatz: another way of saying "nothing"

Prujoot: prosciutto, a dry-cured meat

Puzzi: bad smell; also slang for "shit"

Schifosa: dirty, rotten, lousy person

Stoogatz: "Fuck it."

Stunade: dumb or stupid

Paulie Takes the Bait

As a senior member of Tony's crew, Paulie is as loyal as they come. But confined to a jail cell, a man has time to think. At the beginning of Season Four, Paulie is in jail awaiting trial on a firearms charge. A seasoned gunslinger like Paulie can do the time without complaining, provided he doesn't feel abandoned. But when Tony doesn't visit him in the slammer, Paulie grows bitter. He vents to Johnny Sack and grows increasingly careless with his words. Johnny feigns interest in Paulie's woes in a bid to get information that will benefit New York.

When Little Paulie (Carl Capotorto) visits Paulie in jail, he repeats the off-color joke about Ginny Sack having a "ninety-five-pound mole removed from her ass" that Ralph told at a dinner with the guys. Paulie takes offense and subsequently tells Johnny Sack. The revelation sparks outrage that causes a major rift between Johnny and Carmine, who warns Johnny to demand a price from Ralph or cool his jets. Johnny is out for blood and puts a hit on Ralph. Meanwhile, Tony is caught in the middle left wondering who in the family is doing the talking.

Johnny tells Paulie that Carmine asks about him and even suggests that Paulie might come over to the New York family. It's a ruse to get information, and Paulie buys into it hook, line, and sinker. When Paulie sees Carmine at a wedding ("Eloise," Season Four, Episode Twelve), he greets him with a warm familiarity that confuses Carmine. Not only is the New York boss completely unaware that Johnny Sack and Paulie know each other, he doesn't know who Paulie is at all. In that moment, Paulie's blood runs cold, and he knows he's been played. Banking on a future with the New York family, Paulie has been distant with Tony and snippy with Silvio, and his envelopes have been light. Paulie springs into action to make things right, but the damage is done. Tony suspects the betrayal, and the topic rears its head again between the two in Season Six.

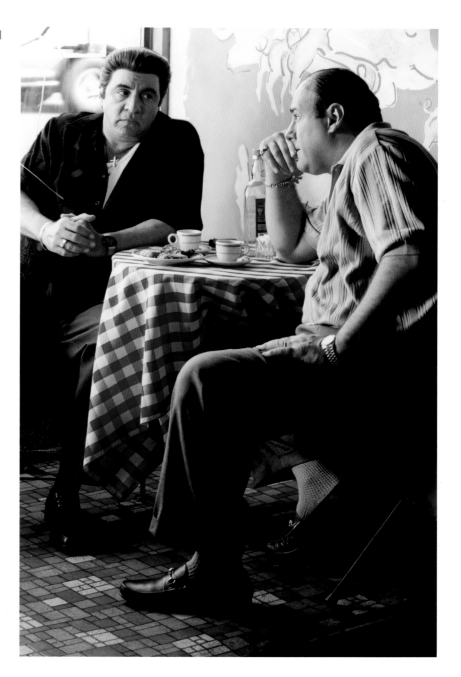

Corrado "Junior" Sopra

When Junior sees the courtroom sketch on TV from his trial, he laments to Bobby, "The fuck! What kind of likeness is that . . . I'm fucking fodder for cartoonists now?" When Junior returns to the courtroom, rather than pay attention to the trial details, he turns in his seat and makes eye contact with the artist. His steely gaze says it all.

Steven Van Zandt as Silvio Dante

Steven Van Zandt had never before tried his hand at acting, but when David Chase saw his colorful introduction of The Rascals at their induction into the Rock and Roll Hall of Fame in 1997, he thought Van Zandt could be a valuable addition to his mob drama series pilot. He saw him playing the lead Tony Soprano.

"Yes, that's how David initially saw me in his creative insanity," Van Zandt recalls. "And I figured, what the hell. Let's give it a shot. I hadn't really thought it through. I mean, in terms of acting, I figured either I was going to be able to do it or I wasn't. And I really wasn't sure until I jumped in."

Jump he did. And while Van Zandt was ultimately cast in a decidedly different role than that of the series lead, he is forever grateful to Chase "for giving me something that's turned out to be a wonderful gift."

It turns out his role of Silvio Dante (consigliere to Tony Soprano) is one Van Zandt was born to play. As Bruce Springsteen's longtime friend and E Street Band guitar virtuoso, operating in the shadow, whether it be to Bruce or Tony, is his comfort zone.

"The second banana, as we used to say," Van Zandt stresses. "That's where I like to be."

Van Zandt recollects the hours on the set of the show were often incredibly long, but the primary lifting naturally fell to star James Gandolfini. "We'd finish at 10 p.m., and then poor Jimmy had to go home and learn seven pages of a script, four or five of which would be him and Lorraine [Bracco], which is why he basically quit the show every day. His brain was fried, especially at first while he was getting used to it."

It was quite a shock for Gandolfini, Van Zandt observes, given that he came from the world of movies as a character actor. "It was a huge challenge, man."

But not for Van Zandt, who took to acting like a duck to water and loved what he was doing from the outset. "I was very comfortable with Silvio, though not really until it was firmly established gradually over the first season," he says. "It was the perfect role at the perfect time for me. It was a lot of fun. Silvio was a bit ambitious and kind of the ambassador of the family, if you will. He was concerned with expanding business and relationships of the family. And he had the trophy wife too—who was played by my real-life wife Maureen."

There was lots of playful back-and-forth on the set, Van Zandt emphasizes. He notes that he and Tony Sirico (Paulie Walnuts) had "a wonderful sort of rivalry to see who could out-mug the other guy." He adds, "I spent a lot of time practicing making my face as different as I could make it. I intentionally gained weight. I practiced walking differently, speaking differently, laughing differently. I tried to be as different as I could because I was just absolutely paranoid about the fact that I'd been a rock star at that point for twenty-five years or whatever it was, and I just wanted to erase that from the people's minds."

Van Zandt feared that if his music persona interfered with the communication of his character, it could damage the authenticity of the show. "I wanted to be an asset, not a problem," he adds, "because of David Chase's extraordinary faith in me. I didn't want anyone saying, 'Wait a minute. I just saw that guy playing Cleveland a month ago.'"

He needn't have been concerned. Van Zandt never heard a negative word about his work as Silvio. In fact, his efforts to distance himself from his Little Steven rock image may have been a bit *too* successful. "Within weeks of the show being on, I'm walking down the street, and people are like, 'Hey Silvio!' and wanting to stop me to talk *The Sopranos*," Van Zandt remembers. "I thought it was going to take a while. Instead, twenty-five years as a rock star, forget it. Gone. Just like that. It was weird, man."

Indeed, the transformation from Steven to Silvio worked so well, his own mother didn't recognize him. "I sent her a tape of the first show, and she says, 'I had to rewind it. I thought I heard your voice, but I didn't recognize you.' I guess that was the ultimate test, you know?"

Season Four
Memorable Moment

Episode Thirteen: "Whitecaps"

Tony and Carmela

Tony: What the fuck? Carmela! What the fuck are you doing?

Carmela: You fucking shitbag! Don't come up here! Get the fuck out of this house!

Tony: Carm, what's the matter? Carm, what did I do now? What did I do? Your mother told you what I said to your father about her psoriasis? I was just trying to be honest with him.

Carmela: You have made a fool of me for years with these whores. Now it's come into our home?

Tony: What are you talking about?

Carmela: The Russian called. Your son answered the telephone.

Tony: Oh, Jesus. She's insane. She's fucking certifiable. I told you, you can't believe nothing she says, whatever it is. We haven't seen each other like that. I swear to Christ. I told you!

Carmela: What about her cousin?

Tony: What? No!

Carmela: The nurse who took care of your mother, who I liked? Who I talked to on the telephone about your mother's alopecia and her bowel movements? Who you told me came from an agency? Who I shared vodka with the night your mother died? You've been *fucking* her?

Tony: There is not a shred of truth in that.

Carmela: Why'd the cousin make it up? Because she's jealous! Why you, fuck. Let go of me!

Tony: Carm.

Carmela: Just get out, Tony. Don't even say anything.

Tony: I'm not going anywhere, and you know it. So let's just lie down, we'll calm down.

Carmela: Get your hands off of me! Don't you touch me ever again.

Tony: Where's A.J.?

Carmela: So you've had a one-legged one now? That's nice. You've had quite a time on my watch. The preschool assistant, the weightlifter.

Tony: At least I never stole from you.

Carmela: Who stole, Tony? Who, me?

Tony: My own wife, $40,000. From the birdfeeder.

Carmela: The birdfeeder. Listen to yourself. You sound demented. What, you want to hit me, Tony? Go ahead. Just go away, please. I can't stand it anymore!

Tony: I didn't do it.

Carmela: I found her fingernail, Tony! You saw it that day, on your night table. I found it, and I put it there. I know you saw it.

Tony: That . . .

Carmela: That? That what?

Tony: Nothing. Nothing. What?

Carmela: You know what I don't understand, Tony? What does she have that I don't have?

Tony: I did not carry on an affair with the cousin, and I will take a goddamn polygraph to that effect.

Carmela: I want you to leave this house, Tony. Please. I want you to leave me alone.

Tony: What about the kids?

Carmela: Yeah, it's horrible. God help them.

The Episodes

Episode 1 "For All Debts Public and Private": Paulie, in jail on a gun charge, is offended that Tony hasn't been to see him; Paulie expresses his displeasure to Johnny Sack, whom he views as an ally. What does get Tony's attention is Carmela's sudden preoccupation with the family's financial situation and worry for the future, but Tony gives her the brush-off. Ralphie cheats on Rosalie with Janice. Tony gives Christopher the address of the retired detective he claims killed his father. Adriana grows fond of her new friend, "Danielle," who is an undercover FBI agent.

Episode 2 "No-Show": Christopher is made acting capo of Paulie's crew, which causes grumbling. Ralphie says disparaging things about Ginny Sack at a dinner, which gets back to Paulie. Meadow, depressed following Jackie Jr.'s death, is encouraged by her new therapist to take a year off school and go to Europe. Janice and Ralphie become hot and heavy. Adriana learns the truth about her friend and is forced to play ball with the Feds.

Episode 3 "Christopher": Bobby's wife Karen dies in a fatal car crash, leaving him inconsolable. Ralph breaks it off with Rosalie. Janice finds opportunity in Bobby's newly widowed status and breaks up with Ralph by kicking him down the stairs. Paulie tells Johnny about Ralphie's off-color remark. Silvio and the guys are offended by a Native American protest of a Columbus Day parade and make their anger known.

Episode 4 "The Weight": Johnny Sack won't let the rancor over the joke at his wife's expense dissipate, forcing Carmine's hand in order to preserve good relations between the families and the Esplanade project. Johnny puts a hit on Ralph who flees to Miami to wait things out. Carmela is increasingly attracted to Furio, and the two share a dance at his housewarming party.

Episode 5 "Pie-O-My": Ralphie invests in a racehorse, viewing the animal as a source of cash, but Tony grows attached to the equine. When the horse gets sick, it's Tony who sits by her side. Janice pushes her way into Bobby's life as he grieves his deceased wife. Adriana meets her FBI handler, Robyn Sanseverino (Karen Young), and finds herself overwhelmed with the anxiety of her fraught new reality.

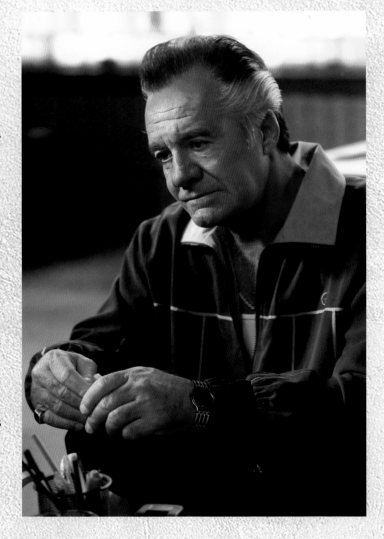

Episode 6 "Everybody Hurts": Tony learns that his ex-mistress Gloria Trillo has died by suicide and struggles to sort out his feelings. His guilt initially inspires him to treat the people in his life with greater kindness. Artie borrows money from Tony to distribute Armagnac, but the distributor craps out on him. A despondent Artie tries to kill himself, which distresses—and angers—Tony. A.J. discovers just how wealthy his new girlfriend is, and Christopher's heroin addiction continues to escalate.

Episode 7 "Watching Too Much Television": Paulie is released from jail but still resents Tony for not visiting. Adriana comes to believe that spouses can't be forced to testify against each other and suggests that she and Christopher get married. He flies into a rage upon discovering Adriana is infertile, but he later agrees to get married. Tony learns that Assemblyman Ronald Zellman has been dating his ex-mistress Irina, which fills Tony with rage. He busts into Zellman's home and beats him with a belt in front of Irina.

Episode 8 "Mergers And Acquisitions": Tony develops a thing for Ralphie's girlfriend Valentina but won't make her his goomar because of Ralph. Paulie moves his mother, Nucci (Frances Ensemplare), into Green Grove and has to intervene when the ladies exclude her from their group. Carmela discovers one of Valentina's acrylic nails in Tony's clothes. She places it on Tony's nightstand and later takes $40,000 from the container where he stores birdseed—and money. Furio returns to Naples for his father's funeral and confesses to his uncle he's in love with Carmela.

Episode 9 "Whoever Did This": Junior and Tony uncover a loophole in Junior's pending trial that could allow him to be declared incompetent, but the ruse isn't convincing. Ralph's son is left with brain damage following a tragic accident. Shortly thereafter, the stable housing Pie-O-My burns down, resulting in the horse's death. Tony suspects Ralph set the fire purposely and confronts him, which leads to a brutal struggle and Ralphie's death.

Episode 10 "The Strong, Silent Type": Christopher accidentally kills Adriana's dog while in a heroin-induced stupor. He later gets robbed while trying to buy more heroin and beats Adriana when she suggests he go to rehab. Tony organizes an intervention with the family that goes horribly wrong. Tony orders Christopher to rehab, demanding that he stay there for the full duration if he knows what's good for him. Furio returns from Naples and picks up where he left off with Carmela. Tony and Svetlana have an afternoon dalliance.

Episode 11 "Calling All Cars": Tony stops therapy in frustration over what he perceives to be his lack of progress. Janice frightens Bobby's kids with a Ouija board to manipulate his feelings for her and pushes him to eat the last of Karen's frozen ziti as a symbolic gesture that he's moving on. Tony's real estate scam causes ill will in both families, leaving Tony to wonder who in his family is giving up information to New York. Tony has recurring dreams of people he's killed.

Episode 12 "Eloise": New York and New Jersey are unable to reach an agreement on numbers from the HUD scam, prompting Carmine to shut down construction at the Esplanade. Johnny suggests that he and Tony join forces to shut down Carmine, but Tony has doubts. Driven by his love for Carmela, Furio is tempted to push a drunken Tony into rotating helicopter blades but pulls back at the last minute. He returns to Italy without telling anyone. Meadow discovers from A.J. that Carmela and Furio have spent time together, causing her to wonder what's transpired.

Episode 13 "Whitecaps": Tony starts the process of purchasing a beautiful vacation home on the Jersey Shore for the family, but a drunk and bitter Irina foils that plan when she tells Carmela about Tony's latest liaison with Svetlana. Carmela flies into a rage that culminates in her wanting a divorce.

A FAMILY IS A FAMILY FOREVER

"In my book, you get points for stayin' out of the can!"
PAULIE WALNUTS

"Next time, there'll be no next time."
PHIL LEOTARDO

"Having sex with your mistress's cousin. Like the mistress wasn't enough to piss off your wife?"
DR. JENNIFER MELFI

"You know what they say: 'Revenge is like serving cold cuts.'"
TONY SOPRANO

"My name is J.T. I'm an alcoholic and an addict. I'm also a TV writer, which by default makes me a douchebag."
J.T. DOLAN

"They compliment you on your new shoes. They tell you that you're not going bald. You think they really care? You're the boss. They're scared of you. They have to kiss your ass, laugh at your stupid jokes."
CARMELA SOPRANO

THEY SAID IT IN SEASON FIVE . . .

"At least Judas didn't go into any Apostle Protection Program. He hung himself; he knew what he did."
ROSALIE APRILE

"Vito Spatafore is a married man, Finn. I seriously doubt he wants to kill you."
MEADOW SOPRANO

"I know what my rights are. I can call social services and they'll send a caseworker."
A.J. SOPRANO

"I've been accused of being part of a certain Italian American subculture."
JOHNNY SACK

"That's the guy, Adriana. My uncle Tony. The guy I'm goin' to hell for."
CHRISTOPHER MOLTISANTI

"At our age, it's enough surprise we're still alive every morning."
UNCLE JUNIOR

"I'm a pre-board-certified massage therapist."
TONY BLUNDETTO

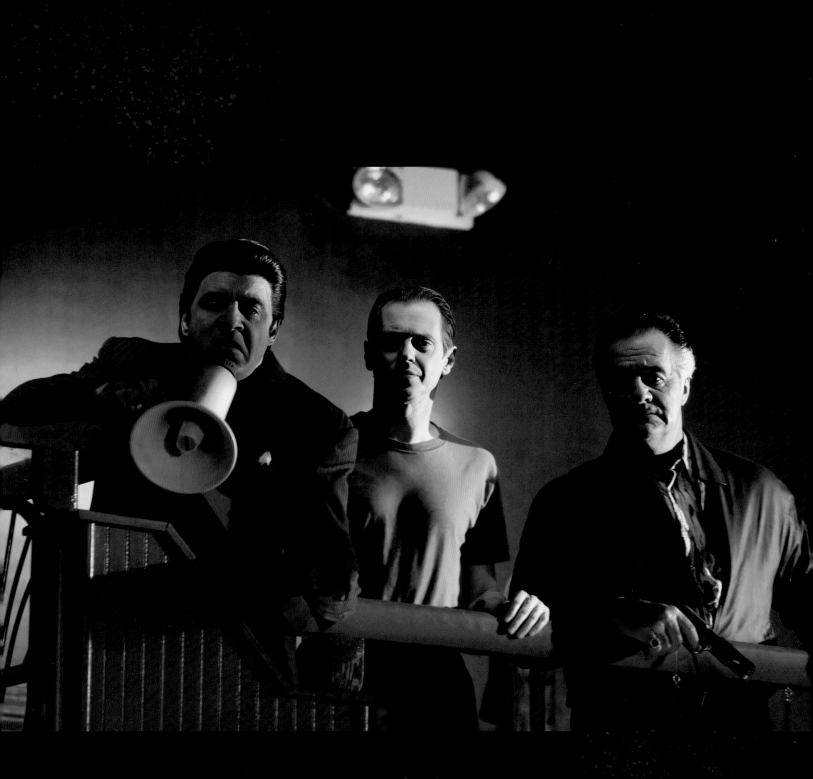

"All I know is he never had the makings of a varsity athlete."

UNCLE JUNIOR

INTRODUCTION TO SEASON FIVE

Four OGs of the DiMeo and Lupertazzi crime families are released from prison after lengthy sentences: Tony Soprano's cousin Anthony "Tony B" Blundetto (Steve Buscemi), Feech La Manna, Angelo Garepe (Joe Santos), and Phil Leotardo (Frank Vincent). Tony B's fifteen-year incarceration for the armed hijacking of a truck—a heist Tony S was supposed to be on—cost him everything. And Tony S harbors significant guilt about it. It's water under the bridge though, and Blundetto emerges from the joint looking to go straight. Despite his best intentions, a series of poor decisions derails Blundetto's plans and leads to serious consequences, requiring Tony S to make the ultimate sacrifice.

Christopher resents being low man on the totem pole and having to pay for every dinner with the guys. He continues to work on his sobriety with mixed results. He abuses Adriana verbally, emotionally, and sometimes physically—particularly after he relapses following a runaway rumor about her and Tony. Meanwhile, Adriana is barely keeping it together as she continues to be a reluctant informant for the FBI. She feels guilty and the stress makes her physically ill. When she becomes an unwitting accessory to murder following a confrontation in the club, she attempts to cover it up—an act caught on the FBI's surreptitiously placed camera in the parking lot. It only goes downhill from there.

Tony and Carmela adjust to life as separated coparents. Tony is both invigorated by his newfound freedom and wracked by loneliness and guilt, while Carmela struggles to keep A.J. motivated with school. As the Disneyland Dad, Tony feels the best way forward is with expensive gifts such as a drum set and an SUV. Carmela has a brief affair with A.J.'s school guidance counselor Robert Wegler (David Strathairn), who breaks it off just as quickly as it begins.

Junior's physical and mental health continues to decline. He's increasingly agitated and confused. His cantankerous behavior continues to irritate Tony, who is still in denial over Junior's diminishing state. Newlyweds Janice and Bobby do their best to care for Junior, but even they have trouble managing the cranky old man. Janice, meanwhile, struggles to control her explosive temper.

Key Plot Points

❋ **Old gangsters are released from prison after decades, and each one gets embroiled in family conflicts almost immediately.**

❋ **Adriana faces mounting pressure from the FBI, which takes a toll on her mental and physical health.**

❋ **Tony and Carmela adjust to life apart while trying to be civil with each other.**

❋ **The death of New York boss Carmine Lupertazzi (Tony Lip) leads to infighting within the Lupertazzi family that ultimately has a negative impact on Tony and New Jersey.**

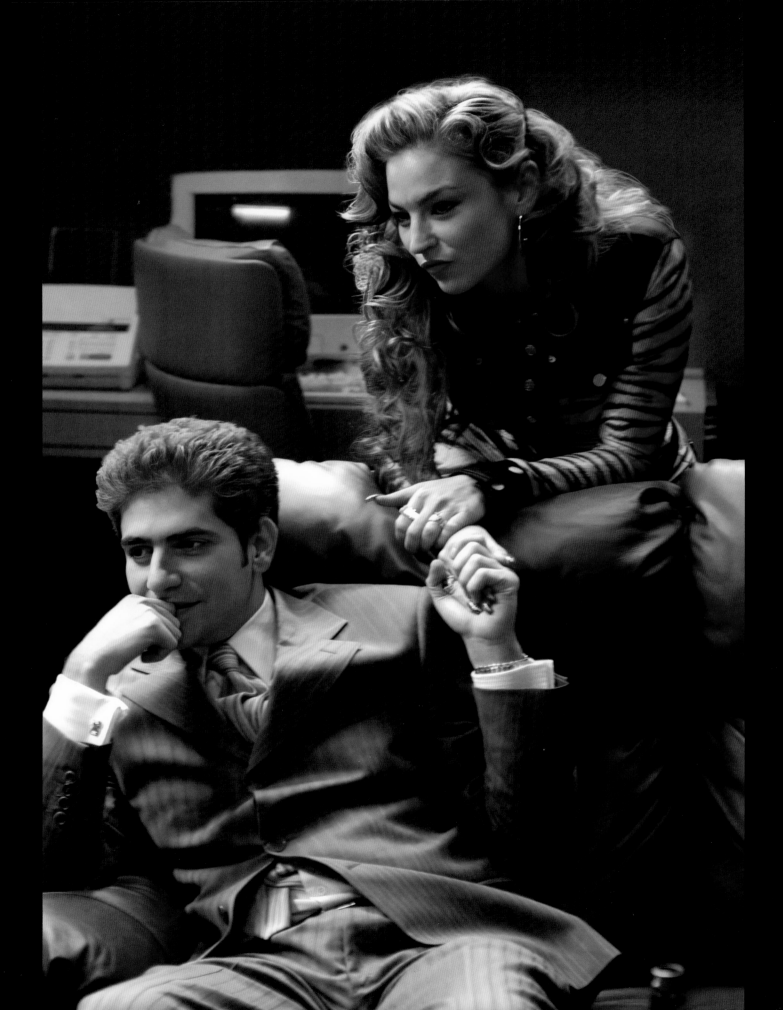

THE TIES THAT BIND

"I bristle when people say it was a mob show. Yeah, it contained the mob. But this could have been Enron. This could have been the federal government. I mean, this could have been Julius Caesar all over again. It's the human condition: it's greed, it's regrets—a lot of regret—it's power and trying not to get killed."

—Vincent Curatola

Who is Tony Soprano outside the confines of his nuclear family? Season Five explores this and more as Tony copes with a lot of unexpected changes in both his families, including his prolonged separation from his wife and the forced exile from his home, the return of his formerly incarcerated cousin Tony Blundetto, the ever-diminishing wits of his Uncle Junior, and growing tensions with the New York family. Season Five examines the topography between cause and effect, choices and consequences, and regrets and resolutions in Tony's families and relationships.

Although Tony and Carmela are separated, they remain tethered to each other. Carmela remains financially dependent on Tony, and he uses his leverage to withhold from her things she asks for, including a new coffee maker and money to pay for a tutor for A.J. At first, Tony finds it liberating to be able to come home late, or drunk, or not at all. He doesn't need to hide his mistresses anymore and can cavort with his latest goomar, Valentina, without fear of detection. When boasting to Silvio about his newfound freedom, Silvio asks, "Yeah, so what's the difference?" to which Tony feebly responds, "I dunno . . . it's the mindset." Even Tony can't downplay the humiliation his ego has suffered at the breakup of his marriage—bravado notwithstanding. The fact is, he's lost without the creature comforts of his home and his wife, so he moves in on the only other woman he thinks can fill that void: Dr. Melfi ("Two Tonys," Season Five, Episode One).

Right: After watching a scene from the movie *The Prince of Tides*, Tony attempts to put the moves on Dr. Melfi. She rebuffs his advances multiple times, which activates Tony's rage response.

Opposite: Although Tony and Carmela are separated, Tony is still a regular fixture at the family home. The couple try to get along for the sake of their children, but it isn't easy for either of them.

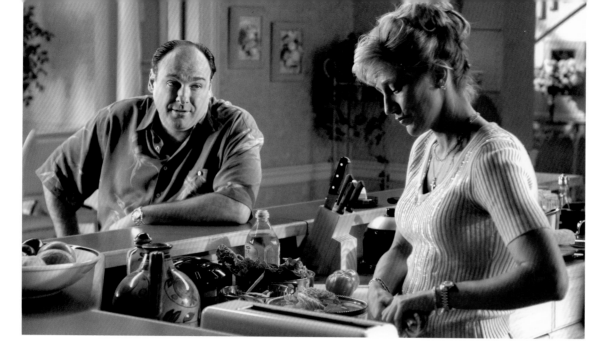

The thought occurs to him after watching a scene from the movie *The Prince of Tides* starring Barbra Streisand and Nick Nolte as psychiatrist and patient, respectively. Tony sends Dr. Melfi a bouquet of roses with a bottle of Tide detergent and a card that reads, "Thinking of you. Your Prince of Tide." From there, he mounts an aggressive campaign to persuade Dr. Melfi to date him. "Forget about the way Tony Soprano makes his way in the world. That's just to feed his children," he tells her. There are two Tony Sopranos, and he wants to show her the other one. Citing professional ethics, Dr. Melfi politely rebuffs his advances. She confides to her therapist Dr. Elliot Kupferberg that, sure she found him sexy at first, but as the years passed, she became disgusted by the ugliness of his life. Dr. Kupferberg reminds her that Tony is unpracticed in not getting what he wants and to use caution. As Tony continues to push Dr. Melfi, she takes a more forceful approach. She doesn't want to provoke him, but he is calm and measured and lulls her into a false sense of security. He wants her to be honest about the reasons she won't date him. She's reluctant, but Tony assures her that whatever it is, he can take it. Dr. Melfi lets her guard down and begins to tell Tony her real reasons, which include her

Thinking of you your Prince of Tide

inability to bear witness to the violence associated with his lifestyle. Before she's even finished her sentence, Tony explodes, curses at her, and storms out of her office, rendering her, literally, speechless.

Living apart from Carmela unravels Tony. He's drinking more, eating more, and even occasionally sniffing a line or two of cocaine. Whether he wants to face facts or not, he is forced to confront his own culpability on their split and the consequences of him being a lying, cheating spouse. Tony starts to reflect on his behavior and the impact it's had on his family—even reflecting on how he is more like his father than he'd like to admit. But back to that in a moment.

Carmela, meanwhile, uses her time away from Tony as an opportunity for self-discovery and asserting her independence. She has a brief fling with A.J.'s high school guidance counselor, Mr. Wegler, which boosts her confidence until he accuses her of using him to help give A.J. an unearned advantage at school. A.J. continues to flail, and Carmela finally hits her limit when he defies her and stays out all night in a New York City hotel to party with friends after a concert. She calls Tony in a panic when she's unable to reach A.J. by the following afternoon. When A.J. returns home, Carmela demands answers. When Carmela grabs A.J., attempting to communicate

In "Marco Polo" (Season Five, Episode Eight), Carmela throws a party for her father's seventy-fifth birthday. The event leads to a night of intimacy for Tony and Carmela but not to a reconciliation.

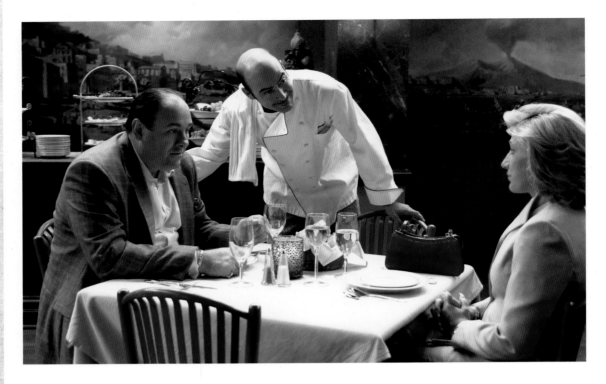

Right: In the episode "Unidentified Black Male" (Season Five, Episode Nine), Carmela asks Tony to meet her at Vesuvio for lunch so she can tell him she wants to move forward with the divorce. The news doesn't go over well with Tony.

Opposite top: A sullen and rebellious A.J. causes Carmela much grief throughout Season Five. She sends A.J. to live with Tony, but Tony doesn't coddle their son the way his mother does. Carmela allows A.J. to return home on the condition that he treat her with more respect.

Opposite bottom: Toward the end of season, Tony and Carmela reunite, and Tony moves back into the house. They celebrate with champagne and a toast over dinner.

with him, A.J. curses at her and jerks away, causing Carmela to trip and fall on the stairs. Out of options, and exasperated when Tony gives A.J. a pass, she sends the boy to live with his father ("All Happy Families," Season Five, Episode Four).

While Carmela and Tony were barely on speaking terms at the end of Season Four, they settle into basic civility with each other in Season Five. A conflicted Carmela, encouraged by her mother Mary, tells Tony it would be better if he didn't attend the surprise party that she's planning for her father Hugh's (Tom Aldredge) seventy-fifth birthday. Tony isn't pleased, but he acquiesces. When Junior spoils the surprise to Hugh, however, Hugh insists that Tony attend. The party is a success and results in a brief reconciliation between Tony and Carmela in the swimming pool. But when Tony fails to push for a permanent reconciliation, Carmela tells Tony she's moving forward with the divorce. Her attempts to retain counsel are fruitless when Tony goes behind his estranged wife's back to pollute the pool of New Jersey's top divorce attorneys. The lesson: Never try to divorce a mobster. It won't go smoothly.

Yet even after all the drama, the couple's time apart allows them the space for introspection, and their frozen hearts thaw long enough for them to realize that they need each other if they are to continue to function in their world. Ironically, the realization for Tony is perhaps fueled more by his subconscious than his mindful awareness. While staying in a suite at the Plaza Hotel, Tony has a vivid dream that concludes with a confrontation with his high school football mentor, Coach Molinaro (Charley Scalies). In the dream, Tony tries to shoot him, but the gun malfunctions and the bullets melt in his hands. What's pertinent is that the experience inspires Tony to call Carmela. "I had one of my Coach Molinaro dreams," he tells her. Presumably, Carmela is the only person in the world who understands the implications of this, and the exchange leads to a warm conversation that rekindles affection between the two ("The Test Dream," Season Five, Episode Eleven).

Not long after this, Tony and Carmela come to an agreement. She yearns to build a house on spec in partnership with her father. Tony agrees to buy land in Montville for $600,000 and put the property in her name. He also vows to do his best to ensure that his "midlife crisis won't intrude anymore" on their marriage. She allows him to move back in and they, along with A.J., celebrate the reunion with champagne over a homecooked meal ("Long Term Parking," Season Five, Episode Twelve).

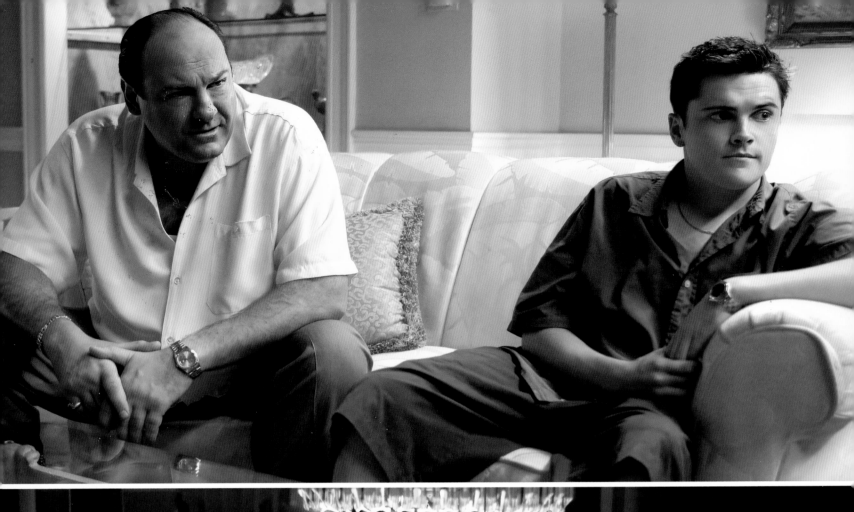
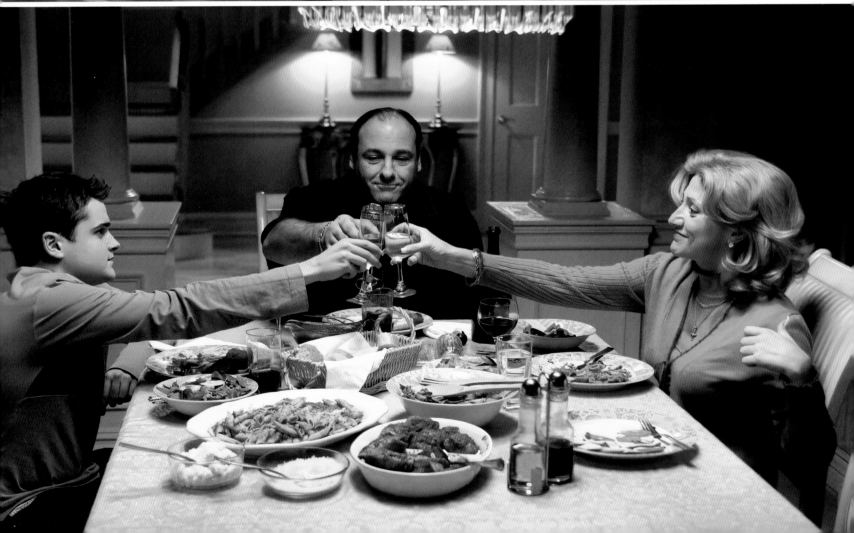

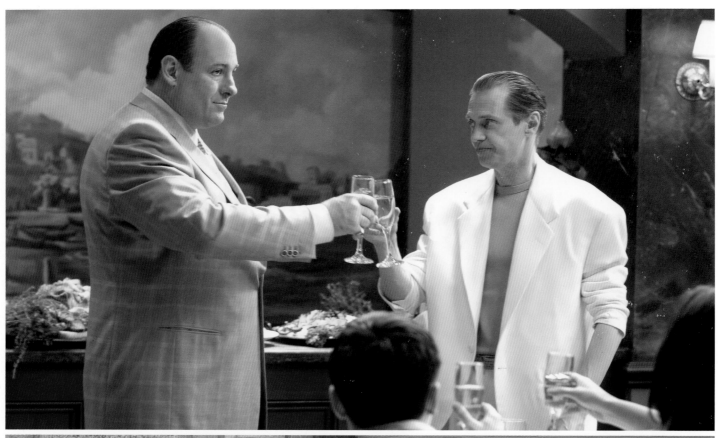

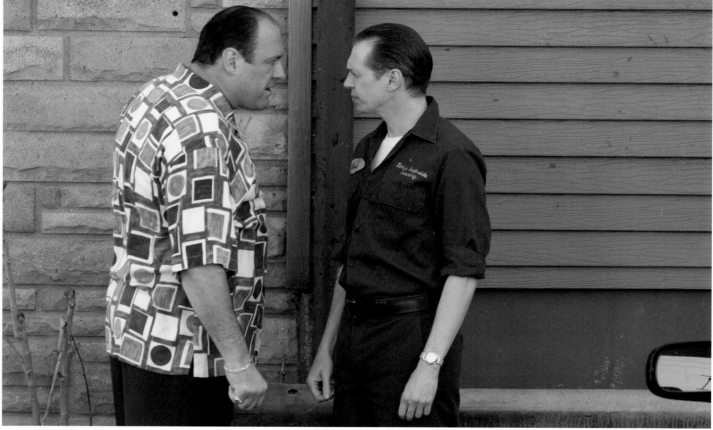

Disciples of the Old School

In the dimly lit corners of New Jersey where shadows dance with the sins of the past, Tony Blundetto's journey unfolds like a tragic symphony. He is a man with a soul weighed down by the burdens of his past, a silent observer in the chaotic world of the mob. Yet, within him lies the flicker of hope—a desire for redemption that would shape his destiny in ways he never imagined.

Anthony Blundetto, better known as "Tony B," is Tony Soprano's beloved cousin and childhood pal. When he went to prison fifteen years prior, in the '80s, he was a good earner—a rising star on par with his cousin Tony S—but not a made guy. His star is extinguished when he is arrested for a violent truck hijacking. Tony S would have been there, too, if he hadn't suffered a panic attack while arguing with his mother . . . although that's not the story he tells at the time. Too embarrassed to admit the real reason for failing to show up that night, Tony S invents a tale about being beaten up by two Black guys. It's the primary reason why Tony S harbors such guilt over what befell Blundetto,

> *"Lemme ask you something. If I really wanted to rob you, you think I would have to put up with this bullshit?"*
>
> TONY BLUNDETTO

who loses his home, family, and livelihood when he goes away. Soprano feels obligated to help Blundetto, not only because they're family, but also to assuage his guilt. It's a relationship fraught with layers.

Upon his release, Tony B returns to a world that's undergone radical changes. His cousin now reigns as the de facto boss of the family. Awkwardness permeates the interactions between the Tonys initially, especially because Tony B's humor includes passive-aggressive jokes. Tony S rebukes his cousin for poking fun at him—after all, he's the boss and must be respected. Blundetto takes it all on the chin. Though he has ample reason to feel bitter about his tragic past, he instead looks forward to a hopeful future. He has no interest in getting back into the family business. He wants to go legit as a massage therapist. Tony S doesn't like his cousin's decision, but he reluctantly respects it—he tells Christopher and Silvio that his cousin is "useless" to them. In other words, don't count on Blundetto to manage any of the family business.

At first, it looks like the stars are aligning in Tony B's favor. He finds a good woman who supports his dreams, he passes the massage therapy licensing exam, and he literally stumbles upon a stockpile of cash discarded from a car being chased by the cops. Even his boss, Sungyon Kim (Henry Yuk), a proud businessman, is willing to front him the money to open his own massage studio. Alas, once a gangster always a gangster. Tony B's resentment and jealousy of his cousin's luxurious lifestyle ultimately results in his undoing. Still, for a while there, things looked pretty good for the guy.

Feech La Manna, Angelo Garepe, and Phil Leotardo settle into life on the outside, as well. Feech was a capo in the DiMeo family before going to prison. After two decades inside, he doesn't recognize—or understand—the modern world of Mafia ethics he's been released back into. For example, he's no sooner out of prison than he's throwing his gangster weight around. He brutally

attacks a neighborhood gardener, Salvatore "Sal" Vitro (Louis Mustillo)—an acquaintance of Paulie's—and informs him that his nephew Gary La Manna is taking over the neighborhood. Paulie tries to intervene and reason with the old guy, but the conversation devolves quickly. Paulie retaliates by attacking Gary, and the entire situation leads to a sit-down with Tony, who rules the neighborhood should be divided between both guys. Feech continues to cause problems for Tony, and it all comes to a head when he boosts dozens of luxury vehicles from the lavish wedding reception of the daughter of one of Tony's wealthy friends. Tony

is reminded of Richie Aprile and recognizes that Feech is a problem that needs to be solved. He arranges for Feech to be set up to violate his parole and remanded back to prison ("All Happy Families," Sesaon Five, Episode Four). Yet just as Tony solves one problem, another is inevitably close behind. This comes in the form of the simmering tensions set in motion by the death of Carmine Lupertazzi—boss of the New York family. Tony wants to observe how things shake out from the sidelines, and he's instructed his people not to get involved. But as conflicts mount, Tony finds himself sucked into the vortex with his cousin, Tony B, in the middle of it all.

Carmine Lupertazzi leaves a mess behind when he dies of a stroke. Having not named a successor, a power struggle ensues in the New York family between Little Carmine, who believes himself the rightful heir apparent, and Johnny Sack, who thinks he's next in line to ascend to the throne. Johnny wastes no time sending a message. Lorraine "Lady Shylock" Calluzzo (Patti D'Arbanville) made weekly payments to Carmine Lupertazzi from her loansharking business. Following Carmine's death, she makes payments to Little Carmine, which infuriates Johnny. Tony tries to intervene and suggests a power-sharing situation in their family

to include Johnny, Little Carmine, and Angelo, Carmine Sr.'s former consigliere; this goes over like a lead balloon with Johnny. In the interim, Lorraine continues making payments to Little Carmine. Johnny dispatches Phil Leotardo, Billy Leotardo (Chris Caldovino), and Joey "Peeps" Peparelli (Joe Maruzzo) to kill Lorraine and her boyfriend Jason (Frank Fortunato), causing all manner of crap to hit the fan.

Little Carmine's ally, Angelo Garepe—Tony B's "ride or die" in prison—is crushed. He and Lorraine go way back. He and capo Rusty Millio want Little Carmine to take forceful action. They ask Tony B

Tony B: They used to call me Ichabod Crane.
Christopher: Who?
Tony B: Some very sorry people, that's who.

if he wants to sign on to take out Joey Peeps in retaliation for the Lorraine hit. Tony declines at first but then changes his mind—he needs the cash. Tony B takes out Joey and a girl as he's leaving a brothel. Joey's car rolls over Tony's foot. The injury leaves him limping away—a telltale sign of his involvement since a witness said the suspect had a limp ("Marco Polo," Season Five, Episode Eight). Johnny suspects Tony B was behind the hit and is out for blood. The cycle of violence that Blundetto had so wanted to avoid is back in his life. Phil and Billy murder Angelo to avenge Joey Peeps's death. In turn, Tony B takes out Billy Leotardo, which leaves Phil thirsty for revenge. Tony B lams it, while Tony S professes not to know where his cousin is hiding. But Johnny isn't buying it, and New York starts to terrorize New Jersey's younger guys, including Benny Fazio (Max Casella), and threaten Christopher. Tony S agrees to give up Tony B but asks Johnny to spare him torture. When Johnny refuses, Tony takes matters into his own hands. In what is an excruciatingly painful decision, Tony ambushes his cousin and kills him with a shotgun ("All Due Respect," Season Five, Episode Thirteen). This leaves Phil doubly incensed and filled with even more venom than before, leaving Johnny Sack to deal with the fallout.

But Johnny is clever. As cunning as he is ruthless and cold, Johnny serves as a mediator in countless disputes, and he is one of the few members of the criminal enterprise who carries the respect to successfully play both sides, allowing him to be an emissary as Tony Soprano's friend and—at least on paper—an ally of the Soprano clan, which is only possible because he grew up with Tony, Silvio, and Ralph. He carries an edge and never wants to give an inch, but he's also a brilliant strategist who is whip smart. He knows when to cut his losses and do what's in the best interest of the family, especially when it impacts him personally—he is, above all else, in the Johnny Sack business. At the end of Season Five, just as Johnny and Tony are in the process of negotiating peace in the wake of the Tony Blundetto fiasco, the FBI moves in and arrests Johnny in his driveway. Tony successfully flees, although his lawyer later informs him that he's not in the FBI's sights—yet. For now, Tony is spared.

Another close call with the Feds combined with the lessons of Tony B will play throughout the rest of the series—those being the relationships between cause and effect, choices and consequences. Blundetto's character arc serves as a poignant exploration of these ideas and brings into focus many of Tony's own struggles with personal identity and the impact of environment and upbringing on individual choice. The dismissive attitude that Tony S had to the idea that his cousin could realistically go straight speaks volumes. And yet he wonders, time and again, how his life might have been different had he not taken this path—the same path of his father—while simultaneously knowing that in the backdrop of his life, a silent clock ticks down to what is likely an inevitable end for him.

IT WAS ALWAYS GOING TO END THIS WAY

"He works so hard for you . . . and what does he get? Merciless ridicule . . . about his weight, about his model railroading."

JANICE SOPRANO

"If somebody shot my nephew, it was him himself. He's a depression case."

JUNIOR SOPRANO

"He 'Marvin Gaye'd his own nephew, the boss of this family."

VITO SPATAFORE

"I'm gonna tell you something I never told anybody. Back when Jackie was at the end, he floated the idea of me stepping up to the big seat. Not Tony. Me."

SILVIO DANTE

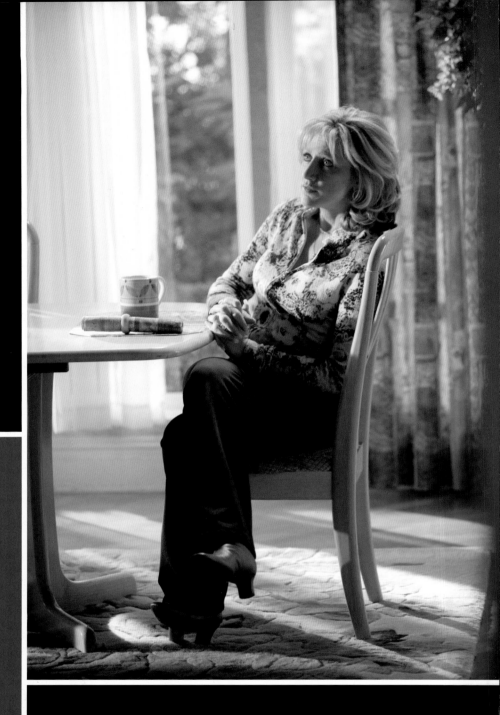

"Well, you can talk about every day being a gift and stopping to smell the roses, but regular life's got a way of picking away at it."

TONY SOPRANO

THEY SAID IT IN SEASON SIX . . .

"The minute I met Tony, I knew who that guy was. On my second date, he brought me and my mother each a dozen roses and my father a $200 power drill . . . and I don't know if I loved him in spite of it or because of it. My parents weren't like that. And I knew, whether consciously or not, I knew that behind that power drill there was probably a guy with a broken arm—or worse."

CARMELA SOPRANO

"I know this is hard for you to believe, but food may not be the answer to every problem."

A.J. SOPRANO

"You ever think what a coincidence it is that Lou Gehrig died of Lou Gehrig's disease?"

CHRISTOPHER MOLTISANTI

"I live but to serve you, my liege."

PAULIE WALNUTS

"The times make the man, honey, not the other way around."

GABRIELLA DANTE

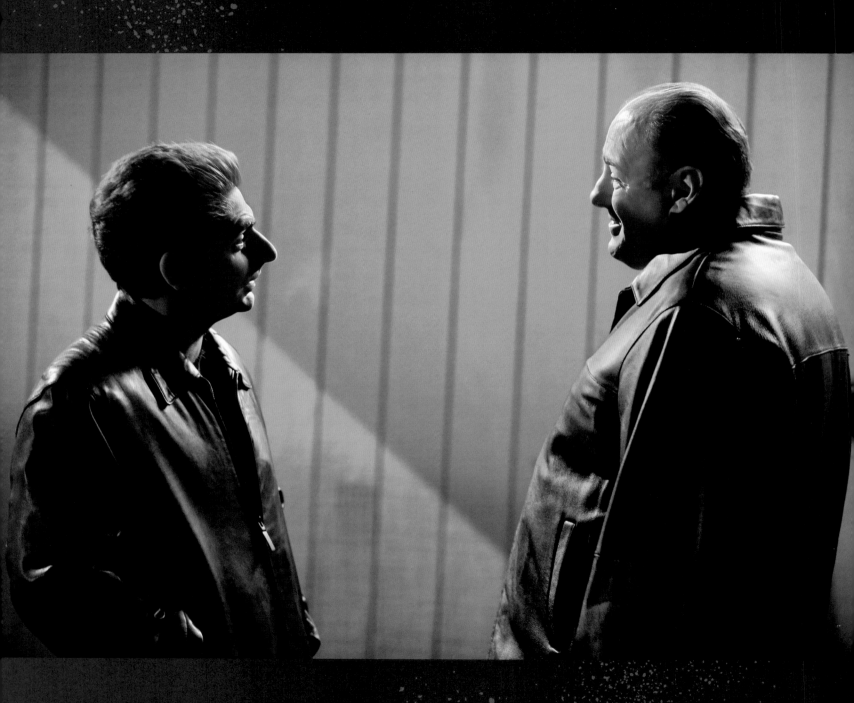

"You make your own luck in life."

TONY SOPRANO

INTRODUCTION TO SEASON SIX

Junior's mental state deteriorates to the point of delusion this season. He's got Tony digging for buried money and later, in his confused mental state, he shoots Tony in the stomach. While in a coma, Tony experiences an alternate identity. With the boss's future in the balance, Silvio does his best to keep things on track, but the buzzards begin circling. Eventually, Tony makes a full recovery but vows that Junior is dead to him.

Johnny Sack goes to prison and cuts a deal to reduce his sentence that requires him to attend an allocution hearing. Later, he succumbs to cancer—the result of his decades-long smoking habit. Phil Leotardo takes over as the boss of New York. He's driven by grudges and emotions, which makes for a deadly combination.

Meanwhile, Phil's cousin by marriage, Vito Spatafore, has a secret that doesn't jive with the beliefs of his archaic-minded crewmates. Vito lams it for a while but eventually returns to Jersey where everyone has turned on him, and a ruthless Phil is lying in wait. Phil's interference in Tony's family affairs escalates tensions.

Christopher gets married, has a baby, buys a fancy house, and makes a slasher film. But old habits die hard, and addiction once again rears its ugly head. While driving Tony, he swerves to avoid an oncoming car and rolls his SUV off an embankment. Tony extracts himself, but Christopher is trapped and gravely injured. While coughing up blood, he confesses that he'll never be able to pass a drug test. Tony is about to dial 9-1-1, but changes his mind and plugs Christopher's nose instead, allowing him to suffocate to death.

A.J. meets the love of his life, Blanca (Dania Ramirez), but when she ends the relationship, he develops a depressive disorder and attempts suicide; Tony vows to get him help. Meadow decides on a career in law and gets engaged to Patrick Parisi (Daniel Sauli), Patsy's son. Tony pays Junior a final visit and discovers his uncle is unable to recognize him or even remember his glory days as a mob boss. The New York and New Jersey families continue to clash throughout the season. Key people are injured and killed, but in this world of street justice and Mafia politics, it's not clear who emerges victorious in the end.

Key Plot Points
❋ **Tony suffers the first of several existential crises during a near-death experience.**
❋ **Christopher's last chance for happiness ends abruptly after a car accident.**
❋ **Phil becomes head of the New York family, escalating tensions with New Jersey.**
❋ **Vito Spatafore is outed as gay and pays the price for it.**
❋ **Tony and family meet for a casual dinner, but their final fate is left to the viewers' imaginations.**

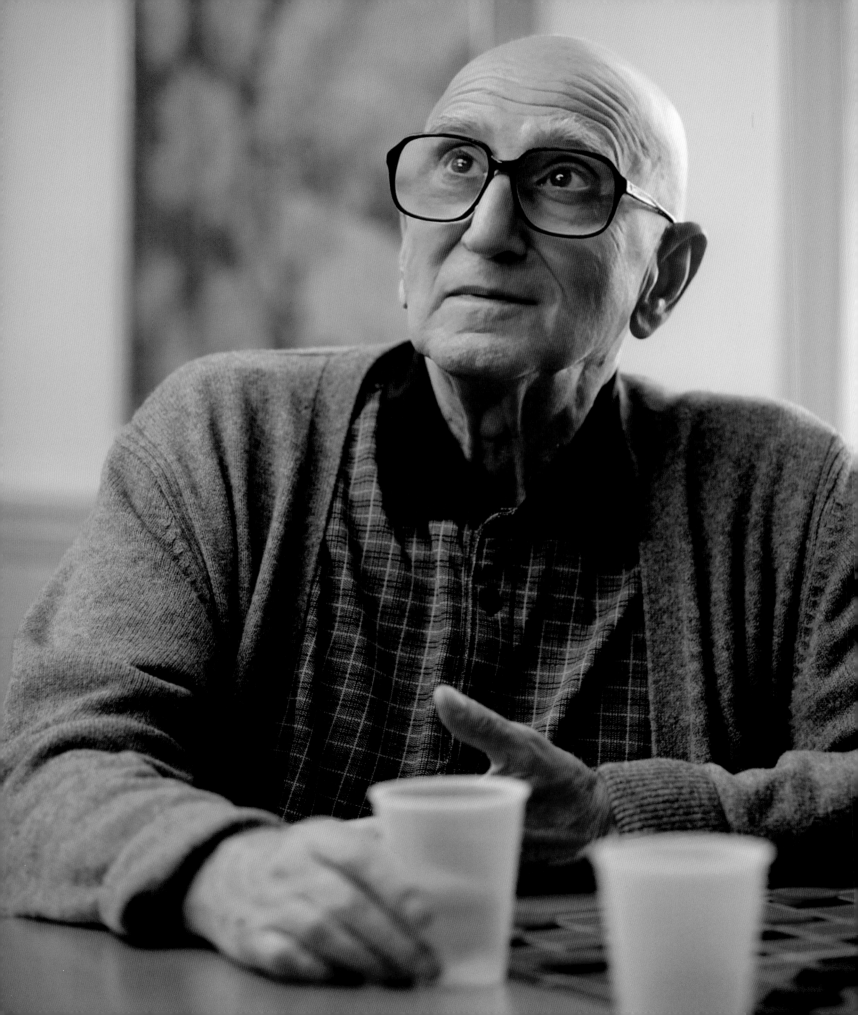

QUESTIONS OF IDENTITY

"I was reading a book . . . a true story about a mobster who had someone in his crew that was gay. And I said, 'Wow, that's kind of interesting.' It was something you didn't see—it was groundbreaking at the time. I brought it to the attention of one of the writers, who brought it to David Chase. I didn't hear anything for a year and a half. And then Season Five is when the [scene with the] security guard happened."

—Joseph R. Gannascoli on the development of his character, Vito Spatafore

Season Six finds several key characters grappling with existential questions related to identity. Tony, Junior, A.J., and Vito all find themselves in dire situations where they don't quite know who they are or where they're going.

Let's start with Tony, who faces some of the most difficult situations of his life. From barely escaping death and seeing what's left of his once-vibrant Uncle Junior to "losing" his nephew Christopher and nearly losing his own son to suicide, Tony Soprano spends most of the season moving from one chaotic situation to the next. At each turn, he is confronted with questions that force him to examine—whether consciously or not—his own identity and the choices he's made that have brought him to these places in his life. Throw in a battle with the New York family and it's just about all a mob boss can handle.

After being shot in the gut by Uncle Junior, Tony hovers in a coma between life and death. Silvio, Paulie, Christopher, and the rest of the crew hang around the hospital on pins and needles awaiting news. It's anyone's guess what will happen, and the future of the family is on the line. Carmela is distraught and fiercely loyal, unwilling to leave her husband's side. In her moments alone with him, she bears her heart—hoping and praying that somehow he's hearing her. Meadow asserts her independence, asking questions of the doctors and medical team. Even Janice properly grieves her brother's near-fatal injuries, although she still finds a way to make it about herself. A.J. continues to be a burden to an already stressed-out

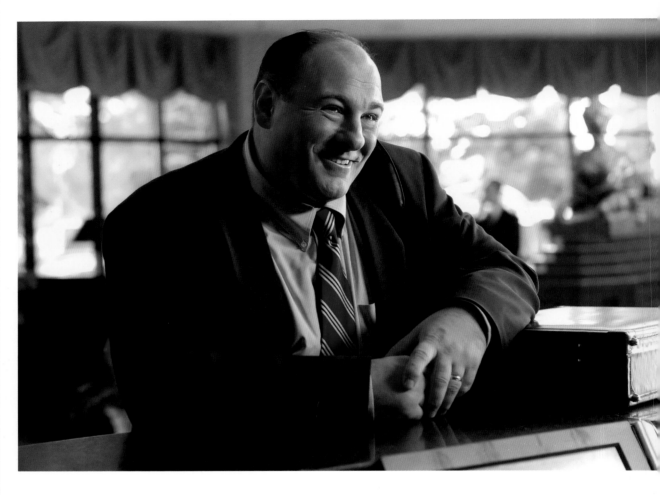

Carmela. He's so fixated on revenge that he can't be relied on to perform the simplest of tasks. He flunks out of community college, violates his mother's wishes by talking to the press, and is generally useless in doing anything outside of feeding himself. But he's also in distress—and we learn he's got a plan to take Junior out.

While the outside world continues to spin, Tony's subconscious is hard at work conjuring a different life for himself as Tony Soprano, but not *the* Tony Soprano. The story unfolds like a parallel universe. As Tony remains hospitalized in New Jersey, his alter ego—a precision optics salesman—is attending a professional convention at a hotel in Costa Mesa, California. When checking in at the convention, Tony realizes he doesn't have his wallet or ID and is carrying somebody else's suitcase—a man by the name of Kevin Finnerty, a heater salesman, from Kingman, Arizona. Kevin looks a lot like Tony. With no wallet, ID, or credit cards of his own, Tony is forced to assume

Finnerty's identity while he figures out how he's going to get home. He checks into a hotel using Finnerty's name, ID, and credit card, and he calls his wife to tell her what's transpired.

This parallel version of Tony has no mob ties. Dressed in a Brooks Brothers-style navy blue blazer and distinctive print tie, he lacks Tony Soprano's edge and hostility. He's a family man with a wife, daughter, and baby boy. When he joins some strangers for dinner, he vaguely alludes to a midlife crisis he's going through. We learn that this Tony is still prone to temptation as he and the woman he meets at dinner end up kissing in the parking lot. She tells him she could never help him scratch that itch after seeing his face when he got off the phone with his wife, and he concedes. He simply loves his wife and family too much to go further.

The alternate identity is clearly a way for Tony's subconscious to explore a life where he's mostly without sin, faithful to his wife, and a straight-up decent man with a normal job. Haunted by his

past actions and grappling with the possibility of redemption, the real Tony Soprano struggles with his identity and feelings of guilt. And his subconscious has all manner of existential questions. When he awakens from the coma for a few seconds, he rips out his breathing tube and asks, "Who am I? Where am I going?" Here, the fear embedded deep inside his subliminal mind is revealed. These are not questions the real Tony would ever utter aloud ("Join the Club," Season Six, Episode Two).

Tony's introspective journey through his psyche is laden with symbolism and the lingering question of "What if?" Is this who Tony would have been had he not been drawn into a life of crime? It's a metaphorical exploration of Tony's inner turmoil and his subconscious desire to perhaps escape the morally ambiguous universe he inhabits. In Costa Mesa, however, it all feels like a pretty dull substitute for a life. Perhaps, instead, this is the real Tony's idea of purgatory, or purga-Tony.

When coma-Tony returns to the world of "purga-Tony" after his brief moment of consciousness, he once again inhabits his parallel world. This time, a series of events unfolds that reveal even more about Tony Soprano's deepest anxieties. First, he is confronted by a pair of Buddhist monks who overhear him checking in as Finnerty. Kevin, it seems, screwed them over on a heating system for

their monastery. A scuffle ensues, even as Tony-as-Kevin swears they've got the wrong guy. We might conclude here that this is Tony's mind wrestling with the deep guilt he feels over the suicide of his goomar, Gloria. A practicing Buddhist, all Gloria asked for from Tony was kindness—*warmth*. Instead, Tony took what he wanted from her without apology. The Buddhists and their failed heating system possibly symbolize not just Gloria but all the innocents that the real Tony Soprano has deeply wounded or killed, literally and metaphorically. Later, when parallel Tony speaks to his wife on the phone, she tells him, "You're off in your own world . . . you're too distracted with work; this is partly your fault." The message is not lost on the viewer. Tony will find no redemption for his actions in this alternate reality.

Right: When he's
finally released from
the hospital, Tony does
his best to relax in his
newfound state of
gratitude for the life he
still has. It's not long
before the old Tony
bounces back up to
the surface ("The Fleshy
Part of the Thigh," Season
Six, Episode Four).

Opposite: Carmela
travels to France
where she finds herself
pondering the deeper
meaning of life and
possibly considering
what her life might
have been had she not
married Tony Soprano
("Cold Stones," Season Six,
Episode Eleven).

Next, while forced to take the stairs at his hotel, Tony slips and falls, striking his head. At the hospital, the doctor tells him he's only got a mild concussion; however, an MRI confirms early signs of Alzheimer's. The news comes as a blow, and yet we see resignation and sadness manifest as he's digesting this news. Tony tells the doctor that his name isn't even Kevin Finnerty. When the doctor asks what his name is, he responds, "What does it matter? I'm not going to know myself soon." It's as though he understands what it means to lose oneself to one's own mind—just as Junior has been lost to his—and that in the end, Tony doesn't have the control he thinks he does. He lives in fear that he, too, will one day end up like Junior, not knowing who he is, where he's going, or where he came from.

In the final "chapter" of Tony's coma saga, he's discovered an invitation in Finnerty's briefcase to the Finnerty Family Reunion at Inn at the Oaks. He decides to attend in the hopes of locating the real Kevin Finnerty. He's back in his hotel room after his stint in the hospital emergency room. He's learned he has early signs of Alzheimer's. He's also agitated because there is a loud, annoying voice in the room next to his that won't stop chattering. He pounds on the wall, yelling at it to stop. In reality, the disembodied voice is Paulie's talking incessantly at the bedside of a still comatose Tony. With Paulie's every word, coma-Tony's blood pressure begins rising like the sun; within minutes, Tony goes into cardiac arrest. Doctors and nurses rush in with the crash cart; they start the defibrillator and begin working on Tony.

Purga-Tony, meanwhile, is driving out to the reunion, thunder crashing in the background. It's a beautiful location—peaceful yet strangely ominous and unsettling. The wind is rustling in the trees and Tony swears he hears a little girl's voice calling out to "daddy." Checking in the guests is none other than Tony Blundetto—Tony Soprano's deceased cousin who is unknown to parallel-universe Tony. Tony B is pleasant, gentle, welcoming. And yet beneath it all lies something sinister. Tony B encourages purga-Tony to let go of Kevin Finnerty's briefcase—it's not allowed inside. But purga-Tony clutches it tighter in his hand, all the while fear rising within him. As he draws nearer to the brightly lit door of the inn, he strains to see who the silhouetted woman is in the doorway. We can tell from her clothing, shoes, and upswept hair that she is a generation older than Tony. Curiosity draws him in, but just as he's walking forward and about to surrender the briefcase, Tony Soprano is jolted back from his comatose state into the living, breathing world of New Jersey. Was he on the doorstep of heaven or on the precipice of hell? It's another question without an answer.

Carmela's Brush with Existentialism

In "Cold Stones" (Season Six, Episode Eleven), Carmela and Rosalie travel to Paris for vacation. For Carmela, the experience opens a portal to a new depth of feeling. Carmela has always been intrigued by art and culture, and she's searched for ways to satisfy her intellectual thirst through relationships with Father Phil and, briefly, Mr. Wegler. Generally, Carmela's lack of education and world experience has limited her capacity to connect to these things on a more profound level. Outside the boundaries of her small New Jersey life, however, Carmela sees the world anew. She drinks in her Francophile experience with almost childlike fascination.

Although Carmela longs to connect with Rosalie through more meaningful conversations, Rosalie is a simple woman with a temperament and tastes honed by a lifetime of exposure to the sights and sounds of Newark. While in a museum, they see a thirteenth-century jewel necklace, which prompts Carmela to ponder about the life of the woman who wore it. Rosalie, however, sees it as just another museum exhibit. Later, while the friends are visiting an ancient ruin, Carmela begins waxing philosophical about all the generations of people who have come and gone. "It makes you look at yourself," she says to Rosalie. She tells Rosalie about Tony's words in the hospital when he'd woken briefly from his coma—"Who am I? Where am I going?"—and says that she didn't understand what they meant until that very moment. "We worry so much," she says as she begins to sob. "Sometimes it feels like that's all we do. In the end, it all gets washed away." Rosalie comforts Carmela by giving her a hug and humming the song "La Vie en rose."

Carmela's emotional moment arises from the intrinsic recognition that she's missed out on a life that could have been very different. She grieves it and accepts it all at once. Her words—that it all gets washed away—are both a warning and a promise. They foreshadow danger and the end of life as Carmela knows it while simultaneously offering hope of a fresh start in the future.

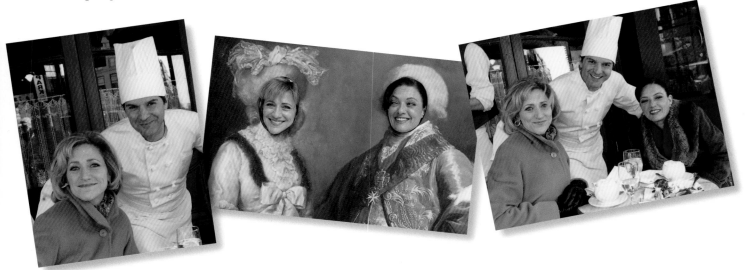

Sharon Angela as Rosalie Aprile

Sharon Angela wasn't sure how long her character would last on *The Sopranos* after her on-screen husband Jackie Aprile Sr. died early in Season One. "I'm wondering, 'What are they going to do with me?'" Angela says. "Luckily, they allowed me to stick around in Carmela's life as her friend. I'll be forever grateful that David [Chase] gave me a place."

If Angela had to guess, she believes her future on the show was cemented in her first episode, "Denial, Anger,

Acceptance" (Season One, Episode Three), when she's in the hospital room with her cancer-riddled husband Jackie. Mikey Palmice visits and tells Jackie that he needs to watch out for air in the IV line because "it'll kill ya." Rosalie assures Jackie that nothing like that will happen and gives Mikey a quick slap across the neck. "That wasn't in the script," she recalls. "I asked Al and our director [Nick Gomez] if I could slap him, and I got the go-ahead. I think David might have been impressed that I came up with that on my own."

Rosalie Aprile never had it easy. First, her husband dies; then, her brother-in-law Richie disappears. Next, she takes up with the lout Ralph Cifaretto, and then her son Jackie Jr. gets murdered. "The woman goes through a lot, but that makes it fun," Angela maintains. "She's able to fall down and get back up and just be a survivor in this world, over and over. On this show, the writing was so unbelievably good that you were able to make your choices and live in the character kind of easily." And Ro has seen it all.

Angela, who is of Italian, Irish, and Polish descent, is different enough from her character to have always made the experience interesting. "Rosalie is different from me in the sense that she's subservient," says Angela. "She was comfortable living in a world where guys rule. She plays it safe and is Catholic and all of that stuff. Cooking made her happy. But still, Rosalie had a gangster kind of quality that if you fucked with her, or fucked with her children or friends or family, she'll go after you. That was the fun part. It's really not me."

In so many ways, it was a dream-come-true gig for Angela. "My goal as an actress was to have my work respected, and this show made that happen. I'm just proud to be associated with *The Sopranos*. It's like a great song or a great painting or any great art. It stands the test of time in the sense you can always watch it again and see something new. Every generation gets to appreciate it all over again."

Vito's Secret

It turns out that in the mob, or at least the version depicted in *The Sopranos,* there are two behaviors for which there is no redemption: being a rat and being gay. This was the dilemma faced by Vito Spatafore, who kept his secret life as a gay man well hidden. He understood that being out in his world would not be well-received by either his wife Marie (Elizabeth Bracco) or the family. And though Vito tried to avoid discovery, a secret like that is bound to be exposed—particularly when you're caught in a gay nightclub wearing a leather vest and chaps. When his double life is revealed, things predictably don't go well for the mobster.

Mind you, Vito is a deeply respected member in the DiMeo crime family. He's a high earner who produces thick envelopes of cash, the most visible marker of success with this clan. But that mattered little after he was caught one night dancing provocatively at a gay club by a Lupertazzi wiseguy named Sal (Jimmy Smagula), who was there making a collection.

Technically, the cat is already out of the bag. When Meadow's boyfriend Finn Detrolio shows up early one morning to the construction site, he sees Vito performing oral sex on another man. This leads to Vito trying to bribe, and then threaten, Finn into silence ("Unidentified Black Males," Season Five, Episode Nine). But once word is officially out on the street, Vito grabs cash and disappears into the night. He goes into hiding in New Hampshire under the alias "Vince" where he meets and falls for a gay short-order cook and volunteer fireman named Jim Witowski (John Costelloe). Vito and Jim live together for a short time with Jim helping "Vince" land work as a handyman, but that mundane life quickly grows tiresome for Vito.

Despite the stakes, Vito returns to New Jersey, hoping against hope to resume his life. He arranges to run into Tony at a mall while his brother Bryan (Vincent Orofino) keeps watch. Vito tries to explain away his activity as an aberration caused by medication. He then offers Tony $200,000 to buy his way back into the family. He's willing to run drugs and girls in Atlantic City, out of the spotlight. Tony feels ambushed and leaves without giving Vito an answer. He knows that Phil Leotardo, Vito's cousin by marriage, is already gunning for him for the shame Vito has purportedly brought down on the family. Tony orders a hit on Vito to rid himself of the problem, but Phil and his goons get to Vito first. When Vito returns to his motel room later that night, Phil is waiting for him. Phil tells him he's a disgrace to self-respecting organized criminals everywhere and brutally beats Vito to death. It's yet another tragic ending in a long line of tragic endings the show is known for ("Cold Stones," Season Six, Episode Eleven).

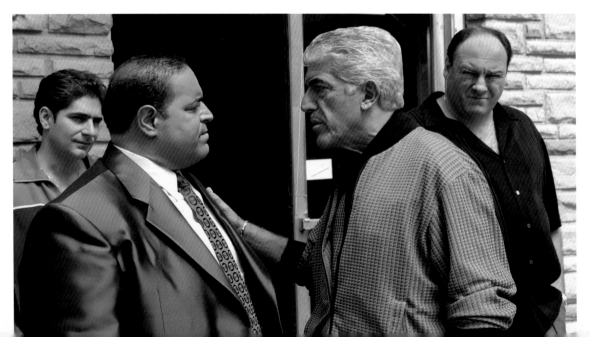

Vito Spatafore's weight loss has given him a boost of confidence; however, he's harboring a secret that he never expected to get out.

Joseph R. Gannascoli as
Vito Spatafore

For Joseph R. Gannascoli, who so memorably portrayed made guy Vito Spatafore, it's always been about hustling. He hustled to become a renowned chef in New York City. He's hustled to do cooking and catering for private events. And he hustled to make a name for himself on the show. So, it's no surprise that when his big breakthrough on *The Sopranos* came, it was Gannascoli's own hustle that made it happen.

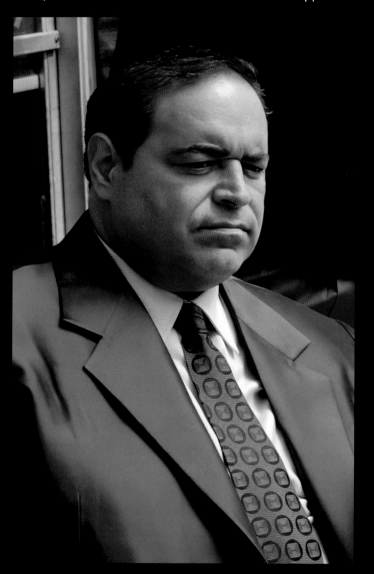

He'd already had a few scenes, including killing Jackie Aprile Jr., in Season Three but, by his own admission, he was looking for something special to really make his mark. Gannascoli had read a nonfiction book about a mobster who had a gay guy in his crew. He took the idea to the writers, who in turn presented it to David Chase—but there was radio silence for more than a year. At that point, Gannascoli didn't get full scripts in advance. He relied on a crew member for insider info.

"One week I asked him, 'Do I have anything in the next script?' and he's like, 'Oh yeah, I forgot to tell you—you're going to be blowing a guy,'" Gannascoli says. "And I freaked out because—first of all—they're going to fucking do it. Second, it's not exactly what I had in mind. Three, I'm thinking, 'Oh my God, my fucking friends are going to break my balls forever.' Four, I know real wiseguys. How are they going to take it?" That's when reality set in for Gannascoli. "At the first read-through, Jimmy [Gandolfini] took me aside and said, 'Look, if you have a problem doing this or don't feel comfortable, we'll go talk to David.' But I told him, 'I asked for it. I'm on the wrong end of this blow job, but I want to do it.'"

The scene takes place at a construction site and is shown from Finn's point of view. Finn arrives to the site early, parks his car, and glances over to see a security guard in the driver's side of a truck who appears to be sleeping. But then Vito suddenly raises his head from the guy's lap. The day after the episode aired, "Everybody was talking about it," says Gannascoli. From there, Vito's storyline kicked in, and the actor's profile on the show soared. Gannascoli shares, "[Producers] said, 'You'll see.' They told me, 'Get ready, you're going to have a big year.' And that's exactly what happened. And it changed my life."

to uncover meaning in his own existence but struggles to find it. He's not tough like his father, he's not driven entirely by material wealth like his mother, he's not a successful, ambitious student like his sister. He doesn't know where he fits in.

The fact that A.J.'s suicide attempt takes place in the pool brings Carmela's words in France back into focus: "Everything just washes away." Had A.J. succeeded, his life would have been washed away; however, submersion in water also represents rebirth and the washing away of sins. In the final episode of the series, A.J.'s SUV catches fire when it's parked on a pile of dead leaves. He later tells his therapist that watching his car become engulfed in flames made him feel "cleansed." Does the pool ultimately cleanse A.J. of his father's sins and release his burden of growing up a Soprano? Or will the curse of the putrid Soprano gene metastasize in A.J. and lead him down a darker path? We will never truly know.

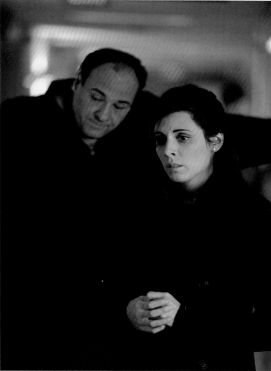

Junior (points in recognition): We used to play catch.

Tony: You don't remember that you shot me?

Junior looks away, uncomprehending.

Tony: All right, enough with the fuckin' birds. I'm Anthony, Johnny's son!

Junior: Fuck you want, a boutonniere?

Tony turns in disgust before coming up and sitting next to him.

Tony: All right, listen to me. Uncle Pat came to see me. About Janice. About your money.

Junior: People keep askin' me. I don't know. There's a man from another galaxy that came here.

Tony: That's your accountant.

Junior: I'm confused.

Junior looks tortured and frightened.

Tony: Any money should go to Bobby Bacala's kids. Now Janice may not do that. But Bobby was with us. He's a made guy. Wouldn't be right.

Junior: Me, I never had kids.

Tony: You remember where your stash is, you let Uncle Pat know. Me, as the head of the family, I'll hold onto it as a guardian for Bobby's kids.

Junior nods but stares blankly.

Tony: You remember Bobby?

Junior: Sure!

Junior: I was involved with that?

Tony: You and my dad. You two ran North Jersey.

Junior: We did?

Tony: Yeah.

Junior: Hmm. Well, that's nice.

Junior stares off again into space. Tony, now fighting back tears, lets a few seconds pass before rising from his chair and walking out.

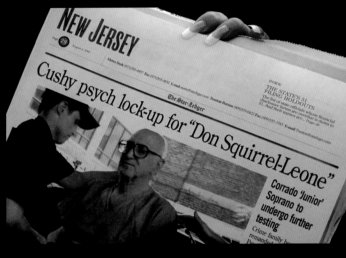

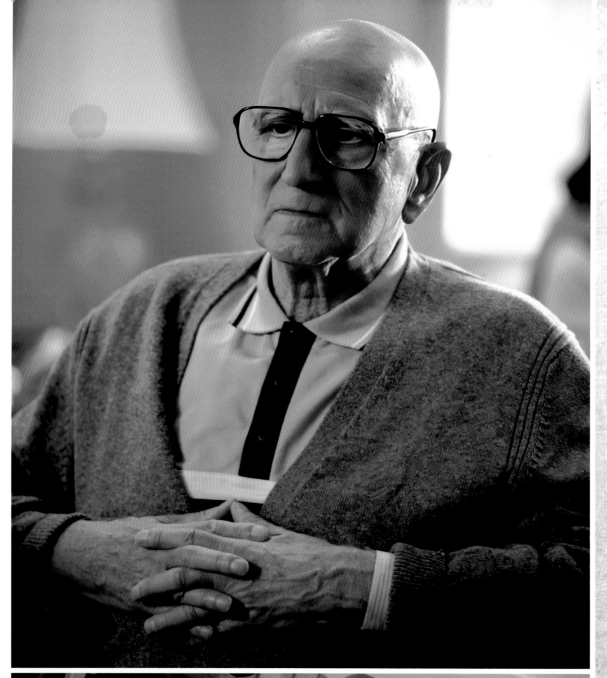

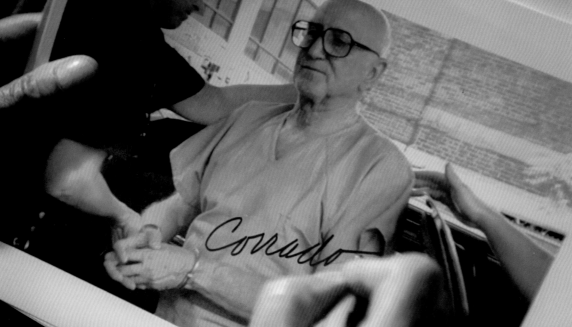

Top: Junior tries to run a racket from within the walls of the psychiatric facility, but it doesn't take long before his doctor changes his medication, which makes him lethargic and less prone to anger and violence.

Bottom: Junior signs a photograph of his arrest for an orderly in the hospital, who plans to resell it on eBay for a profit.

Everything Comes to an End

These are the very words that Carmela says to Tony at the start of Season Five. They foreshadow events in the penultimate and final episodes of *The Sopranos:* "Blue Comet" (Season Six, Episode Twenty) and "Made in America" (Season Six, Episode Twenty-One).

By the time we arrive to the twentieth episode, New York and New Jersey are in an all-out war. Phil is proving to be the most ruthless of all the Lupertazzi family bosses. Which family will emerge victorious is anyone's guess.

Phil orders that the top DiMeo guys—Tony, Silvio, and Bobby—be taken out to pave the way

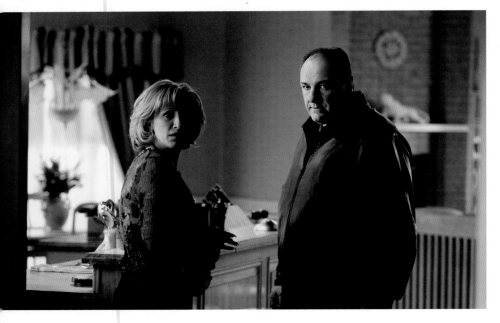

for New York to take over New Jersey. FBI Agent Harris, who is no longer working organized crime and has become something of Tony's frenemy, warns Tony that Phil has issued hits on him and his top brass. Tony orders in reinforcements from Italy to take out Phil, but a case of mistaken identity results in the hit being taken on Phil's goomar and her father instead. The mishap has dire consequences. Phil is one step ahead and already in hiding. Tony orders everyone to watch their backs while he and Silvio prepare to go into hiding.

Silvio and Patsy call Bobby to warn him, but Bobby leaves his cell phone in his car while he's inside a model train store buying a rare and expensive train car called the Blue Comet. As the scene unfolds, we can feel the tension build as the sound of a model train chugs around a track in the middle of the store. As the train circles around, the camera flashes to the miniature world inside the train track where the faces of tiny people figurines are contorted in horror. Two gunmen enter the shop and unload a barrage of bullets into Bobby. Bobby collapses on the model train setup, which crashes down under the weight of his body. It's the end of the line for the gentle giant who won viewers' hearts with his calm nature. As Silvio and Patsy are leaving the Bada Bing, they get ambushed. Patsy gets away, but Silvio has no such luck. He's shot multiple times and the next time we see him

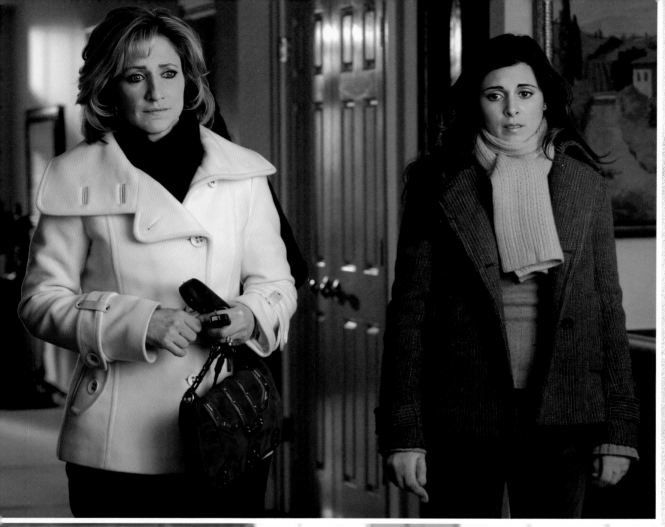

Opposite bottom: In "Blue Comet" (Season Six, Episode Twenty), Carmela learns that Bobby is dead and Silvio is in the hospital, after Phil Leotardo issued hits on Tony, Silvio, and Bobby. The Soprano family is forced into hiding as a result.

Carmela and Meadow pay a visit to a stunned and grief-stricken Janice after hearing the devastating news.

he is in a coma in the hospital. He is unlikely to return to a full state of consciousness. Tony gets Carmela and A.J. to safety and then Tony goes to a safehouse to wait it out until Tony's guys can get to Phil in this deadly game of cat and mouse.

The finale, "Made in America," may be the most famous (and infamous) series wrap-up in TV history, complete with a last scene that's been dissected frame-by-frame like the Zapruder film. It's the eighty-sixth episode of the show, written and directed by series creator David Chase, and it predictably finds a lot of things wrapping up while other stuff remains forever ambiguous and unexplained by design.

As the installment kicks off, Tony remains in hiding with his crew. With a little inside information from FBI Agent Harris, Tony tracks down Phil at a gas station on Long Island. Tony sends his guys to

take him out, and Phil meets his end memorably. While leaning through the passenger window of his car while he's talking to his wife, he's executed with a bullet to the brain. His two grandkids sit in their rear car seats, comfy and clueless. Phil's wife panics and jumps out of the car to check on her husband, but she leaves the car in drive. While she's screaming and jogging alongside the car, it rolls over Phil's head. With Phil out of the picture, the Sopranos can resume their normal lives, which have been rocked substantially through the loss of Bobby and the state of Silvio.

Carlo Gervasi (Arthur J. Nascarella) is suddenly missing, and Paulie suspects he's become an informant after his son Jason is arrested on a narcotics charge. With Carlo poised to testify, Tony will be indicted. Things are beginning to close in on Tony. He asks Paulie to step up to captain of

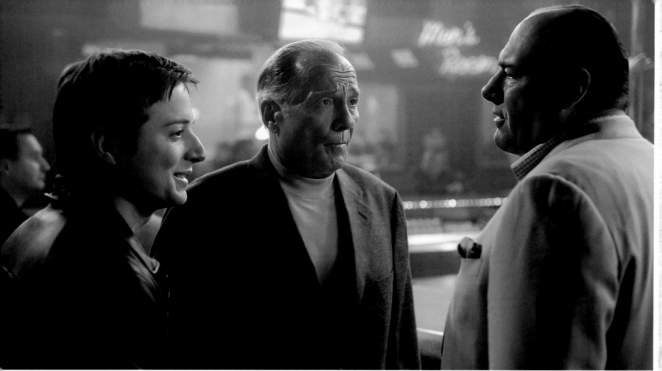

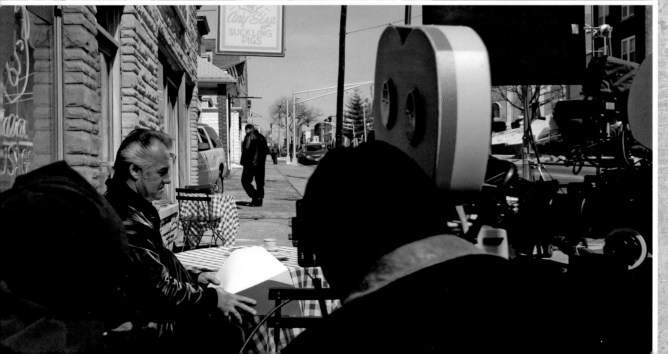

Opposite: Show creator David Chase and crew members set up the scene where Phil's head gets crushed by his SUV after he is shot in the episode "Made in America" (Season Six, Episode Twenty-One).

Top: Jason Gervasi (Joe Perrino) and his father Carlo shoot the breeze with Tony at the Bada Bing. When Jason gets arrested on drug charges, Carlo becomes an FBI informant to help keep his son out of jail.

Middle: After some convincing, Paulie agrees to take over the Aprile crew as captain. His story comes to a close in Season Six with him sunning himself in front of Satriale's. The message here might very well be that Paulie Gualtieri survives the reign of terror from New York, and that for him, life goes on as usual.

Bottom: The crew shoots Tony Sirico's final scene of the series as Paulie Walnuts.

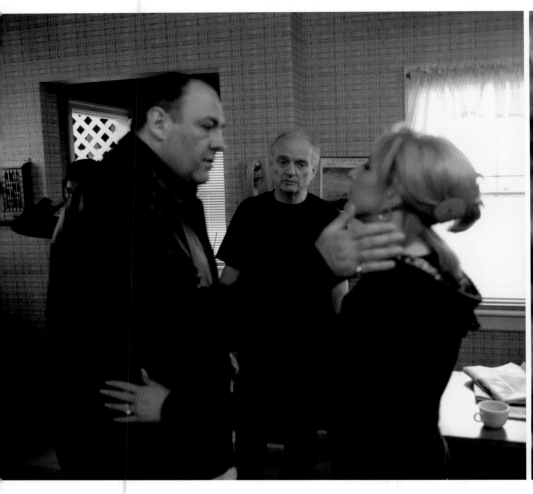

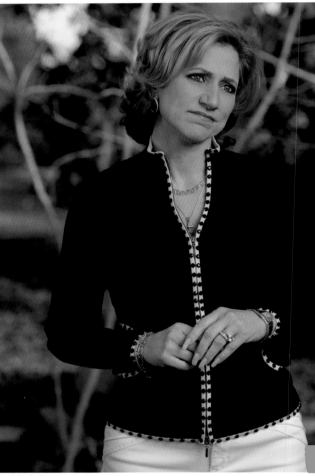

As Tony flips through the jukebox in the final moments of the series finale, the song titles read like his epitaph; however, the final two songs, "Don't Stop Believin'" and "Any Way You Want It" by Journey feel more like messages for the audience. The ambiguity of the ending leaves the door open for us to decide the fate of Tony Soprano.

A.J.: Right, focus on the good times.
Tony: Don't be sarcastic.
A.J.: Isn't that what you said one time? Try to remember the times that were good?
Tony: I did?
A.J.: Yeah.
Tony: Well, it's true, I guess.

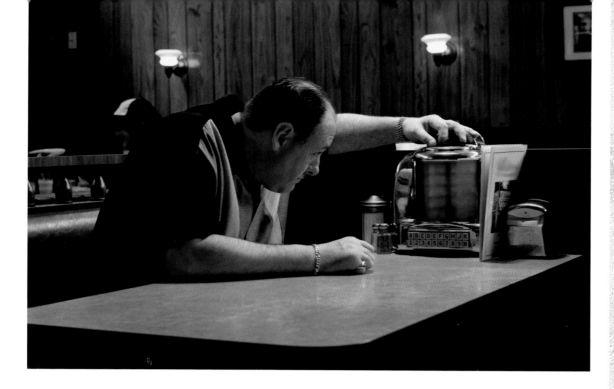

the Aprile crew. While Paulie is reluctant at first, he relents when Tony says that he's going to offer the job to Patsy.

With Tony's world in chaos, the family agrees to meet at Holsten's diner. It begins with a resigned and lethargic-looking Tony entering the eatery by himself. He sits down and flips through the pages on the tabletop jukebox. The songs include "Somewhere in the Night" by Sawyer Brown, "Those Were the Days" by Mary Hopkin, "Only the Strong Survive" by Jerry Butler, and "Victim of Love" by Bryan Adams—every title seeming to have a connection to Tony's ultimate fate while he's seated at that red booth.

There's also "This Magic Moment" by Jay and the Americans and both "Crystal Blue Persuasion" and "I'm Alive" by Tommy James & the Shondells. Tony finally stops on "Don't Stop Believin'" by Journey, inserts his coin, and plays it.

Every time someone enters the diner, a bell chimes on the door, capturing Tony's eye. The first time, it's an older guy sporting a USA cap. The next time, it's Carmela who walks in wearing a smile. We spy a young couple flirting while eating burgers and fries. There's an older guy at a neighboring booth with three Cub Scouts. None of these people are paying a lick of attention to Tony and Carmela.

Tony and Carmela eye the menu together. She mentions that A.J. is en route but that Meadow will be a bit late—she was at the doctor switching her birth control. We'd already learned earlier that Meadow and Patrick Parisi were engaged. Tony tells Carmela that Carlo is going to testify.

Just then, an average-looking dude in a Members Only jacket (Paolo Colandrea) strides in purposefully with A.J. just behind. A.J. sits down and Members Only has a seat at the counter. He glances over at Tony's booth, tapping his fingers.

The scene then shifts to outside the restaurant, where we see Meadow having some trouble parallel parking. She has to repeat the exercise several times with attendant angst.

Back inside the diner, sodas arrive for Tony, Carmela, and A.J. Members Only looks over again. He stirs his coffee and acts twitchy. After some more small talk, Members Only heads to the bathroom. A couple of young guys come into the diner, but they're eyeing a display case and seem to have no interest in Tony. It feels like a red herring.

Onion rings arrive at the table, and the family begins to chow down. Meadow is shown finally maneuvering her car into the spot and exiting her car, moving swiftly toward the diner front door. The bell on the door chimes again. Tony looks up. The picture abruptly goes black for ten seconds. The end.

Cue the controversy.

Opposite top left:
James Gandolfini, David Chase, and Edie Falco on set of *The Sopranos* during filming of the final episode of the series.

Opposite top right:
Carmela finds Tony in the backyard to tell him that they'll be going to Holsten's for dinner.

After coming out of hiding, the Sopranos meet for dinner at Holsten's diner. In this now-famous scene, Tony flips through the pages of the tabletop jukebox while awaiting the arrival of his family.

WELCOME TO SOPRANOSLAND

The pall of doom that hangs over *The Sopranos* darkens as the series progresses. But New Jersey stays the same as it was at the start. Its infrastructure, economy, and social dynamics play pivotal roles in driving the intersecting storylines forward. Whether it is the construction projects that fuel mob profits, the suburban neighborhoods that shelter Tony's family, or the cultural institutions that shape their identities, the state exerts its influence at every turn. Beyond that, the characters' speech patterns, mannerisms, and attitudes are all distinctly New Jersey. It's also where their traditional values often clash with modernity. New Jersey adds layers of depth, texture, and nuance to the narrative that demonstrate the innumerable ways this is more than just a place to live and work. It's also very much a state of mind.

Series filming takes place all over the state—and we do mean all over. In alphabetical order, key locations include Atlantic City, Belleville, Bloomfield, Boonton, Clifton, East Brunswick, East Rutherford, Fort Lee, Garfield, Harrison, Kearny, Lodi, Lyndhurst, Newark, North Arlington, North Bergen, and North Caldwell. In this chapter, we explore some of the key locations in *The Sopranos* and their significance to the series and storylines.

The tour begins with the start of the now iconic tune "Woke Up This Morning" from Alabama 3 as Tony drives from Manhattan to his affluent suburban home via the New Jersey Turnpike. A brief glimpse of the Twin Towers, pre-September 2001, and the Statue of Liberty punctuate the first few seconds as other fleeting sights whiz by during the drive. Tony snaps a turnpike ticket from its dispenser and keeps moving as we spot the Old Hydro-Pruf chemical factory; Wilson's Carpet and Furniture with its big carpet-clutching Paul Bunyon-esque statue in front, located at 220 Broadway in Jersey City (now a marijuana dispensary); the "Drive Safely" storage tank at the Bayway Refinery near Linden; the Pulaski Savings building in Harrison; Satriale's Pork Store, which in the opening credits in the pilot was an actual butcher shop in Elizabeth, but thereafter was a vacant storefront on a commercial street at 1201 Kearny Avenue in Kearny; and Pizza Land (or "Pizzaland" as it reads on the front of the tiny shack) at 260 Belleville Turnpike in North Arlington. We then hit the upscale residential neighborhood where Tony and his family live.

Soprano Family Home

Located in North Caldwell, the Soprano family home is a real home in an upscale suburb. In early 2024, Sotheby's listed one seven-bedroom, eleven-bath mansion for $5.7 million, and many others were in the $2 million-plus range. Tony and family, as we always suspected, were living high on that hog.

Built in 1987, the 5,600-square-foot McMansion sat at the end of a cul-de-sac atop a hill, which makes it easier for Tony to spot potential enemies and FBI agents as he walks down the driveway every morning to get his copy of the *The Star-Ledger*. The pilot episode was filmed inside the house, which wound up proving too disruptive for the home's real owners. In subsequent episodes, all indoor scenes were filmed on a meticulously recreated replica set at Silvercup Studios in New York. Outside scenes were shot on the actual property.

The Soprano home is the center of the family's universe and often the location where its biggest challenges unfold. It's where Tony has panic attacks and secret basement discussions; where Carmela grapples with her suspicions, uncertainties, and desires; where Meadow exercises her independence; and where A.J. generally struggles to find direction in life. Anxiety permeates its walls, and family dinners often devolve into arguments. Even when things are calm, an undercurrent of stress pulsates through the air. After all, one never knows when Tony will lose his temper and pull a phone out of the wall.

Outside, a long driveway leads up to the manse perched on a small hill. In the backyard, a swimming pool and ample outdoor entertainment spaces are the setting for many a BBQ. Step inside the foyer, and guests are treated to a loggia and great room, while the kitchen adjoins a breakfast nook and step-down family room. The formal dining room, also accessible from the kitchen, features French double doors. The entire dwelling is done up in traditional décor that is at times garish in its choices of wall art, decorative Corinthian columns, and heavy-duty window treatments. Carmela treasures her $5,000-a-pop Lladró porcelain figurines with the same level of enthusiasm she does any of her swanky jewels.

The adults who live in the house treat the space like their palace. The children, on the other hand, have no such reverence for the place. To them, it's where they're emotionally imprisoned by clueless parents they look to defy at every turn. Both kids give the impression they would rather be anywhere but there.

In 2019, the real home was listed for $3.4 million. It's unclear whether it sold. Tourists evidently still like to stop at the home wearing a bathrobe; they pick up a newspaper, get back in the car, and leave.

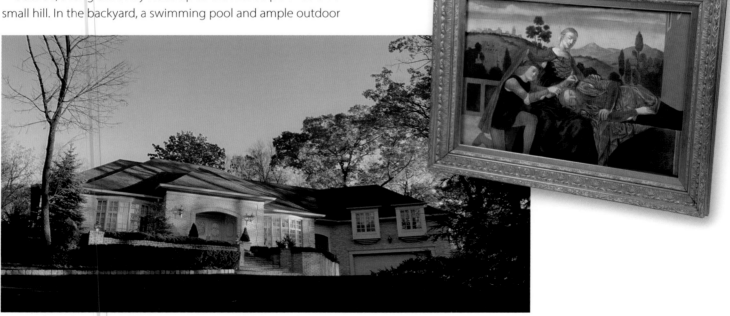

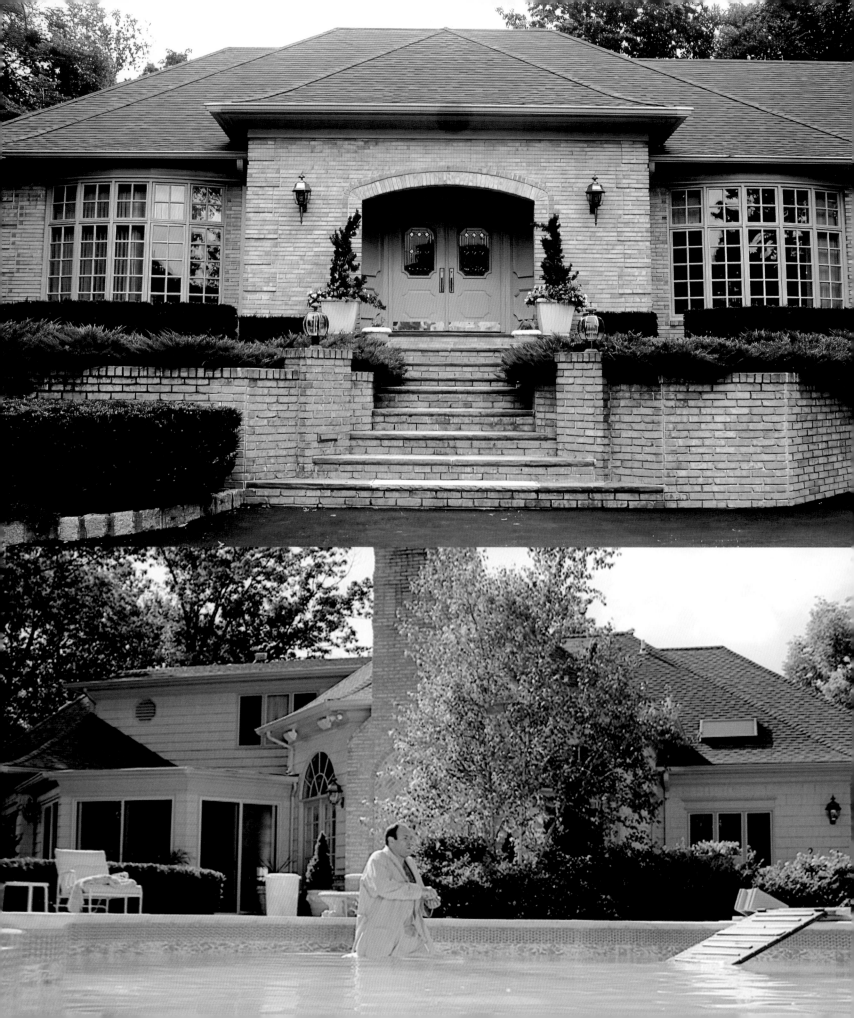

Satriale's Pork Store

Satriale's Pork Store in Kearny, New Jersey, has a long, in[...] history in the DiMeo crime family. Originally owned an[...] managed by butcher Francis Satriale, the place fell int[...] hands of Johnny Boy Soprano in the early 1970s when [...] failed to make payments on a gambling debt. Legen[...] that Johnny chopped off Satriale's pinky finger while [...] Soprano held him down in the backroom. Shortly thereafter, Johnny took over management of the business, and Francis committed suicide.

Now owned by Tony Soprano, Satriale's is both a social club and meeting point for members of the crew. It sells a mouth-watering variety of meats, pork, and sausage as well as deli-style sandwiches, pastries, and espresso. FBI Agent Dwight Harris loves their veal parmesan sandwiches.

[...]
Cucci) from the New Yo[...]
Vito in Season Six, it is in that same back room [...] Carlo throw him a fatal beating with a carving knife.

In real life, Satriale's was a vacant storefront located at 1201 Kearny Avenue. Alas, the real building was demolished once the series ended.

The Bada Bing

Official HBO Licensed Product © 2024 Home Box Office, Inc. All Rights Reserved.

A lot can happen in a strip club. Just ask Silv[...] [...] died. consigliere and owner of the Bada Bing on [...] [...] soccer coach Jersey. A Bergen County staple, it houses or[...] while also serving as a legitimate business [...] [...]prile whacked. play pool, suck down gallons of alcohol, an[...] [...] Pussy is wearing the entertainment. They also host a lot of "[...] [...] he is. prison" parties and gambling in the VIP ro[...] [...]d. (They know meetings take place at the Bing—both in[...] parking lot. And after hours, it's a g[...] [...] gay, but Tony is up and get some sleep after whacking someone, [...] like Tony and Christopher do after taking out Ralph Cifaretto.

Some crucial moments that have taken place here include the time Ralph Cifaretto hit Georgie in the eye with a chain and padlock, only to later beat his dancer girlfriend Tracee to death. The Bing is also where Christopher threatens Tony with a gun for allegedly hooking up with his fiancée Adriana. And Silvio is shot in the parking lot on a hit ordered by Phil Leotardo, resulting in his hospitalization in critical condition. Here are some other key moments that have happened at the Bing:

• Tony orders a hit on Phil Leo[...]

So yeah, the Bing is where the action is. But if you're on iffy terms with any member of your crew, it's a place best avoided.

The Bada Bing is a real-life club called Satin Dolls, which may be one reason why it looked so quintessentially sleazy. The stripper poles and lap-dance stations were real. The only real difference was the facade during the run of the show although today it proudly displays a second sign beneath its main business sign: "Home of the Original Bada Bing!" Today, Satin Dolls still draws plenty of fans looking for the authentic strip-club experience of *The Sopranos*.

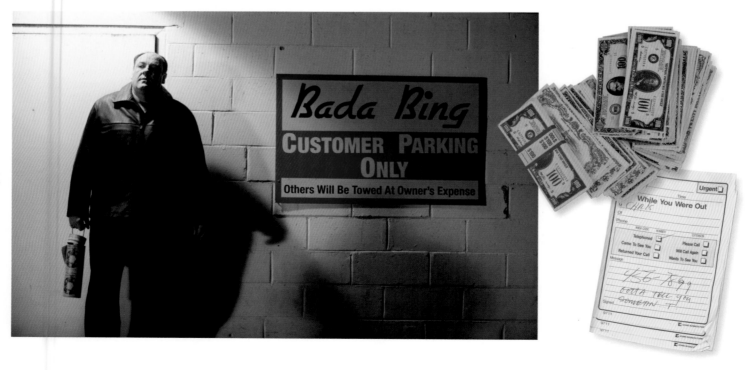

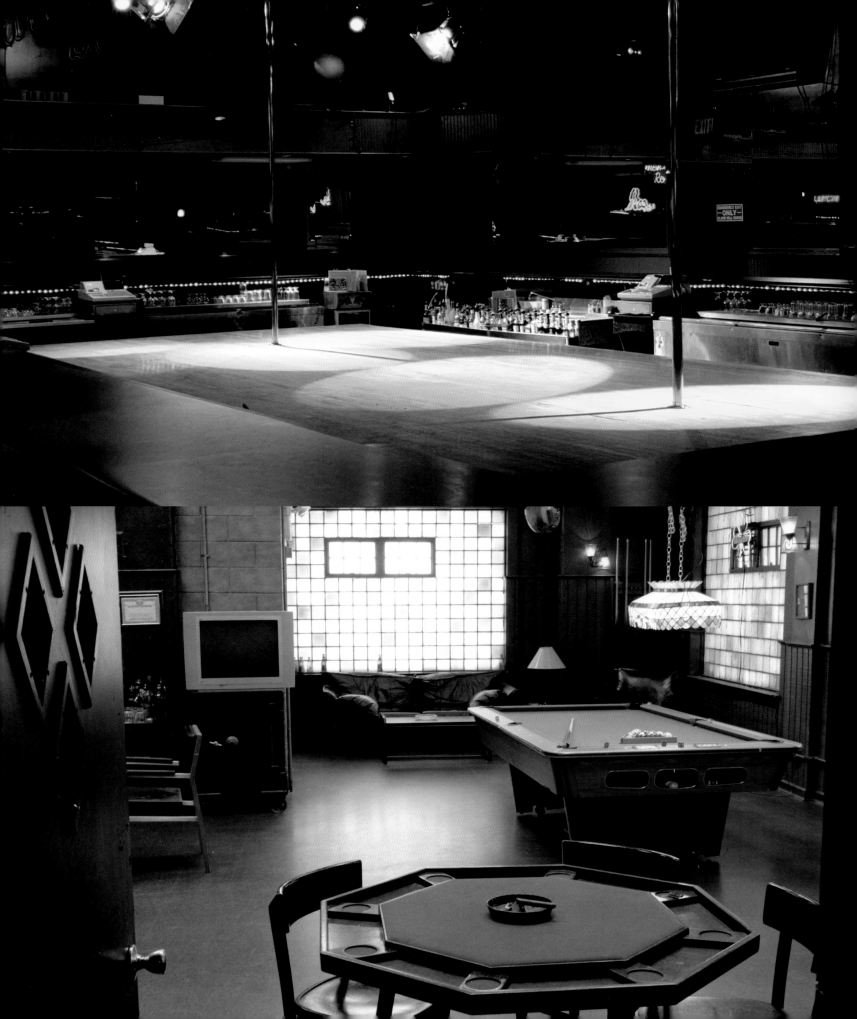

"Jimmy was just a great guy—very, very kind. He was amazingly kind to the crew, which isn't always the case with stars. He was the kind of person who would study everybody's name on the flipside of the call sheet and know everyone's first name, just trying to be that guy who cares. Because he really did care and wanted to make sure everyone felt like they were an important part of what we were doing. He was never a prima donna, and the other actors followed his lead that way. He was approachable and warm and easy to work with. If we ever needed a stand-in to measure the light for a scene, Jimmy always said yes. It would be, 'What do you need me to do? Where do you want me? How do you want me?' That kind of accessibility made things so much easier on the set."

—Alik Sakharov, director of photography

"Jim wasn't at all the guy you saw on the show. He wasn't Tony in the slightest; he was a Birkenstock-wearing, music-loving guy. I didn't get there until the second season, but he treated me like I'd been there forever. And it was because of him that everywhere we went during the shooting of the show, we'd be treated like royalty. It was like we were playing for the Yankees. Four of us would walk into a restaurant, and everyone would stand up and give you an ovation. And that all stemmed from Jim . . . After the fourth season, we had a dispute over pay and filming was delayed. Jim called all the regulars together and gave each of us about $33,000. He said, 'Thanks for sticking by me.' This was out of his very own pocket. How can you not love this man?"

—Steve Schirripa (Bobby Baccalieri)

"Working with Jim was just an amazing acting experience for me. We'd done the movie *Mr. Wonderful* together before *The Sopranos,* so we knew each other. But for some reason, I got really nervous the day of our first table read. They sat me next to Jim, and he reached over and took my hand. I think he could sense my nervousness, and he went out of his way to calm me down and make me feel welcome. It worked. I instantly felt I was with family. That was the feeling on the set, too, and it all emanated from Jim."

—Annabella Sciorra (Gloria Trillo)

"James and I had a pretty deep unspoken connection. I could feel his protectiveness of me, Jamie, the person, which I think translated to Tony and Meadow. I always felt very safe in his presence and very supported. He was the guy who reminded me I had worth at work and that I could have an opinion, I could ask for more, I could ask questions . . . He taught me how to conduct myself on a set and gave me a lot of important lessons . . . There was never a moment where he phoned it in. He and Edie both expected me to bring it and operate on the same level with them, and when professionals like them have that expectation of you, it means they believe in you wholeheartedly. It gave me a big boost of confidence I wouldn't have otherwise had."

—Jamie-Lynn Sigler (Meadow Soprano)

"In hindsight, Jim has become kind of a gold standard that I've been able to compare to some of my other experiences with actors. Because on the one hand, here was a guy who had been doing the same character for years, knew it better than anyone else, worked with a dramaturg partner to really refine his performance, and yet I never worked with an actor who was more open to direction than Jim. There was not a single moment working with me where he seemed to dismiss or brush off the directing process . . . The two of us had an affectionate, warm, and playful relationship. On our last day of shooting together, he picked me up and threw me in the swimming pool—playfully. He also had a nickname for me: Cupcake. I never learned why."

—Alan Taylor, director

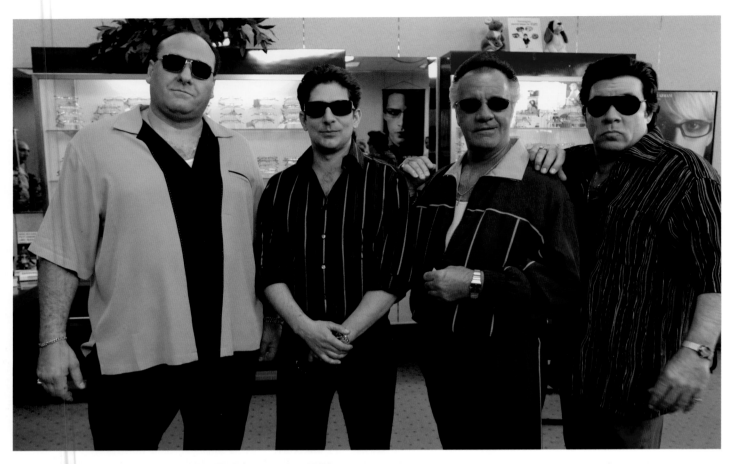

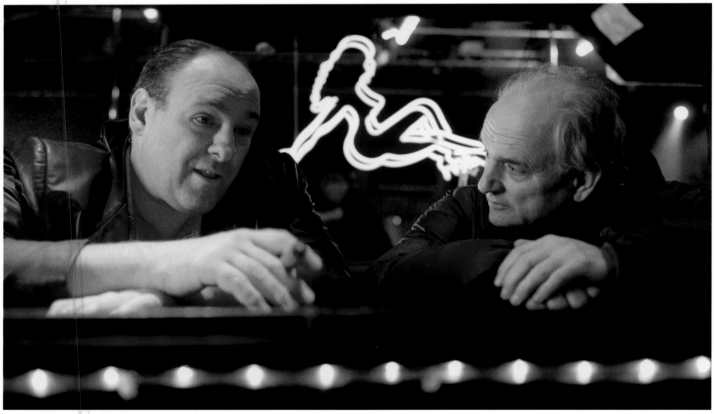

"Jimmy and I had some history together before we played brother and sister on *The Sopranos*. We were in a 1992 Broadway production of *A Streetcar Named Desire* together with Alec Baldwin and Jessica Lange. And we stayed friends after that . . . We found that we had this same rhythm working together. It's kind of like acting with yourself. When I got there, I saw that James didn't necessarily love being the star of the show. He would have loved it just as much to not be the star. He didn't crave the attention that came with it. But he operated on the set with generosity. He was really fair. He didn't lead with his ego. He was there for people and shared the spotlight graciously. That truly made it feel like we were a family."

—Aida Turturro (Janice Soprano)

"Jimmy never showed up unprepared. I think his process was one he was very serious about, and he and Edie complemented each other perfectly. They had such mutual respect and sort of tempered each other. But Jimmy had a great, deep understanding of that character and a personal connection. He probably wouldn't like that character as a person, but the connection was undeniable. Jimmy owned it, and I can't imagine that was easy. His personal morals and beliefs sometimes got in the way, and I saw him as an actor agonizing over what the script asked him to do. But Jimmy was such a deep human being and such a great actor. He was incredibly versatile. He could play anything."

—Tim Van Patten, director

"As I've said many times, you do a scene with Jimmy Gandolfini, and you come away a better actor just from his incredible talent and craft and presence. We were very close while doing the show and stayed that way right to the end. Jim was a remarkable guy, on top of being one of the greatest actors ever. He was great in everything he did. The business, the industry, the craft misses him for sure. And I miss him personally as well—every single day."

—Steven Van Zandt (Silvio Dante)

"So Jim shows up for the first audition to play the lead in this show for a character then named Tommy Soprano. He sits down. I've got a young lady working the camera, and I'm trying to read lines with him—and he just stops. He says, 'This is much denser than I thought.' He and David [Chase] banter for a little while, just guy talk, and it was decided he'd come in again to read in Los Angeles later on. Why did David give him another chance? Well, there were less than a handful of Italian male actors out there who could do this. Jim was too smart a guy to do this halfway and the wrong way. And David respected that. He got the role because he refused to bring less than his best to the table."

—Georgianne Walken, co-casting director

"Jim was exactly like a great athlete. And like some athletes, I think he really sacrificed himself for the team. I think it was very hard on him. He put every ounce of himself into the show and the character. There were moments of levity, but for the most part *The Sopranos* was very serious business for him."

—Matthew Weiner, writer-producer

"Jim and I had more of a professional relationship than an off-camera one. But it was also very honest. We sometimes got into it. We'd argue with each other if we had to. I'm thinking of the time Tony had the physical fight with his mistress, Gloria Trillo, where he had to literally pick her up and slam her into the floor and strangle her. It was hard for him to get into that headspace because Jim was absolutely *not* Tony Soprano. He was about as 180 as you can get. So having to become Tony with that ugly sometimes greatly impacted him. It finally came down to trust—in me, in the writing. But through it all, Jim was very approachable and incredibly generous as a person, as an actor, as a colleague."

—Terence Winter, writer-producer

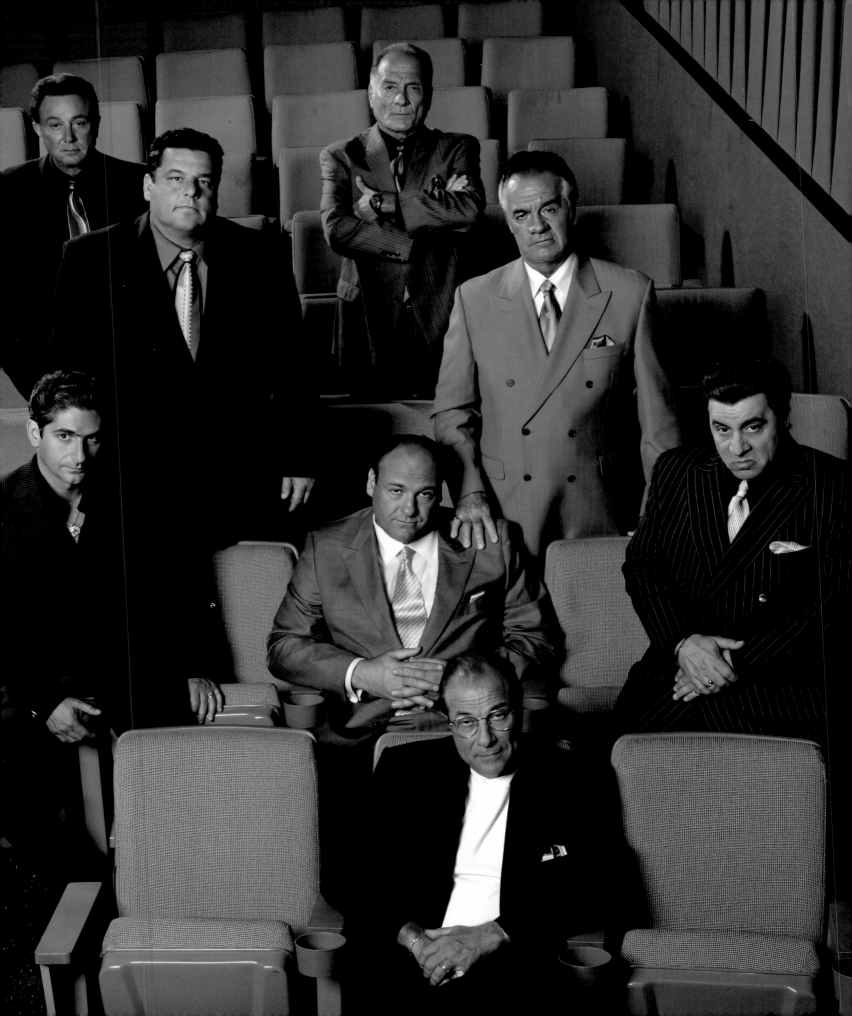

The Sopranos Now and Forever

"A gangster goes to therapy to work through issues with his mother."

That was the basic elevator pitch for *The Sopranos*: simple, accurate, to the point, and yet so thin a description for a show that is today widely accepted as one of the greatest and most influential shows in the history of TV. More than a quarter-century after its premiere, its characters—so colorful and complex—have been etched into the consciousness of viewers worldwide. And new generations continue to discover them every month.

Tony, Carmela, Christopher, Paulie, and Silvio may use flip phones and tool around in pre-Tesla gas guzzlers, but otherwise the show is timeless. "It could have been written yesterday," believes Steve Schirripa, cohost with costar Michael Imperioli of the *Talking Sopranos* podcast. Schirripa and other cast regulars are still selling out small arenas around the country when they tour to talk about the show. "More people watch the show now than when it originally came on. Only 11 million had HBO at the time we premiered in 1999. Now with streaming, they watch us in Saudi Arabia," Schirripa says.

In those days before Netflix, Hulu, and max, the show introduced an entirely new way of watching televised entertainment. Whereas broadcast networks had rigid and long-entrenched rules for what could and could not be shown in terms of language, storylines, sex, violence, and racial themes, *The Sopranos* was bound by no restrictions. And yet the audience flocked.

And while there had been unconventional series that pushed the envelope dating back to *All in the Family* in the '70s, *Hill Street Blues* in the '80s, and *NYPD Blue* and *Twin Peaks* in the '90s, no show so completely obliterated the rulebook as *The Sopranos*.

Soprano, an upper-middle-class New Jersey mobster who was murderous, angry, impulsive, reasonable, pragmatic, shortsighted, and generous. When he wasn't presiding as boss over his not-always-organized criminal family, he was pretending to be a devoted husband while cavorting with mistresses, playing the role of engaged father to his two kids, and pouring out his heart to his shrink. He was, at nearly every turn, a sociopath who struggled to embrace a conscience; an individual more prone to caring about racehorses and ducks than human beings.

Tony's presence lingers like a ghost in the collective consciousness of society. The ongoing fascination with him the mundane challenges of family life, while still finding time to enjoy hedonistic pleasures on the side. There were no characters like Tony on TV pre-*The Sopranos*. Sure, there were morally ambiguous figures leading up shows but none that so challenged viewers to embrace them despite their considerable flaws—you know, a brutal beating here, a murder there. And yet the show was really, at its heart, a black comedy filled with psycho mobsters, corrupt cops, and long-suffering mob wives struggling to be high society while looking past how their husbands made a living.

Before *The Sopranos*, there were no villainous central characters, no serialized narrative arcs that failed to wrap

up storylines inside each hour. Sometimes, the show didn't wrap up at all. Incomplete storylines left open to audience interpretation would spark watercooler conversations around the country every week—igniting the ultimate controversy with its now infamous cut to black that ended the series. That took boldness and guts, and some viewers still haven't forgiven David Chase for it.

There are many compelling reasons why the show doesn't feel like a relic of the aughts. Firstly, it pioneered the idea of cinematic TV. Chase was always looking to graduate from TV to film, and he infused *The Sopranos* with cinema-style quality and production values.

The Sopranos represented a watershed for storytelling on the small screen. It upgraded the soap opera beyond the nighttime sparkle of *Dallas* and *Dynasty* to an elevated level of artistry. It brought out flawed characters who were all-too-human and sometimes died— just like in real life. This is what succeeding generations are responding to in embracing *The*

Sopranos today and why it remains relevant. It doesn't go out of style any more than humanity itself does.

The show's characters, catchphrases, and themes have become part of the cultural lexicon and remain woven into the zeitgeist. Its stories are eternal in the same way that Shakespeare is, bringing a similar emotional depth to its characterizations. In that way, it invented the concept of prestige television and singlehandedly raised the profile of TV as a medium. And the spirit of *The Sopranos* lives on in many high-profile dramas that have followed in its wake. Introducing a protagonist capable of acts both heinous and humane paved the way for such antiheroes as Vic Mackey on *The Shield,* Jax Teller on *Sons of Anarchy,* Walter White on *Breaking Bad*, and Don Draper on *Mad Men:* guys who trudged the line between good and evil whose decency was often called into question.

At the same time, *The Sopranos* changed the way we watch TV, ushering in a new golden age of drama that also brought us the likes of *Six Feet Under, The Wire, Boardwalk Empire, Game of Thrones,* and *Succession.* All these shows arguably bore the same mark of *The Sopranos*. The show also taught us that people will pay extra for quality original programming, giving rise to the streaming model we know today. And yet, none of these other shows has been feted with podcasts, food pop-ups, and seemingly endless nostalgia to mark life milestones. In January 2024, to mark its twenty-fifth anniversary, a TikTok campaign presented episode recaps in twenty-five-second snippets, while Max released never-before-seen deleted footage along with five hours of behind-the-scenes content.

What is it about this show that continues to capture the public imagination? Well, part of it is the rich tapestry of talented performers who graced the series. But of course, they're only as good as the scripts and the quality of the direction. It's also the relatability of the stories being told across generations. It's a mirror that reflects an intricate web of human desires and flaws, a prism through which audiences examine the complexities of identity and principles. Just when we think the show has finally moved off the forefront of our consciousness, it returns—much as Silvio Dante mirthfully echos the words of *The Godfather*'s Michael Corleone: "Just when I thought I was out, they pull me back in."

As it turns out, a lot of people used quarantine as an opportunity to binge *The Sopranos* for the first time or rewatch it with fresh eyes. It's also the show's meme-ability that has kept its fire burning bright. A serious drama about

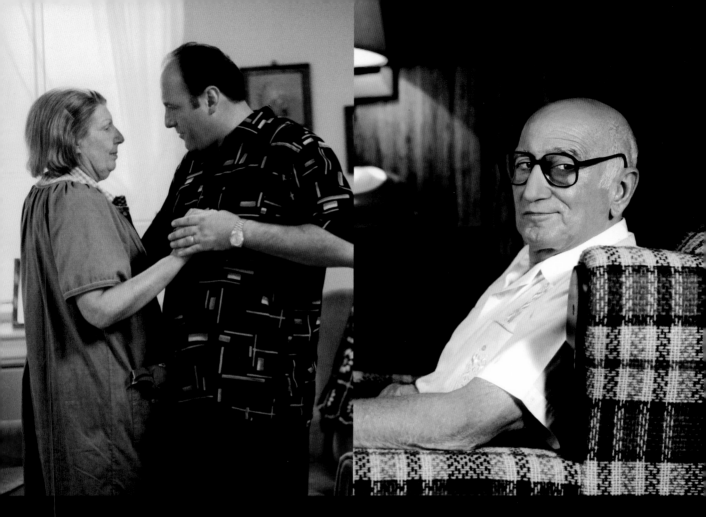

crime, mental illness, and family dysfunction that's also funny. The "mob wife aesthetic" has further driven its enduring popularity as a fashion trend, promoting a broad camp style of animal prints, big hair, bling-y jewelry, and squared French-tip manicures.

But at its core, *The Sopranos* is still about the Mafia, and Americans never seem to lose fascination with the organization. As unctuous as these mobsters are, there is an aspect of folk heroism to them, operating with such verve and swagger on the margins of society. The wise choice that Chase made in crafting the series was never to infuse the writing with lofty moral messages about the gangster lifestyle. Instead, it's left to the audience to draw their own ethical lines and interpret the corruption of the characters for themselves.

Going forward, *The Sopranos* will remain the template for groundbreaking entertainment. And if we dare attempt to extrapolate who Tony Soprano is in the context of today's mindset, consider that he's basically a middle manager struggling to keep his underlings in line when all form of chaos is erupting around hm. That sort of anxiety is a feeling known to tens of millions around the world. It may even drive them into therapy.

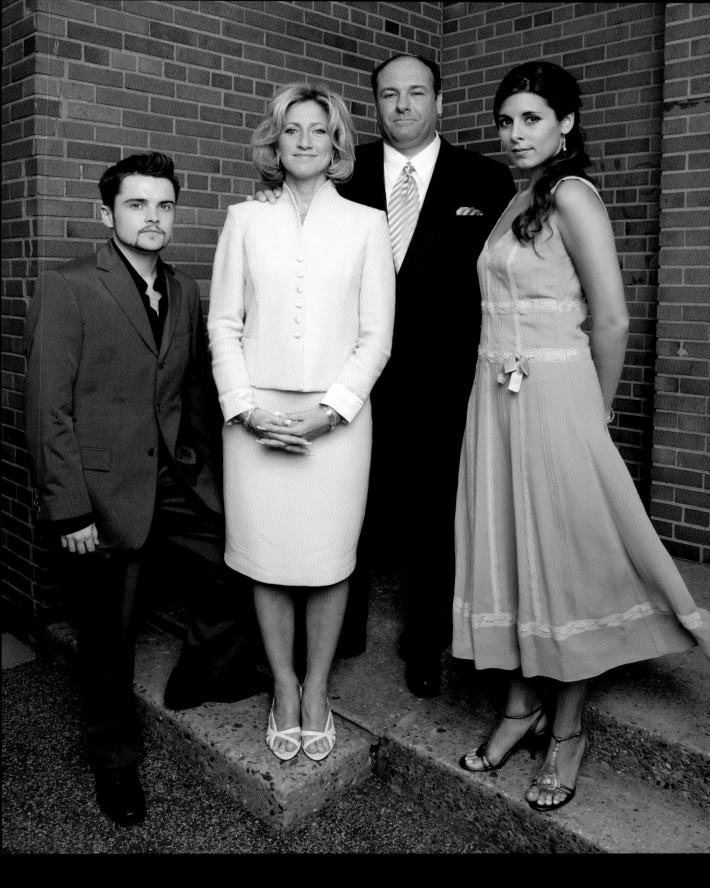

The Lineup

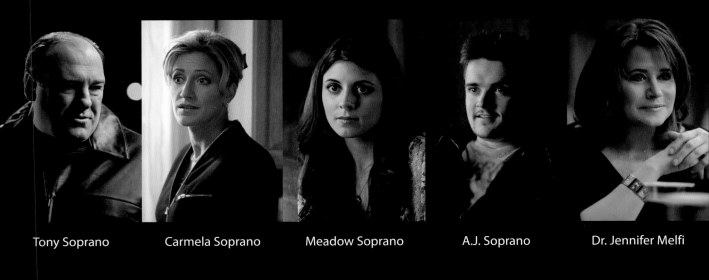

Tony Soprano　　Carmela Soprano　　Meadow Soprano　　A.J. Soprano　　Dr. Jennifer Melfi

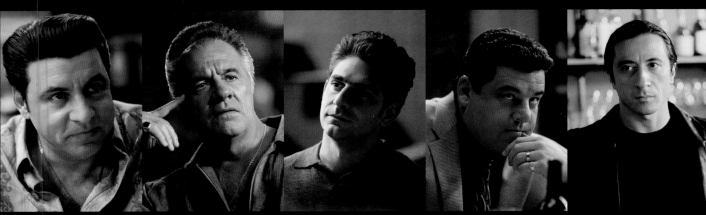
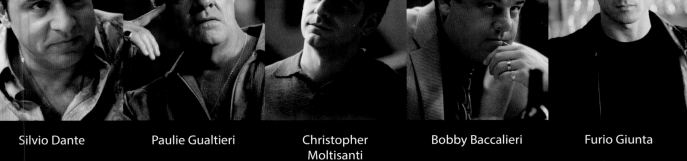

Silvio Dante　　Paulie Gualtieri　　Christopher Moltisanti　　Bobby Baccalieri　　Furio Giunta

Larry Boy Barese　　Carlo Gervasi　　Patsy Parisi　　Johnny Sacrimoni　　Phil Leotardo

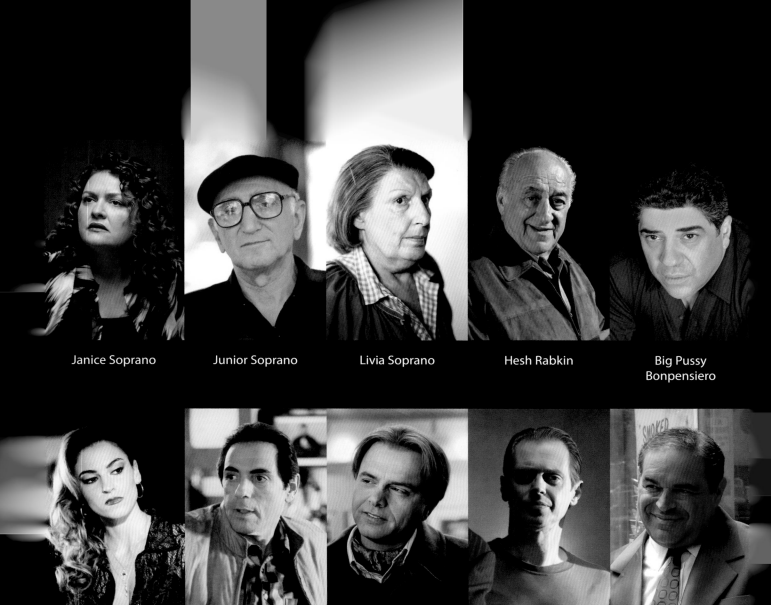

Janice Soprano

Junior Soprano

Livia Soprano

Hesh Rabkin

Big Pussy
Bonpensiero

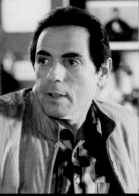

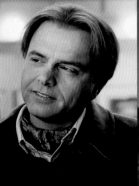

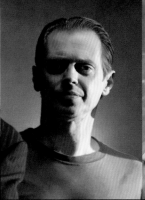

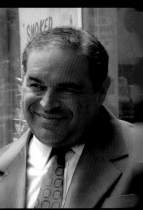

Adriana La Cerva

Richie Aprile

Ralph Cifaretto

Tony Blundetto

Vito Spatafore

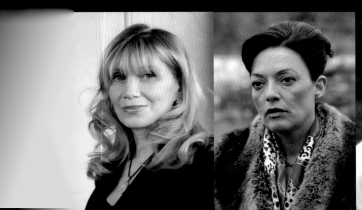

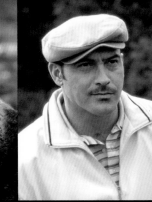

Gualtieri, Maria "Nucci," 171, 233, 246
Gualtieri, Paul "Paulie Walnuts," 9, 10, 15, 25, 33, 65, 69, 96, 98, 100, 101, 105, 107, 126, 128, 137, 141, 143, 155, 164, 165, 168, 170, 171, 174, 188, 193, 204, 209, 213, 229, 233, 240, 243, 246, 247, 256, 258, 269, 271, 282. *See also* Sirico, Tony

H

Harris, Dwight, FBI Agent 154, 238, 240, 247, 256
Haydu, Barry, 164
Heard, John, 64. *See also* Makazian, Vin
Holsten's diner, 243, 247, 265

I

Iler, Robert, 35, 57, 202, 203, 271. *See also* Soprano Anthony, Jr. "A.J."
Imperioli, Michael, 9, 54, 58, 109, 227, 277. *See also* Moltisanti, Christopher
Intintola, Father Phil, 45, 47, 64, 156, 163, 217, 263

J

Jaffe, Sheila, 15, 16, 37, 118, 271
Jersey Shore, 97, 149, 171, 262

K

Kalem, Toni. *See* Bonpensiero, Angie
Kingsley, Ben, 224, 246
Kirilenka, Svetlana, 76, 112, 136, 143, 146, 150, 171
Kolar, Emil, 63, 256
Krakower, Dr., 125
Kupferberg, Elliot, 53, 100, 114, 181, 283

L

La Cerva, Adriana, 26, 65, 100, 107, 109, 129, 137, 143, 145, 154–155, 170, 171, 177, 193, 198–199, 204, 205, 222, 225, 258, 264, 283. *See also* de Matteo, Drea
La Manna, Feech, 131, 177, 187, 188, 204
Landress, Ilene, 271
LaPaglia, Jonathan, 224
La Paz, Valentina, 146, 171, 205
Leotardo, Phil, 174, 177, 187, 193, 204, 205, 211, 210, 219, 229, 233, 238, 240, 246, 247, 258, 270, 282
Leotardo, William "Billy," 189, 193, 205, 247
Loggia, Robert. *See* La Manna, Feech.
Lupertazzi, Carmine, Sr., 140, 165, 170, 171, 177, 188, 204, 229
Lupertazzi, Carmine, Jr., 189, 190, 193, 204, 205, 224, 229, 246, 247, 270. *See also* Abruzzo, Ray

M

Makazian, Vin, 63, 64, 65
Marchand, Nancy, 25, 37–38, 74, 78, 81, 113. *See also* Soprano, Livia
Margulies, Julianna, 19. *See also* Skiff, Julianna
Massarone, Jack, 193, 204
de Matteo, Drea, 65. *See* La Cerva, Adriana
Matush (drug dealer), 193, 198

Melfi, Jennifer, 7, 17, 25, 35, 40, 48, 52–53, 64, 65, 68, 100, 101, 107, 113, 114, 118, 136, 137, 157, 174, 179, 181, 192, 204, 232, 246, 247, 260, 282. *See also* Bracco, Lorraine
Millio, Rusty, 189–190, 205, 233. *See also* Valli, Frankie
Moltisanti, Kelli, 230, 246
Moltisanti, Christopher, 9, 25, 26, 32, 58, 64, 65, 69, 71, 98, 100, 101, 104, 107, 109, 113, 126, 128, 129–131, 136, 137, 140, 143, 145, 155, 163–164, 164, 170, 171, 175, 187, 190, 193, 198, 199, 204, 205, 209, 211, 213, 224–225, 230, 232, 233, 246, 247, 256, 258, 264, 282. *See also* Imperioli, Michael

N

Narducci, Kathrine, 19, 54, 271. *See also* Bucco, Charmaine
Nascarella, Arthur J., 240, 256
Nieves, Gilbert, 193, 198
Nuovo Vesuvio/Vesuvio restaurant, 8, 64, 65, 96, 157, 204, 221–223, 263

O

Old Hydro-Pruf factory, 253

P

Palmice, Mikey, 63, 64
Pantoliano, Joe, 9. *See also* Cifaretto, Ralph "Raphie"
Parisi, Patrick, 211, 243, 247
Parisi, Patsy, 10, 105, 136, 155, 238, 243, 282
Pastore, Vincent, 19, 94, 271. *See also* Bonpensiero, Salvatore "Big Pussy"
Patrick, Robert, 78. *See also* Scatino, David "Davey"
Peltsin, Irina, 69, 101, 143, 146, 150, 169, 171, 262
Peparelli, Joseph "Joey Peeps," 189, 190, 193, 205
Pie-O-My (racehorse), 143, 146, 163, 164, 171, 278
Polcsa, Juliet, 45, 47
Pontecorvo, Eugene "Gene," 129, 233, 246
The Prince of Tides (movie), 181
Proval, David, 78, 81. *See also* Aprile, Richie

R

Rabkin, Hesh, 58, 60, 65, 192, 233, 247, 283. *See also* Adler, Jerry
Riegert, Peter, 146. *See also* Zellman, Ronald

S

Sacrimoni, Ginny, 145, 157, 164, 165, 170, 229
Sacrimoni, John "Johnny Sack," 140, 143, 145, 157, 164, 165, 170, 175, 189, 190, 193, 204, 211, 229, 233, 246, 247, 282. *See also* Curatola, Vincent
Sakharov, Alik, 273
Salgado, Blanca, 211, 234, 247
Sanseverino, Robyn, 170, 233
Sapienza, Al, 64. *See also* Palmice, Mikey
Satriale's Pork Store, 232, 253, 256
Scatino, David "Davey," 69, 78, 80, 100, 101
Schirripa, Steve, 19, 78, 80, 157, 160, 227, 273, 277. *See also* Baccalieri, Bobby

AUTHOR ACKNOWLEDGMENTS

This book simply wouldn't have been possible without the tireless efforts and expertise of Rebecca Razo, my literary guide extraordinaire who started off as my editor and grew to become my coauthor. No one on the planet is a greater authority on *The Sopranos* universe than she.

I am also indebted to the exquisite Ilene Landress, who was an essential guide in all things *The Sopranos* and who went several extra miles to open doors that provided access to numerous series players and crew.

Without Jeff McLaughlin, my point man at Insight Editions, the book would never have been able to come together on the accelerated timetable that it did. No one in the publishing business approaches their job with greater vision and passion.

My thanks also to everyone from the series who supplied their time and cooperation on a project a quarter-century in the making. Their dedication to a show that changed their own lives, and those of so many others, remains a source of genuine inspiration. Thank you, also, to the folks at the HBO Archive for all their help in locating and accessing prop assets from the show. A very special thank you to the HBO Licensing and Legal team, particularly Michele Caruso, who went above and beyond to secure the photo assets needed to complete the book.

Finally, to my wife Jill Holden, who tolerated my obsession with *The Sopranos* with uncommon patience and understanding.

ABOUT THE CONTRIBUTORS

Ray Richmond has worked as a TV critic and columnist as well as an entertainment reporter and editor for a number of publications, including *The Hollywood Reporter, Daily Variety, The Orange County Register, Deadline Hollywood,* and the preeminent Hollywood awards website Gold Derby. He is the author of several books, including the bestselling *The Simpsons: A Complete Guide to Our Favorite Family; This is Jeopardy!: Celebrating America's Favorite Quiz Show;* and the coffee-table biography *Betty White: 100 Remarkable Moments in an Extraordinary Life.* He has also ghostwritten and collaborated on many memoirs, including those of the legendary actress Janis Paige and the renowned character actor William Sanderson. Ray teaches a graduate course in television history each fall as an adjunct professor at Chapman University in Orange, California, enlightening students to the seismic impact of *The Sopranos* among other shows. He makes his home in LA but resides in New Jersey in his mind.

Rebecca Razo has worked in publishing for more than twenty years. A prolific writer and editor, she has overseen the creative development of hundreds of books, and she writes across multiple categories, including art, DIY, design, lifestyle, and more. After fifteen years in trade book publishing, Rebecca founded Coffee Cup Creative LLC, a creative-services provider specializing in illustrated nonfiction books for adults and children. A Southern California native, Rebecca relocated to the greater Portland, Oregon, metro area in late 2020. In her free time, she enjoys reading, hiking, traveling, and spending time with her four-pawed family members. She has watched every season of *The Sopranos* at least a dozen times and considers herself a superfan of the show. Visit coffeecupcreative.net.

Alicia Freile is a veteran book designer originally from the Philadelphia area, now living in Brisbane, Australia. She has designed and art directed a wide variety of books, including *Burning Man: Art on Fire* and *Fender Telecaster and Stratocaster.* Alicia is the Design Director of Tango Media Australia and USA. Visit tangomedia.com.au.

INSIGHT
EDITIONS

PO Box 3088
San Rafael, CA 94912
www.insighteditions.com

Find us on Facebook: www.facebook.com/InsightEditions

Follow us on Instagram: @insighteditions

HBO

ISBN: 979-8-88663-638-3

Publisher: Raoul Goff
VP of Licensing and Partnerships: Vanessa Lopez
VP of Creative: Chrissy Kwasnik
VP of Manufacturing: Alix Nicholaeff
Designer: Alicia Freile, Tango Media
Executive Editor: Jeff McLaughlin
Editor: Rebecca Razo, Coffee Cup Creative LLC
Copyeditor: Liz Weeks
Editorial Assistant: Alecsander Zapata
Senior Production Manager: Joshua Smith
Sourcing Manager, Subsidiary Rights: Calvin Kwan
Indexer: Timothy Griffin
Prop photography: Todd Blubaugh

 ROOTS of PEACE REPLANTED PAPER

Insight Editions, in association with Roots of Peace, will plant two trees for each tree
used in the manufacturing of this book. Roots of Peace is an internationally renowned
humanitarian organization dedicated to eradicating land mines worldwide and
converting war-torn lands into productive farms and wildlife habitats. Roots of Peace
will plant two million fruit and nut trees in Afghanistan and provide farmers there
with the skills and support necessary for sustainable land use.

Manufactured in China by Insight Editions

10 9 8 7 6 5 4 3 2 1